Medieval Drawings

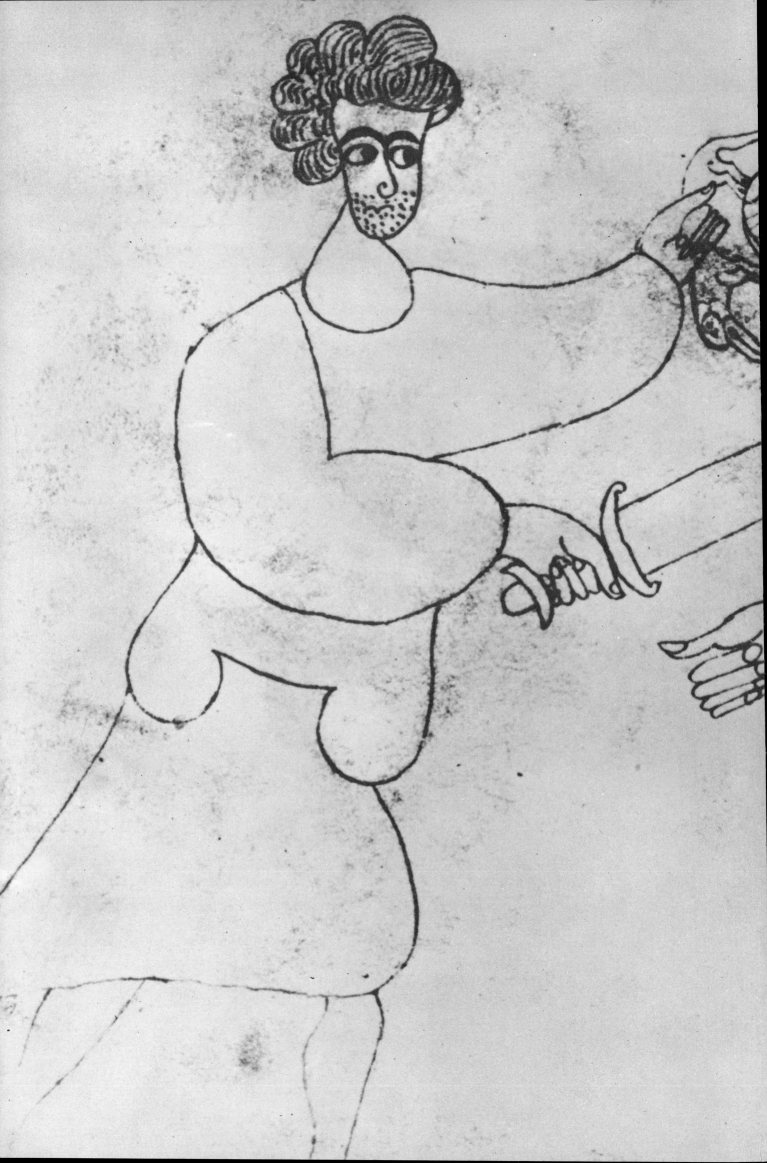

M. W. Evans

MEDIEVAL DRAWINGS

Paul Hamlyn
London/New York/Sydney/Toronto

Acknowledgments

The drawings in this volume are reproduced by kind permission of the following collections, museums and libraries to which they belong:
Archives of the Collegiata, Mirabella Eclano (Plate 30); Augustinermuseum, Freiburg im Breisgau (Plate 93); Bayerische Staatsbibliothek, Munich (Plates 16, 33, 34, 35, 73, 81, 115, 116, 117); Bernisches Historisches Museum (Plates 100, 101); Biblioteca Apostolica Vaticana (Plates 21, 38, 60, 83, 84, 85, 128); Biblioteca Capitolare, Vercelli (Plates 28, 29, 90); Biblioteca Casanatense, Rome (Plate 74); Biblioteca Civico, Bergamo (Plate 125); Biblioteca Mediceo-Laurenziana, Florence (Plates 47, 61, 76); Bibliotheek der Rijksuniversiteit, Leiden (Plates 8, 86, 87); Bibliotheek der Rijksuniversiteit, Utrecht (Plate 18); Bibliothek des Domkapitels, Merseburg (Plate 3); Bibliothèque Municipale, Amiens (Plate 4); Bibliothèque Municipale, Avranches (Plate 44); Bibliothèque Municipale, Cambrai (Plate 42); Bibliothèque Municipale, Dijon (Plate 46); Bibliothèque Municipale, Rheims (Plate 80); Bibliothèque Nationale, Paris (Plates 7, 10, 11, 39, 43, 92, 94, 95, 96, 132); Bodleian Library, Oxford (Plates 12, 24, 25, 52, 64, 65, 82); Trustees of the British Museum, London (Plates 13, 14, 19, 22, 23, 26, 45, 53, 55, 56, 63, 68, 69, 91, 108, 109, 110, 112, 113); Cabinet des Dessins, Musée du Louvre, Paris (Plates 120, 131); Caius College Library, Cambridge (Plate 67); Cathedral Library, Winchester (Plate 104); Cathedral Treasury, Auxerre (Plate 41); Cleveland Museum of Art, Delia E. and L. E. Holden Funds, John L. Severence Fund (Plate 121); Corpus Christi College Library, Cambridge (Plate 9); Dean and Chapter of Durham Cathedral (Plate 62); Provost and Fellows of Eton College, Windsor (Plate 31); Germanisches Nationalmuseum, Nuremberg (Plate 130); Dean and Chapter of Hereford Cathedral (Plate 49); Herzog-Anton-Ulrich-Museum, Brunswick (Plate 123); Herzog-August Bibliothek, Wolfenbüttel (Plate 2); Hessische Landesbibliothek, Darmstadt (Plate 70); Historisches Archiv, Cologne (Plates 71, 72); Kupferstichkabinett, Basle (Plate 122); Landesbibliothek, Kassel (Plate 32); Master and Fellows of Magdalene College, Cambridge (Plates 126, 127); Musée de l' Œuvre Notre-Dame Strasbourg (Plate 99); Oesterreichische Nationalbibliothek, Vienna (Plates 36, 77, 78, 89, 114); Master and Fellows of Pembroke College, Cambridge (Plate 48); Pierpont Morgan Library, New York (Plates 51, 102, 103, 111); John Rylands Library, Manchester (Plate 40); Sammlung für Plastik und Kunstgewerbe, Kunsthistorisches Museum, Vienna (Plate 124); Schlossbibliothek, Pommersfelden über Bamberg (Plate 58); Janos Scholz, New York (Plate 129); Staatliche Bibliothek, Bamberg (Plate 1); Staatsarchiv, Koblenz (Plate 106); Staatsbibliothek Preussicher Kulturbesitz, Berlin (formerly Preussische Staatsbibliothek) (Plate 57); State Public Library, Leningrad (Plate 5); Stiftsbibliothek, Einsiedeln (Plate 88); Stifts-Bibliothek, St Gall (Plates 15, 98); Board and Fellows of St John's College, Cambridge (Plate 50); President and Fellows of St John's College, Oxford (Plate 66); Master and Fellows of Trinity College, Cambridge (Plates 20, 75); Board of Trinity College, Dublin (Plates 6, 54); Universitaetsbibliothek, Basle (Plates 27, 119); Universitätsbibliothek, Heidelberg (Plate 105); Universitetsbiblioteket, Uppsala (Plate 59); University Library, Cambridge (Plate 17); University Library, Prague (Plate 107); Walters Art Gallery, Baltimore (Plate 37); Württembergische Landesbibliothek, Stuttgart (Plates 79, 97); Zisterzienserstift, Lilienfeld (Plate 118).

Published by the Hamlyn Publishing Group Limited
London, New York, Sydney, Toronto
Hamlyn House, Feltham, Middlesex, England
© The Hamlyn Publishing Group Limited, 1969
Phototypeset by Filmtype Services, Scarborough
Printed by Continental Printing Company, Hong Kong.

Drawing was invented by Philocles the Egyptian, or perhaps by Cleanthes the Corinthian; so maintained the Roman writer Pliny, whose version of the history of art consists of an orderly sequence of happy discoveries. Subsequently, he goes on, one Ecphantus of Corinth thought of filling in the outline with colour, and thus invented painting. Pliny has little more to say about drawing after that, and one understands that from then on art never looked back.

This evolutionary theory of art history is now old-fashioned; a drawing is not regarded as a primitive form of painting any more than a bicycle is considered to be a primitive form of motor-car. But it is a theory that is relevant to the study of Medieval drawing, because, throughout the Middle Ages at least, something that was coloured was believed to be superior to something that was not. The usual definition of beauty from the time of St Augustine onwards stated that it depended on proportion and colour, and the importance of colour in physical objects is suggested by the fact that the Latin word *color* means the external appearance of something as well as colour as understood today. If a Romanesque or Gothic manuscript was illustrated with drawings, it was quite probably not because the artist or his patron preferred that technique, but simply because there was not enough time or money available to do the thing properly. There are exceptions to this: sometimes drawings imparted a quality that could not be obtained from paint; sometimes the nature of the picture demanded that it should be in outline. But a number of the most beautiful examples of Medieval drawings were never intended to be seen at all, except as the basis for thick, opaque colour. The modern idea of a drawing as a spontaneous and expressive sketch would hardly have been appreciated during the High Middle Ages. Bright, costly materials and exquisite craftsmanship were what Medieval connoisseurs admired, and although they might have enjoyed the meticulous drawings of Ingres, it is unlikely that they would have been very impressed by the work of Cézanne. The rapid sketch exists in Medieval art, especially in the margins of manuscripts, as a guide to the illuminator; but so little was thought of it that such sketches are frequently not even rubbed out or trimmed off the page. Preparatory drawings of this type look impressively bold and spontaneous in enlarged photographs, but they are not comparable in intention or appearance with the sketches of Renaissance artists.

In considering Medieval drawing, it is necessary to broaden the accepted definition of what a drawing is. There were no pencils in the Middle Ages, and paper was rare; the lengthy process of preparing parchment would discourage too much aimless scribbling, and the metal stylus with which the artist drew was a less responsive instrument than a graphite point. He could opt for a pen and ink or a brush to draw with, but he still had to make his ink, and fashion his pen or brush from the raw materials of goose-wing or hog-pelt. The drawing he produced after so much initial effort was often covered with a thin wash of paint, producing something like a modern watercolour; but since the dominant feature of these works is their outline, they can be treated as drawings rather than paintings and are regarded as such in this book. The only exclusions are those drawings

5

that have been discovered under wallpaintings – only drawings on parchment or paper are considered – and of course anything in which the colour obscures the linear quality of the picture.

The earliest Medieval drawings sometimes show a survival of Roman art, but most are stylised and unclassical, reflecting barbarian or even oriental influence. Only in the 9th century, under the rule of Charlemagne and his successors, was there an intensive revival of interest in Classical art. Charlemagne's empire, in his own opinion at least, was a continuation of the Roman Empire, and the conduct of his court, together with its art and literature, was based on Roman models. Ancient texts were recopied and so were the pictures that illustrated them. These illustrations were not usually contemporary with the text – they seem to have been devised during the 5th century – but they preserve the character of earlier Classical art.

The works to be copied were generally chosen because of their usefulness, not their literary merit. One of the most popular was the *Psychomachia* of Prudentius, a 5th-century allegorical poem which told of the epic struggle between the Vices and the Virtues, which were personified as warmongering women. The earliest known text is unillustrated, but two 9th-century copies made in Rheims survive, and there is a large number of later manuscripts. The earlier ones show strong Classical influence, both in the appearance of the figures and in the way they are drawn; there are usually two drawings per page, done in spaces left between the verses. Some of the illustrated Classical texts that were copied during this period, such as the fables of Æsop, have kept their place even today as part of the tradition of European literature. Others enjoyed more limited popularity, confined to their historical context; the *Psychomachia* was one of these. Nevertheless, it was still being reproduced in the 13th century and although the style of the drawing became less Antique over the centuries, the original form and disposition of the figures was often preserved.

The plays of Terence are not apparently of any educational value, yet they too were copied and illustrated many times. Medieval interest in these was engendered by the purity of their Latin; they became models of stylistic elegance, and in the 10th century a nun named Hrotswitha even composed a number of imitations of them. They, like the *Psychomachia*, were first illustrated in the 5th century, and copies with pictures survive from the 9th century. The illustrations do not reproduce actual stage performances; they show objects that are only suggested by the dialogue, and the figures are arranged artificially from left to right in order of speaking. But the drawings do represent the actors wearing masks, as was customary in the Roman theatre, and even late copies preserve the Classical style of costume.

Of all the aspects of Classical civilisation known to the Middle Ages, it was probably Classical learning that seemed most enviable. Medieval philosophy and science was based upon the achievements of Antiquity, and that this should have been so was due largely to the copyists of the Carolingian period. The principal illustrated works of this type were those on plants, animals and astronomy. Pictures of plants were normally coloured to help the student to identify them;

in the other works colour was a luxury and only the more lavish manuscripts introduced it.

The main work on astronomy was a Greek poem by Aratus, called the *Phaenomena*, and known to the Middle Ages through two fragmentary Latin translations. The useful if inaccurate maps of the sky it usually contained were later additions; in its early form its illustrations consisted simply of pictures of the constellations and through these pictures the Middle Ages received not only its knowledge of Antique astronomy, but also an idea of the appearance of the Classical gods and heroes. Pagan deities otherwise were a part of Classical culture that did not have much relevance in early Medieval society, but they can be found depicted in contexts where some knowledge of them is necessary to the understanding of an edifying text, such as Martianus Capella's *De nuptiis Mercurii et Philologiae*.

The collection of Classical animal lore ascribed to one Physiologus was the forerunner of the famous Bestiary; the pictures were an important part of these books and were usually drawn. The *Physiologus*, like the *Psychomachia*, is not strictly a Classical work, because the account of each animal concludes with a bit of Christian moralising, but it and its pictures preserve many Classical attitudes. Similarly, Bibles and early Christian texts often had illustrations in a style no less Antique than those to pagan literature, and these too were copied.

But the most important manuscript with drawings of this period is less likely to be a direct copy than an imitation of Classical art: this is the Utrecht Psalter, made near Rheims in about 820. More than any of the works mentioned above, this book evokes the skill and artistry of the ancient world – the figures have the liveliness and delicacy of stucco reliefs and they inhabit a landscape that is as full of space and atmosphere as the ones in Pompeian painting. The Psalter is not the easiest book of the Bible to illustrate, for it contains neither narrative nor description. The technique employed by the artists of the Utrecht Psalter was to seize on every fragment of visual imagery, every sentiment which could be expressed pictorially, and to recompose it into something that is almost a rebus. All this is executed in a light, disjointed style of drawing, full of nervous energy; pen-strokes are used economically, and much is left unstated. There is a visual harmony between the columns of text and the picture that unifies the page, yet the pictures themselves are neither flat nor static and this was an achievement that could only be attained by a drawing.

Painted copies after Classical art are usually less successful, and the reason why drawing should be so much better at reproducing the style of Late Antique illusionism lies in the way an outline is interpreted. The principal difference for the observer between a drawing and a painting is in the amount of information each gives: a drawing tells one nothing about colour, and often nothing about the modelling of the forms. But drawings are not therefore interpreted as being flat and colourless any more than a black-and-white photograph is thought to depict a scene whose natural colours are monochrome; the imagination supplies these deficiences, and what is seen is the real world expressed through a convention of colourlessness. Reality is more effectively evoked through suggestion than through statement. This is so even if the statement is a meticulous trompe-l'œil painting,

and it is even more obvious when it is expressed through the stylised art practised during most of the Middle Ages. So when early Medieval artists wished to imitate the illusionism of Roman painting, it was natural that they should do so in outline. Carolingian artists in Rheims attempted to do the same thing in colour, but there the effect is surrealist rather than realistic, with figures looming out of unearthly surroundings like figments from a nightmare. In a drawing, however, the absence of colour unites the figures, the background and the parchment on which they are represented in a continuum in which all contribute to the illusion.

The Utrecht Psalter is a most important document in the history of Medieval drawing, not only because it is so beautiful in itself, but because of its enormous influence. At some time before the year 1000 it was brought to Canterbury, where it remained throughout the Middle Ages. It seems so to have impressed English artists that they acquired a sympathetic understanding for outline work which they never lost. It was copied several times, and the influence of its light, flickering outline can be detected in English art at a period when other countries had adopted a harder, more solid style. The first copy was made at Canterbury in about 1000. It follows the original closely, but where the Rheims artists had used the outline to evoke the illusion of reality, the Canterbury ones used it to create decorative patterns. Landscapes become ornamental rather than naturalistic, and the figures are distorted. The greatest change, however, is in the medium itself: instead of brown ink, many different colours are used so that the decorative aspect of the page is increased, its semblance to reality lessened. Coloured drawing of this kind became very popular in Anglo-Saxon England; later artists used a band of pigment following inside or outside an ink outline, giving a stronger, even more decorative effect. This was the technique adopted for the second copy of the Utrecht Psalter, made in about 1150, also at Canterbury. The arrangement of the illustrations is the same, but they are tidied up and made to look more orderly. The illusion of space and atmosphere is completely lost, and a desire for decorative pattern governs everything from the composition of the pictures to such details as the forms of the trees in them; the original neo-classical design has been made to correspond to Romanesque aesthetic ideals. In the last copy, done in the early 13th century, no vestige of Antique style remains; it belongs entirely outside the Classical tradition and also outside the scope of this book, because the pictures are painted in the heavy colour of Gothic illumination.

The Utrecht Psalter was not the sole source of English drawing, although it was more influential than any other single work. But long before it arrived in England other Carolingian manuscripts were known, and from them derived a firmer, less dramatic style of drawing. The fact that the English works were in outline while their originals were probably painted suggests that a special aptitude for drawing already existed in England, perhaps as a result of the linear interlace ornament developed with such virtuosity in early Insular art. The less Classical character of this style was strengthened in the 10th century by Scandinavian influence, which encouraged an expressive but quite unrealistic type of illustration, closer to that in use on the con-

tinent. There, after the collapse of Charlemagne's empire, art suffered along with the rest of European civilisation. Only in the great monasteries such as St Gall and Monte Cassino was there sufficient security and the incentive to undertake something as time-consuming as the illustration of a long manuscript. Monastic art generally lacked the pretensions and grandeur of court art; only liturgical books, which formed part of the furnishings of the church, were ostentatiously splendid to look at. The ordinary books of the monastery library were illustrated simply, if at all. Copying texts was one of the monks' duties, and this task left little time for elaborate decoration: a florid initial or at the most a drawing was all that these books could afford to contain by way of ornament. Such drawings may have had more than a decorative purpose, however, in helping the reader to remember what he had learnt – pictures were certainly employed in this way in the later Middle Ages – and the initials were used to mark important divisions in the text.

In so far as the Carolingian court had a successor as patron of the arts, it was the Ottonian dynasty of the later 10th and early 11th centuries. But now taste was already tending towards the glowing but opaque colour that was customarily used for manuscript illumination in the later Middle Ages. Beautiful drawings were made in this period, such as those in the Paderborn Gospels, but it is in the painted manuscripts made for the emperors that the Ottonian style appears at its most characteristic. Drawing was now a second-best and remained so throughout the 12th and 13th centuries, except in special circumstances when it was more effective than painting and in a few areas which for some reason preferred outline illustrations.

One such area was England, where the proficiency and delight in manuscript drawing which had developed during the Anglo-Saxon period was never lost. Another was southern Germany, especially around the old imperial city of Regensburg, and Austria. Here, during the 12th and 13th centuries, drawing was the predominant technique for manuscript illustrations. Some are entirely in outline, with only a variation in the thickness of the stroke to enliven the controlled, unbroken contours, others are set against a coloured background, which makes them stand out and allows the artist to use a fainter, more delicate line. Many of these miniatures are didactic, incorporating explanatory inscriptions, and acting as an extension of the text rather than as decoration. Later German art was to develop this use of drawings, which, because they are in the same medium as the writing, integrate with the text much more easily than do paintings.

Elsewhere in Europe drawing existed alongside painting but was seldom exploited to its full potential. Some vigorous and ambitiously large-scale pictures were drawn in Catalan manuscripts and where English influence had been strong, as in northern France, outline work was no less magnificent than painting. In the monastery of Cîteaux in Burgundy, which owed much of its later fame to the work of its English abbot Stephen Harding, manuscripts were illustrated with typically English coloured drawings. But in France as a whole, painted and gilded miniatures were preferred whenever time and money permitted.

9

Colour and gold were used frequently in England, too, but the tradition of drawing was never forgotten and a style similar to that of the first Utrecht Psalter copy was still in use in the 12th century. Even when drawings were painted, it was often with a transparent tinted wash, and although the schematic forms of Romanesque art were used as much in England as in France, they were not necessarily represented as solid masses of colour; they could be made quite as apparent in outline. It has been suggested that the reason why the pictures in Bede's *Life of St Cuthbert*, now in the library of University College, Oxford, start as fully-coloured paintings and later in the book change to drawings is not that the artist ran out of paint or time, but that he preferred them that way. The colour in the later illustrations is transferred from the bodies of the figures to their outlines, which are in red, green and purple.

In the 13th century a new type of religious book became popular in England, which was often illustrated in outline, perhaps because of the large number of pictures it required. This work, which seems to have been a favourite among the educated laity, was the Book of Revelation – a somewhat surprising choice until one remembers the quantity of apocalyptic prophecies circulating at the time and also that St John's vision had all the fantastic ingredients of the contemporary romances. The picture emphasised this exotic quality. Like the Utrecht Psalter drawings, they attempted to include everything that could be expressed visually, but the composition of the scenes is much more orderly and almost diagrammatic by comparison.

Many English drawings of this time, including some of the Apocalypses, are associated with the artist and writer Matthew Paris, but it is probable that the only works he illustrated personally were those he wrote himself, which include some saints' lives and a history of the world. Matthew Paris was a monk of St Albans and in 1236 became the official chronicler of the abbey. His drawings are intimately connected with the text, and sometimes a picture at the top of a page is composed in such a way that it echoes the division of the writing below into two columns. He has the unusual distinction among Medieval artists of possessing a name, so he is inevitably credited with rather more works than he in fact executed, and since his distinctive but unobtrusive style was perfectly suited to the illustration of narrative, he had many imitators, who helped to keep the English tradition of outline drawing alive throughout the Middle Ages.

Even in England, however, a religious manuscript made for use in church was usually illustrated with painted miniatures. So too were books intended to be given as lavish presents. The majority of 12th- and 13th-century drawings are to be found in secular books, especially in technical manuals. Other non-religious writings, such as literature and history, are disappointingly empty of drawings. For works of literature this is understandable; poetry and fiction in the 12th and 13th centuries was recited rather than read, and what was written down was intended for an educated and wealthy audience, who would demand by way of illustration something more sumptuous and more in keeping with the subject of the book than mere drawings. Chronicles were recorded in writing from a much earlier date,

yet these too are seldom illustrated. The principal history book of the earlier Middle Ages was Orosius's *Historia adversum paganos*, but few of the numerous manuscripts of this work have pictures, and in the most extensively illustrated copy the drawings are squeezed awkwardly into the margins, which suggests that they were added later.

Why histories and chronicles, apart from those of Matthew Paris, should so rarely have pictures is puzzling, for the Middle Ages fully appreciated the value of the visual aid to both understanding and memory, and illustrated handbooks on medicine and astronomy were common. Such pictures, like the text, had a practical purpose, so they were done in the cheapest and clearest technique available: that of drawing. It was not necessary for them to be in any sense works of art. A medical diagram showing where the body should be cauterised or how a patient should posture himself for an operation needed to conform to anatomical truth only where that was relevant to the case, and aesthetic considerations were even less important. Nevertheless, some medical drawings are gratuitously beautiful and appear to have no surgical use whatever, except possibly as the equivalent of old magazines in the doctor's waiting-room.

Astronomical illustrations still show the influence of Classical copies of Aratus, though these were modified to incorporate the new knowledge brought from the East in the 12th century. This was ultimately Classical in origin too, but had been lost to the early Middle Ages and preserved only in Arabic translations. The same sources reintroduced astrology to the West, which transformed the study of the stars from an erudite pursuit into a matter of universal interest. Many more astronomical manuscripts were consequently produced, with increasingly complex diagrams to illustrate the comprehensiveness and accuracy of the science. These are frequently as unappealing to the modern art-historian as they are irrelevant to the modern astronomer, but as documents of cultural history they are highly revealing.

The most curious examples of Medieval drawings are those which use a diagrammatic form to set out scientific or philosophical ideas. At first sight these may appear to do nothing except make a complex subject more complicated. This is because they do not explain but summarise; to understand what they mean one has to know it all already. But once one is familiar with the subject they illustrate, it can be seen that they frequently express the concept they embody more concisely than a written account could have done. They also exemplify an important characteristic of Medieval thought: its wish to impose order on everything and to allocate it an appropriate position in Creation. Since the Medieval philosopher had to respect both the revealed truth of Christianity and the traditional truth of such Classical authorities as he knew, his opportunities for uninhibited speculation were limited. The reorganisation of these acknowledged facts and the demonstration of their mutual compatibility and dependence were his principal task, and diagrams, which are statements and not arguments, were a valuable aid in this. Figures of this type had been used in Antiquity, particularly to demonstrate constructions in logic, but only the Middle Ages felt the need to devise similar designs to expound the whole cosmos.

The simplest kinds of Medieval diagram consist of squares and circles labelled with inscriptions, and they show how different concepts co-ordinate with one another; how, for instance, the Four Elements and the Four Humours correspond, or how the Twelve Prophets and the signs of the Zodiac can be seen as part of the same harmonious system. These fundamentally unrelated sets of ideas could then be superimposed, and such diagrams could attain considerable complexity and comprehensiveness. The draftsmen were often not content with bare geometric shapes and introduced extraneous decoration, transforming plain figures into arabesques.

The same sort of thing had been done from early Medieval times to the Canon tables in liturgical manuscripts. These were concordances which set out in four columns references to the corresponding passages in the Gospels. They were commonly enclosed in architectural shapes, which converted what would otherwise have been dull pages of index into a grand ornamental design. A diagram based on a physical object, whether architectural like the Canon Tables or a natural form, was more effective than those made out of abstract shapes, for the characteristics of the object could be used to reinforce the meaning of the image. An example of this much used in the Middle Ages and still familiar today is the family tree. The growth and spread of a family is reflected and made apparent in a vegetable form and it must have seemed significant in the Middle Ages that the analogy of a root with trunk and branches to set out a genealogy has no less a precedent than Jesse's divinely-inspired dream. But a schematic tree was not only appropriate for showing the descent of a family; it could be used to demonstrate any system of classification which involved division and sub-division, such as the Medieval philosopher was tirelessly devising to expound the order of the universe. This application of the tree-diagram had been known in Antiquity from the writings of Porphyry, who had used it to show the relationship of species and genera, and the Tree of Porphyry, reproduced literally or with variations, was a familiar figure in Medieval works on philosophy. But many more elaborate trees were invented to illustrate other concepts; there were trees showing the classification of the sciences, trees showing how the Vices and Virtues sprang from the roots of Pride and Humility and even a tree setting out the Table of Kindred and Affinity.

A diagram based on an objective form is more attractive to look at, as well as having this additional level of meaning, and this is obviously useful if its purpose is to educate an uninformed and possibly unwilling public. The friars, who as a preaching order had an understandable interest in new educational methods, invented several such designs. St Bonaventure, a Franciscan, devised one which he called the *Lignum Vitae*, a combination of a tree and a Crucifix which summarised and commented on the life of Christ. Another friar, Bonacursus, collected a whole anthology of diagrams based on such forms as trees, wheels and figures of angels. He also invented an original one himself: the Tower of Wisdom. This was a castle whose architectural members expounded a lesson in ethics. This process could operate in reverse too – Durandus interpreted the different parts of a church symbolically, as though the building were an

enormous three-dimensional allegory of the Christian faith.

As well as expressing concepts diagrammatically, Medieval teachers liked to represent them in human form; Vices and Virtues were personified as women in the *Psychomachia,* and similar anthropomorphic equivalents that could be devised for almost anything – the Liberal Arts, the Five Senses or the Year, for instance. Schematic pictures introducing such figures ceased to look like diagrams and became comparable to a sculptured church portal, where each statue has a meaning and forms part of a symbolic ensemble. As with the portals, their beauty belies their didactic qualities and their meaning is often as mysterious.

Not all the figures in such compositions are personifications; some represent man himself. The Middle Ages believed that there was between man and the universe a harmony that amounted to identity – man was a miniature of the cosmos, his bones being like the rocks, his breath like the wind, his hair like grass, and so on. This 'Microcosm' was illustrated schematically, as was the somewhat similar theory that different parts of the body were under the influence of different signs of the Zodiac. It was not invariable for such pictures to be drawn. There is a huge painted Microcosm in the crypt of the cathedral at Anagni, and there are many manuscripts with beautifully coloured diagrams. Colour could even be an asset because of its symbolism, but usually a coloured outline alone was enough to show that, for instance, the Tree of Virtue is green, without resorting to paint. Outline drawings were almost always more satisfactory, because of the frequent inscriptions in these works. Lettering on a painted ground usually had to be isolated on scrolls for clarity, whereas in a drawn picture it could be introduced where it was needed, without being difficult to read and without destroying the visual harmony of the composition. Solid colour might have obscured not only the inscriptions but also the form of the diagram itself if the latter was at all complex.

The most elaborate and fantastic of all diagrams are those done by Opicinus de Canistris, an Italian priest who was a member of the Papal court at Avignon during the second quarter of the 14th century. He began drawing after a serious mental illness. It has been suggested that he was schizophrenic and his drawings certainly take diagrammatic exposition to lunatic lengths. They are very large, drawn on pieces of parchment up to three feet long, and combine geometrical constructions, natural forms and personifications in strangely emotional compositions. His favourite image was the map of the world, which he distorted so that the different countries resembled monstrous human beings: Europe became a man, Africa a woman, and the Mediterranean Sea was the Devil. These were interpreted as symbols of the evil state of the world and more particularly as personal allegories of Opicinus's own predicament. There are two whole manuscripts devoted to these extraordinary documents, composed between 1335 and 1341. They contain notes and religious pictures as well as a variety of diagrams showing almost obsessive ingenuity in converting concepts to visual forms. One of the most ambitious (and more rational) of these is a circular autobiography.

Opicinus's manuscripts were the equivalent of his private diary.

Other artistically-inclined thinkers may have kept similar note-books, but nothing comparable has survived. Nor have medieval artists left any personal sketch-books; the nearest things to those are model-books. The drawings contained in these are not original inventions but copies of standard types, and the common property of the artist and his associates. Not until the late 14th century were drawings of this kind considered to be an artist's personal possession. For a painter to be accused of stealing another's models, as Jacquemart de Hesdin was in 1398, would have been unthinkable in the earlier Middle Ages. The need for this kind of book was created by the conservative character of Medieval iconography. The form in which subjects were represented was dictated by tradition, so a repertoire of models, or *exempla*, recording these was a necessary part of the artist's equipment. These *exempla* were not observations from nature, but conventional formulae; nor were they complete compositions, but clearly-drawn, single figures to be used in any work in which they were appropriate.

The purpose of model-books was practical, not aesthetic, and this governed their appearance. Provided the model was clearly portrayed, it did not matter how it was presented, whether upside-down or juxtaposed with something quite irrelevant. Nor was fineness of execution important, for since the drawings were patterns that would be used by many generations of artists, it was often necessary to retrace their outline in fresh ink, which would destroy any subtlety of line they might once have had. This was usually done just to strengthen the form, but sometimes the opportunity was taken to make modifications, such as altering the costume of the figures to accord with contemporary fashion. The earliest known model-book is that of Adémar de Chabannes, a monk of Limoges who died in 1034. The drawings show figures from the New Testament arranged on the page in no particular order, and some ornamental designs. The book also contains illustrated texts of Prudentius, Æsop, and Hyginus's work on astronomy. Some other early model-books are combined with written texts often quite unconnected with the pictures. Such compilations seem to have been regarded as general reference books, which suggests the community of interests to be found in monasteries. Most model-books probably began as loose sheets kept in portfolios and were bound up only later. Some have survived as detached leaves, or as fly-leaves pasted into later volumes.

Artists in the Middle Ages seldom restricted themselves to working in one medium. The same man might be a sculptor, a goldsmith, a painter of miniatures and a painter of frescoed walls – even an architect. This versatility is reflected in the model-books, where the patterns often do not seem to be intended for any particular medium. The most comprehensive model-book is that compiled by Villard de Honnecourt and his successors from 1230 onwards. This contains not only the usual traditional models but also the memorable sights that Villard saw on his travels. His drawing is clear and rather impersonal and this is not only because it has been redrawn; he is using outline as a vehicle for the precise and objective presentation of forms. These are not exact records, however; the subjects are set out in terms of their most important elements, which include not only their

more notable visual features but also the geometrical constructions underlying them. For Villard this geometrical foundation was an essential part of a work of art. A note on one page describes his book as giving information about the art of drawing 'as the science of geometry directs and teaches it'. In some of his pictures the geometrical basis is made apparent, in others it is less noticeable; but all of them are governed by it. Even his famous drawing of a lion 'from the life' is based on a circle drawn with a compass. As well as the customary *exempla* of animals and religious figures, the book contains some more specialised drawings, such as designs for mechanical devices and automata, and architectural plans and elevations.

Architectural drawing, in the sense of a design for builders to work from, probably did not exist until Villard's day. There is a 9th-century ground-plan from St Gall showing the layout of a monastery, but it is a theoretical disposition of elements rather than a practical solution to an architectural problem. At that date, and for a long time afterwards, a building would have been designed directly on the earth where it was to be erected, and details would have been drawn full-size on the stone from which they were to be carved. But the complexities of Gothic architecture demanded small-scale plans and it is possible that the character of mid-13th-century churches, with their surface ornament and preference for flat screens rather than masses of masonry, owes something to the practice of designing elevations on parchment.

Villard's drawings are not particularly practical either. Like so many medieval copies they are selective and emphasise those features which Villard found especially notable, such as the sculptured oxen on the towers of Laon cathedral, while other, less memorable details are omitted. Not until the second half of the 13th century do architectural drawings achieve the kind of scientific detachment normally associated with works of this kind. Even those drawings were not always practical, however. Designs for late Gothic spires often embodied as much wishful thinking as the ideal plan from St Gall and had to wait for the engineers of the 19th century before they could be realised.

The nearest thing to a sketch that survives from the Middle Ages is the preparatory drawing made for a painted miniature. Sometimes these were drawn beside the space where the painting was to go; more often they were done directly on the area to be painted and have been covered. But enough unfinished miniatures remain to show what these looked like. The usual practice seems to have been to do a carefully finished ink or dry-point drawing over a faint but sure outline. Photographs taken with transmitted light show that the artist who painted the picture – not always the same person as the one who drew it – did not feel bound to follow the drawing precisely. In any case the addition of colour totally altered the character of the work. Many of these incomplete miniatures are of great beauty and give no indication that they are but fragments. In fact as far as those who commissioned a book were concerned, it does not seem to have made very much difference what state the miniatures were in when they acquired it. Maybe they accepted a degree of incompleteness as inevitable in an especially lavish work. Indeed, Medieval ideas about

the point at which something could be considered finished were not the same as those of the present day. The practice of adding to and modifying cathedrals is well known; few of these great churches reached a definitive state during the Middle Ages. 'Finish' was a cumulative, not an absolute, concept. So a manuscript which had not yet been painted was not necessarily unpresentable and when it had been painted it was not necessarily finished, for it might yet have ornamental covers fitted to it or other miniatures inserted. A degree of finish which had got as far as the addition of colour was preferred, naturally, but the Gospel Book of Matilda of Tuscany was nevertheless thought to be in a fit state to be kept on the altar of San Benedetto di Polirone, although only one of its miniatures was ever painted. To suggest, as has been done, that the two pages of drawings in the Winchester Bible were never to be obscured with anything more than a transparent wash of colour is to forget that Medieval artists had no fears about spoiling something by over-enriching it. The Middle Ages preferred their lilies gilded. An injunction like the one on the back of Brother William's drawing of the Apocalyptic Christ, that nothing more is to be written on the page lest the picture on the other side be damaged, shows exceptional concern that a work should be preserved in its existing state. Such a drawing might often have been regarded as a masterpiece in the 13th century, but only rarely as the ultimate expression of an image.

Modern drawing began in the 14th century. By 1400 the drawing was no longer commonly an illustration lacking colour or something with a specialised practical purpose; it had become an independent artistic form. Such drawings had never once been part of a manuscript, and they were preserved neither by chance nor because they were useful or had religious associations, but because they were beautiful and were collected by connoisseurs. The art-historian Vasari, for instance, began his album of drawings with a late 14th-century example which he attributed to Cimabue.

The origin of this new kind of drawing is obscure. It may have developed from model-books or from the preliminary sketches under wall-paintings, but it is significant that its appearance coincided with a revival of interest in drawings for manuscript illustrations. As manuscript decoration became more delicate and more widely deployed over the page, heavily-modelled painted surfaces were used less often. Already in the 13th century it was customary to depict in paint only the draperies of the figures, and to draw faces and hands in ink on a pale ground. Now the increasing sophistication of the finest paintings called for lighter colours throughout, articulated by elegantly flowing contours. New painting techniques were invented to convey this refined and subtle art, such as grisaille, in which the palette was restricted to shades of grey. The result looked like a shaded drawing. Another technique used was camaieu. This was similar to grisaille, but employed a limited range of pale colours on tinted parchment. In these ways it was possible to combine all the exquisite craftsmanship of painting with the delicate restraint of drawing. It was also possible to counteract the tendency of the increasingly realistic miniatures to disrupt the flat surface of the page; the new developments in perspective could be employed, but miniatures in

grisaille would preserve the unity of the page. They could never emulate the drawing's unique characteristic of incorporating the actual substance on which it was done into the picture, but they nevertheless became so popular that some late Medieval drawings even seem to be imitations of grisailles.

Sometimes drawings and paintings were used together on one page, allowing the artist to enjoy the advantages of both techniques. In Queen Mary's Psalter there is an introductory series of Old Testament scenes done in tinted outline, followed by the Psalms themselves with the usual painted initials but decorated with further drawings at the bottom of each page. The effect is rich and varied, without being overpowering like some fully-painted 14th-century Psalters. In the Windmill Psalter another way of avoiding heaviness has been found: the miniature which gives the book its name has as a background a meticulous filigree of pen-work.

Despite the refinement of drawing in the 14th century, in its basic form it still remained the quickest and cheapest way of illustrating a manuscript. During this period the number of books and readers was increasing greatly and the book-trade was expanding. The production of books was an organised profession with its own guilds, and book-shops developed run by 'stationers', so called because they were not itinerant tradesman, but had permanent establishments. The most popular books were illustrated devotional works, in which picture and text were closely integrated. As with the diagrams in earlier manuscripts, pictures like these were more satisfactory drawn than painted, because they then preserved the continuity of the page. Since the subject was the important thing in these pictures, their artistic quality did not matter, and many are crudely and even incompetently executed. Those which are more carefully done are often lacking some of the illustrations, which testifies to the speed at which such manuscripts were turned out.

The best-known of these popular works was the so-called *Biblia Pauperum,* which was composed in Germany in the mid-13th century. Its familiar title, the Bible of the Poor, indicates its purpose, but it was more than just a Bible in pictures. Its form was similar to the 13th-century *Bible moralisée,* in which each incident of the Bible was illustrated and paired with another event that drew a lesson from the scriptural story. The *Bible moralisée,* with its 1,784 miniatures, was an enormous book and one of the most ambitious undertakings of the age. The *Biblia Pauperum* was more modest and limited itself to some 38 illustrations from the New Testament, two to a page. Each scene was linked with two Old Testament incidents which were supposed to prefigure it. Thus it provided a lesson in Biblical interpretation as well as in sacred history.

A more complex version of the same idea was devised in 1324. This was the *Speculum humanae salvationis,* or Mirror of Human Salvation. In this there were three prefigurations or 'types' to one Biblical scene or 'antitype' and these types included incidents from secular history. The most elaborate creation of this kind was the *Concordantia Caritatis,* invented by Abbot Ulrich of Lilienfeld in the mid-14th century. Here there were two Biblical types, two comparisons from nature and four prophets making apposite prophecies, to each antitype. The

ones on paper, which a press could reproduce more efficiently and just as well.

A new type of drawing, however, had appeared in about 1350: the preliminary sketch on a single sheet of paper, pertaining to one particular picture. It is from this, rather than from late manuscript drawings, that modern drawing has developed. Some of these sketches are simply figure studies, others are complete compositions; some are preparatory models done by the artist for his own benefit, while others are contractual drawings to show how a commissioned work would look—such drawings came to have the force of legal documents.

Model-books remained in use at this time, but their character had changed: they showed more interest in recording observations from nature than in preserving iconographic conventions. Many of the pictures are of animals, and although these are still presented as general types which could be introduced piecemeal into a composition, they are also nature-studies. Established patterns for religious figures are included but, in Italy at least, where some of the finest 14th-century model-books were made, less reliance was placed on them —when Giotto's pupils copied from model-books, it was only as an exercise.

Italian drawings of the late 14th century can hardly be called Medieval any longer. The sketchbooks of Gentile da Fabriano and Pisanello preserve the layout of model-books, but their style belongs to the Renaissance. In the rest of Europe Medieval elements were more pronounced, but the Gothic style was modified by Italian influence, particularly in the representation of space. The result has been called the International Style, though the adjective has little more relevance to the art of the period than the Goths have to Gothic. The drawing of this time is fully modelled, and artists attempted to extend the medium with new techniques and materials; the forms are often highlighted in white, and some drawings are done on prepared boxwood panels. The pictures combine the artificial elegance of French Gothic with the close observation of detail associated with Flemish art. Most of them are figure studies or preliminary drawings for compositions, but they are complete in themselves as few such sketches are. It is not only their exquisite finish that makes this so; it is the fact that they use monochrome to do everything that a painted surface could accomplish, just as the Utrecht Psalter had done almost 600 years earlier. number of antitypes was increased to 156 and the work called for almost as much labour as the *Bible moralisée*, so it is not surprising that only 6 out of the 24 surviving manuscripts are illustrated.

Manuscripts with drawings continued to be the basic form of popular literature until printing provided a more convenient alternative. In the 15th century German artists evolved a simple but effective style of manuscript illustration to keep pace with the growing demand. It employed vigorous, angular pen-strokes and broad areas of colour wash and was very similar in appearance to the pictures in block-books. Printing was at first regarded as providing an inferior alternative to manuscripts and its ousting of hand-written and illustrated books was a slow process. It was, however, an inevitable one, and the first manuscripts to be replaced were the cheap pen-drawn

Drawing had regained its identity as a medium in its own right, the equal of painting as a means of expressing the artist's vision, and Cennino Cennini's artists' handbook of the early 15th century asserts that all aspiring artists should begin by learning to draw.

But although it was recognized as a necessary stage in an artist's training, and although its recommendation by Aristotle and Vitruvius gave it a dignity even above painting, drawing was paradoxically less evident now than before. No longer an alternative to a painted work, it had become simply a transitory stage on the way to making a painting, and in being placed at the beginning of an artist's training, it was confirmed in the preliminary station it had occupied in Pliny's sequence of art history.

It has been questioned whether drawings in the modern sense of independent works of art ever existed in the Middle Ages. It is true that there are enormous differences between the drawings of the Renaissance and later, and Medieval ones, and it can be maintained that drawing as it is understood today is a creation of the Renaissance. It is true also that many of the works illustrated in this book go beyond the orthodox idea of what a drawing is. They admit colour, some are as highly finished as paintings and few exploit all the advantages of representation in outline alone. Yet they cannot be adequately classed with any other medium, and although a survey of Medieval drawings in isolation is certain to give a distorted idea of the history of European art, and although the works discussed here form no single group, they demonstrate that alongside the well-known tradition of painted manuscript illumination there existed an equally productive, if more limited, tradition of outline illustration. To a denial that this is drawing one can only retort with an adaptation of the words used by Dr Johnson when Boswell, in an abortive attempt to provoke him into conversation, asked him why he believed in freewill: 'Sir, we *know* it is so, and *there's* an end on't'.

Notes on the Plates

Plate 1 Monastic craftsmen making books. St Ambrose, Works. Bamberg, first half of 12th century.

The first stage in the manufacture of a book is shown on the left, in the second circle from the bottom, where a monk is preparing parchment. In the scene opposite he cuts the skin to size. The next part of the process is illustrated in the top left-hand circle, where a monk is cutting his pen from a goosefeather, and in the top right-hand one he has finished writing, placed the pen out of the way behind his ear, and is busy painting the manuscript. The monk below is binding the book, and the two to left and right at the bottom are making the covers and the metal clasps to hold it shut. In the centre at the top another monk proudly thrusts the finished book out beyond the frame of the medallion, and in the centre at the bottom the volume is seen in use. The remaining circle shows an artist at work on a diptych. In the central panel another paints an architectural structure, perhaps a shrine. The Archangel Michael, the patron saint of the abbey of Michelsberg, where this coloured drawing was probably made, presides over all the activities.

Bamberg, Staatliche Bibliothek, MSC. Patr. 5 (B. II. 5), f. 1v.

Plate 2 Portrait of Agenus. Corpus agrimensorum Romanorum. Northern Italy, 6th century.

The *Agrimensores* were a collection of Roman writings on surveying, and this drawing of one of the authors is not so much Medieval as part of an unbroken tradition of Antique art. The brown ink is very faded and parts of the picture have been redrawn, but it still has a strongly Classical character; the representation of space and the human body is Classical in intention if not in execution, and the details of the architecture and the furniture are Roman.

Wolfenbüttel, Herzog-August-Bibliothek, Cod. Guelf. 36.23. Aug. Fol., f. 73v.

Plate 3 Scenes from Roman history. Consular List from Ravenna. 11th-century copy of 5th-century work.

So few drawings from the beginning of the Middle Ages have survived that one has to rely on later copies for an idea of their appearance. This is a copy of a 5th-century chronicle from Ravenna, recording the last years of the Roman Empire. The text is written in three columns and gives a list of consuls and the most important events that occurred during their year of office. Some of these are illustrated with small, unframed pictures. Only the bottom half of the page is preserved; this fragment includes events between 435 and 454, and the pictures show the Emperor Valentinian III raising his general Aetius to the rank of patrician, Attila the Hun capturing Aquilea, and the death of Aetius. The figure of a man ending in a dragon's head represents the earthquake of 443.

Merseburg, Bibliothek des Domkapitels, MS. 202.

Plate 4 Five initials. Corbie Psalter. France (Corbie?), *c.* 800.

Many early Medieval decorative initials are made out of human or animal forms. Sometimes these figures were appropriate to the text, like the sea-monster for *De Profundis*, and sometimes they were purely ornamental. English monks had worked at Corbie during the 8th century and British art may have affected the style of drawings done there; but in these initials one may detect also the influence of Coptic textiles. The letters are two Ds, to Psalms 129 and 130; M, to Psalm 131; S, to Psalm 136 and L, to Psalm 150. Later Medieval artists preferred to form letters out of abstract shapes and introduce more natural figures within the spaces which these enclosed, but the technique of building initials out of living forms persisted throughout the Middle Ages (compare Plate 125).

Amiens, Bibliothèque Municipale, MS. 18, f. 110r., 110v., 113v., 123r.

Plate 5 Samuel anointing David; David and Goliath. Paulinus of Nola. England, *c*.800.
Although the picture is an illustration, the outline is used for decorative rather
than descriptive ends. The artist depicts the hands of his figures from the palm
side regardless of anatomical possibility, because of the interesting patterns made
by the closed fingers. Also he indicates heels with little spirals, which have a
proper place in calligraphic ornament, but none in the human body. The head
peering out from between David and Saul is a later addition.
Leningrad, State Public Library, MS.Q.v.XIV.N.1., inserted leaf.

Plate 6 Symbols of the Evangelists. Book of Armagh. Ireland, 807-845.
Early Medieval culture in Ireland was influenced by Classical civilisation, but
Antique ideas were given a strongly barbaric flavour. The art of the time
combined a Classical sense of formal balance with a Celtic mastery of abstract
ornament, executed with lapidary precision. Most Irish manuscripts were
painted in jewel-like colours; this page is in outline, but shows the same hardness
of contour, and the doubled lines and the hatching provide an equivalent to the
sparkle of colour.
Dublin, Trinity College, MS.52, f.32v.

Plate 7 Luxuria seduces the Virtues. Prudentius, Psychomachia. Tours, 10th century.
This and the following three drawings show illustrations to an allegorical poem
describing a war between the Vices and the Virtues. To reinforce the hard-
pressed Vices, Luxuria, or Excess, comes from the West in a marvellous chariot.
The Virtues are beguiled and throw down their arms. Of the 20 manuscripts of
Prudentius with pictures, this one preserves most accurately the appearance of
the original Classical illustrations to the poem.
Paris, Bibliothèque Nationale, MS.lat.8318, f.52v.

Plate 8 Sobrietas routs Luxuria. Prudentius, Psychomachia. Rheims, 9th century.
Sobrietas comes to the rescue of the Virtues, making the horses of Luxuria's
chariot panic by confronting them with the Cross. The style and iconography of
this manuscript is different from the group of copies to which Plate 7 belongs—
the bulging forms are notably unclassical—but the archetype was probably the
same.
Leiden, Bibliotheek der Rijksuniversiteit, Cod.Burm.Q.3, f.134v.

Plate 9 Wrath and Patience. Prudentius, Psychomachia. England (Malmesbury?),
c.1000.
Wrath sees Patience standing apart from the battle and taunts her; but she proves
to be impervious to spears and Wrath kills herself in disgust. These drawings, too,
are descended from the common original, but the Anglo-Saxon style had given
them a character of their own.
Cambridge, Corpus Christi College Library, MS.23, f.9r.

Plate 10 The Death of Luxuria. Prudentius, Psychomachia. Paris, 1298.
Sobrietas kills Luxuria with a stone and harangues her corpse. The pictures in this
manuscript are still dependent on the same original as the other Prudentius
illustrations, but they have been transformed by the Gothic idiom: the figures
wear flowing robes and the chariot has become a curious construction with
pointed arches.
Paris, Bibliothèque Nationale, MS.lat.15158, f.48r.

Plate 11 Parmeno presenting gifts to Thais. Terence, Comedies. Rheims, 9th century.
The scene is from Terence's comedy 'The Eunuch'. The drawing is a copy of a
Late Antique illustration and preserves the vivacity and sense of space to be found
in Classical painting, as well as the appearance of the Roman costumes. It is not,
however, a reproduction of a stage performance, but an imaginative reconstruc-
tion of a dramatic episode.
Paris, Bibliothèque Nationale, MS.lat.7899, f.47r.

Plate 12 Parmeno presenting gifts to Thais. Terence, Comedies. St Albans, c. 1150.
This later copy of the same scene ignores almost all the Classical qualities of the original. The figures no longer stand on the ground; their environment is not a street in Athens but the surface of the page. The light, evocative strokes that the earlier artist used to depict the characters and their setting are replaced by a firm, continuous line which portrays every detail at the expense of the general atmosphere.
Oxford, Bodleian Library, MS. Auct. F. 2.13, f. 47r.

Plate 13 The constellations of the Centaur and the Serpent. Aratus, Phaenomena. Fleury, late 10th century.
The Middle Ages adopted the Classical practice of identifying groups of stars with mythological gods or heroes. This was done more for convenience than from superstition, but the drawings of the constellations preserved the iconography of legendary figures rather better than they did scientific information about the stars. This manuscript was probably made by English artists working at Fleury and shows Classical influence in its style as well as in its subject.
London, British Museum, MS. Harl. 2506, f. 44r.

Plate 14 The constellation of Sagittarius. Aratus, Phaenomena. England (Peterborough), c. 1122.
The scientific information in Aratus was not always sufficient for later ages, and his work was added to and glossed. To keep these embellishments distinct from the original text, they were sometimes inscribed within the outlines of the drawings of the constellations, while the poem itself appeared at the foot of the page.
London, British Museum, MS. Cott. Tib. C. 1, f. 25v.

Plate 15 Celestial map. Aratus, Phaenomena. St Gall, c. 837.
The aspiring Medieval astronomer would have found a star map considerably more useful than individual pictures of sky-demons, which is what the Aratus illustrations basically were. Celestial maps were accordingly added to Aratus manuscripts. The traditional figures of the constellations were kept, but they were arranged in their correct positions relative to one another. The map was constructed around the circular belt of the Zodiac; the sky was divided into two circles, each one containing half the Zodiac, with the other major constellations in their proper places.
St Gall, Stiftsbibliothek, Cod 902, p. 76.

Plate 16 Mythological figures. Remigius of Auxerre, commentary on Martianus Capella. Regensburg, c. 1100.
The Middle Ages got its knowledge of the pagan gods not only from pictures of constellations but also from written accounts. The latter were not always understood and Jupiter, Mars, Saturn, Apollo and the Graces as portrayed in this drawing are not immediately identifiable. The artist has represented what he read in the description in terms of subjects with which he was familiar so that, for instance, Jupiter and his prophetic raven bear a marked resemblance to a saint receiving inspiration from the Holy Ghost.
Munich, Bayerische Staatsbibliothek, Clm. 14271, f. 11v.

Plate 17 The Aspidochelone. Bestiary. England, 12th century.
The Aspidochelone is a huge fish which unsuspecting sailors mistake for an island. The fish waits until they have moored their ship and disembarked on its back, and then sinks suddenly, drowning them; the fish's tactics are those of the Devil. Moralised animal legends such as this were very popular during the Middle Ages. Many of the texts are not in Latin, but in the vernacular. They were calculated to be entertaining as well as instructive, and the illustrations, which were an important feature of them, helped to increase the morally improving amusement to be derived from these essentially didactic books.
Cambridge, University Library, MS. Ii. 4. 26, f. 54v.

Plate 18 Psalm 1. Utrecht Psalter. Hautvillers, near Rheims, *c.* 820.

This and the next two plates show three versions of the same illustration to Pslam I. Each phrase of the Psalm is illustrated. In the building at the top left is the 'blessed man' of the opening words, studying Scripture with the help of an angel. In the middle on the same level is another man refusing to walk in the counsel of the ungodly and to the right is the seat of the scornful. The scene below to the left depicts the phrase: 'And he shall be like a tree planted by the rivers of water'; and the puffing head to the right of the tree illustrates the simile that the ungodly are 'like the chaff which the wind driveth away'. The rest of the picture, with the devils and the mouth of Hell, shows that the way of the ungodly shall perish. The drawings are full of life and space and are a most successful recreation of Classical art.

Utrecht, Bibliotheek der Rijksuniversiteit, MS. 32,f. 1r.

Plate 19 Psalm I. Psalter. Canterbury, *c.* 1000.

This copy of the Utrecht Psalter, made more than 250 years later, preserves the iconography almost exactly; but the open, atmospheric quality of the original has vanished. Each object seems to have become larger and to take up more room in a less spacious setting, which is now limited by a frame. The figures are distorted, their gestures more emphatic, and emotional intensity replaces the breadth and naturalism of the 9th-century work. Forms which in the Utrecht Psalter were used to suggest landscapes and draperies are now organised into decorative patterns and the picture is drawn not in monochrome but in colour, which heightens the artificial appearance of the copy.

London, British Museum, MS. Harl. 603,f. 1v.

Plate 20 Psalm I. Eadwine Psalter. Canterbury, *c.* 1150.

The third copy of the Utrecht Psalter ignores the Classical qualities of the original manuscript entirely. Not only individual forms but also the composition of the whole page are subordinated to the demand for pattern. While the tree is transformed into an interlaced ornament, the ground-line of the upper scene becomes a series of spirals which divide the picture in half, and elements of the composition are placed as far as possible symmetrically. As if to confirm that the picture is no longer a representation of reality but a stylised visual complement to the text, the various parts of the scene are labelled with inscriptions.

Cambridge, Trinity College Library, MS. R. 17. 1,f. 5v.

Plate 21 Psalm 78. Bury Psalter. Bury St Edmunds, 1025-50.

In this Psalter no space was left in the text for pictures and they are spread freely around in the margins. They illustrate the psalms less exhaustively than do the pictures of the Utrecht Psalter, and they are not so delicately drawn or so Classical in appearance as its first copy, but they are full of movement and recapture something of the effect of space and atmosphere found in Antique art. The drawings illustrate verses bewailing the desolation of Jerusalem and provide visual references to relevant incidents from the New Testament such as the Massacre of the Innocents and the Martyrdom of St Stephen. The integration of text and picture could hardly go further than in the episode of St Stephen kneeling on the line: 'remember not against us former iniquities', while the executioners hurl their stones right across the script.

Biblioteca Apostolica Vaticana, MS. Reg. lat. 12,f. 87v.

Plate 22 Occupations of the month of February. Hymnal. England (Canterbury?), early
11th century.
Calendars recording local saints' days and religious festivals were included in
most liturgical books. Often each month was illustrated with an appropriate
picture either of the sign of the Zodiac or of an activity associated with that time
of year. This drawing shows men pruning trees, the occupation for the month of
February; the style is similar to the first of the Utrecht Psalter copies, but instead
of the spiritual fervour of the psalm illustrations, these designs have a more
luxuriant ornamental quality, and a bucolic sturdiness suitable to their subject
London, British Museum, MS. Cott. Julius A. VI, f. 3v.

Plate 23 Life and Death. Psalter. England, *c.* 1050.
Amongst the prefatory material to be found in religious manuscripts were
various computistic tables. This page from a Psalter shows the Sphere of
Apuleius, an oracle for forecasting the outcome of an illness. The result is calcu-
lated by adding the day of the month on which the illness began to the numerical
value of the letters in the patient's name, dividing by 30, and finding the
remainder in one of the two tables. The two figures represent the alternative
answers: life or death.
London, British Museum, MS. Cott. Tiberius C. VI, f. 6v.

Plate 24 Christ and St Dunstan. Eutychis, Treatise on Grammar, *et al.* England
(Glastonbury?), *c.*950.
The inscription at the top of the page says that this drawing is by St Dunstan
himself, but the figure of Christ and the portrait of the saint are not by the same
artist. If any of it is Dunstan's work, it is probably the small figure of the saint and
the prayer written above it; it has been suggested that these were added by
Dunstan, or at his instigation, before he set out on a dangerous journey. The style
of the drawing is firm and linear, the division between form and background is
clear and there is no suggestion of the surrounding atmosphere such as could be
found in the Utrecht Psalter.
Oxford, Bodleian Library, MS. Auct. F. 4. 32, f. 1r.

Plate 25 Two scenes of Creation. Caedmon, Poems. England (Canterbury?), 1025-50.
In the upper part of the picture, God creates the dry land, the plants, birds and
animals, and also the tree from which the Cross will one day be made. Below he
creates the stars. The naturalism of copies after Classical art has been abandoned
for a skeletal delineation of simple forms which matches the visionary and ecstatic
character of the text. The ethereal quality of the drawing is emphasised by the
bubble-like frames.
Oxford, Bodleian Library, MS. Junius XI, p. 7.

Plate 26 God's Covenant with Abraham. Aelfric, paraphrase of the Pentateuch.
Canterbury, 1025-50.
The pictures in Aelfric's English verse translation of the first five books of the
Bible were intended to be painted, but the scene of God's covenant with
Abraham is unfinished and reveals the firm, sweeping lines that underly the
colour. God is shown descending from Heaven down a ladder, and again at the
bottom addressing Abraham. The addition of paint transforms the parallel lines
on the garments into palpable folds, but conceals the graceful calligraphy that
makes the drawn angels so buoyant.
London, British Museum, MS. Cott. Claudius B. IV, f. 29r.

Plate 27 The Holy Women at the Sepulchre. Homilies. St Gall, second half of 10th century.
The tomb of Christ is shown as a hexagonal walled enclosure with the angel and the women on one side and the sleeping soldiers on the other. This is a most unusual way of depicting the episode and the planimetric representation of space is not common either. The picture is almost like a map and can be compared with the plan of Jerusalem in Plate 97.
Basle, Universitaetsbibliothek, MS.B.IV.26,f.68v.

Plate 28 Theodius II at the Council of Ephesus. Canones conciliorum. Northern Italy, c.900.
The drawing solves with unusual skill the problem of representing a crowded area and the figures have lively and rather knowing expressions. The work is probably a copy of a Classical original.
Vercelli, Biblioteca Capitolare, MS.CLXV,f.3v.

Plate 29 Psalm 44 (45). Martyrologium Rabani Mauri. Northern Italy, 10th or 11th century.
The 'Queen in gold of Ophir' of the psalm, to whom God says 'incline thine ear', was interpreted as the Church. She is shown here with the enthroned Christ. The painted miniatures in this book are rather muddy, but this one is full of light because the artist has just edged the outline in green and let the bare parchment show through.
Vercelli, Biblioteca Capitolare, MS.LXII,f.6or.

Plate 30 The lighting of the Pascal Candle. Exultet Roll. Italy (Mirabella Eclano?), second half of 11th century.
Exultet Rolls were used in the services on Easter Saturday. As the priest sang the Hymn *Exultet iam angelica turba*, he unwound the scroll on which it was written over the front of his lectern so that the congregation could see the pictures. For this reason they are often upside down in relation to the text. This scene shows the start of the ceremony; the celebrant stands in an ambo, chanting the invocation *Lumen Christi*, while the Pascal Candle is lit. After the service the roll would be hung up beside the candle.
Mirabella Eclano, Archives of the Collegiata, Exultet Roll No. 1.

Plate 31 The Funeral of St Gregory. John Diaconus, Life of St Gregory. Italy, second half of 11th century.
St Gregory was buried in front of Old St Peter's in Rome, which was destroyed in the Renaissance. This drawing shows the façade of the great church, which was decorated with mosaics and had bronze peacocks on the roof.
Eton College Library, MS.124,f.122r.

Plate 32 The Crucifixion. Paderborn Gospels. Germany (Fulda or Corvey), late 10th century.
Apart from Christ, the Virgin and St John, the figures in this Crucifixion are symbolic. The episode of the dead rising from their graves, which occurred when Christ died, is represented by a personification of the Earth holding up a naked man. The sun and moon are personified as busts carrying torches. The serpent at the foot of the Cross is an allusion to the Fall of Man and Christ's atonement for it.
Kassel, Landesbibliothek, MS.Theol.fol.60,f.1r.

Plate 33 The Third Day of Creation. St Ambrose, Hexaëmeron. Regensburg, c. 1170.
The *Hexaëmeron* is a treatise on the six days of Creation, and the picture of God
separating the sea from the dry land prefaces the third book. Earth is personified
as a fertile mother suckling living creatures, and Water as an anthropoid sea-
monster with a fish. German artists of the 12th century were influenced by
Byzantium, but they often reproduced the Byzantine forms in suave outline
drawings of a kind unknown in Constantinople.
Munich, Bayerische Staatsbibliothek, Clm. 14399, f. 40r.

Plates Vices and Virtues with Exemplars. Solomon of Constance, Glossarium.
34, 35 Regensburg, c. 1150.
The Vices and Virtues are represented by female figures holding scrolls explain-
ing what they do, and beside each is a picture showing the results of their
influence as exemplified by a story from history. Vainglory stands over the
suicide of Saul and says: 'Thus I look after people', while Joseph receiving his
brothers is accompanied by Prudence, who says simply: 'I guide'. As well as
these scrolls, the pictures have many unframed inscriptions. The scrolls represent
what the figures are saying, the other texts are explanatory labels. The subjects
are: Avarice with the Daughter of Babylon; Wealth with Crœsus; Love of
Honour with Haman; Power with Pharaoh; Vainglory with Saul; Pleasure with
Ahab and Jezebel; Charity with the Daughter of Zion; Prudence with Joseph;
Longsuffering with Morcadai; Meekness with Moses; Humility with David;
and Sobriety with Elijah.
Munich, Bayerische Staatsbibliothek, Clm. 13002, f. 3v., 4r.

Plate 36 The naming of St John. Antiphonary. Salzburg, c. 1160.
When drawings were set against coloured backgrounds, the atmosphere of
space found in manuscripts like the Utrecht Psalter was destroyed; but by the
12th century this effect was desired less than one of pattern and clearly defined
forms, which was exactly what a coloured ground enhanced. The figures in this
drawing stand out almost as though in relief.
Vienna, Oesterreichische Nationalbibliothek, Ser. n. 2700, p. 261.

Plate 37 The Mandrake. Honorius Augustodunensis, Expositio in Cantica Canticorum.
Austria, 1150-75.
The mandrake has a root like a human body, but no head. Honorius's mystical
commentary of the Song of Songs interprets the mandrakes mentioned in
chapter 7 as the Gentiles who lack Christ, the head. In this illustration Christ
crowns the Queen Mandrake with a head like his own, which symbolises the
conversion of the heathen.
Baltimore, Walters Art Gallery, W. 39, f. 103v.

Plate 38 Two visions of Ezekiel. Farfa Bible. Spain, 1010-20.
The Book of Ezekiel in this manuscript begins with two pages showing the
prophet's visions. One page is painted, the other drawn. The vision of the dry
bones is at the top of this page, and below is that of the man like brass who
measured the dimensions of the Temple. The sequence of naked figures rising
from the earth as the wind inspires them with breath is curiously cinematic.
Biblioteca Apostolica Vaticana, MS. lat. 5729, f. 209r.

Plate 39 Illustrations to the Book of Amos. Roda Bible. Spain, early 11th century.
Amos is shown preaching to the cows of Bashan, praying for the destruction of
the grasshoppers, and seeing God on the wall holding a plumbline; the fourth
scene is the non-biblical episode of the prophet's death. The way in which the
strange drawings are not framed, but rise up as it were out of the written words
inscribed in their bases nicely matches the fantastic literary style of the book,
where the verbal images also seem to be rooted in words rather than visual
concepts.
Paris, Bibliothèque Nationale, MS. lat. 6, f. 79v.

Plate 40 The Wheel of Fortune. St Gregory, Moralia in Job. Spain, late 9th century with later additions.
The wheel of fortune was a moral lesson that appeared in many forms during the Middle Ages; here it is a drawing that was added in the 12th century to a manuscript of St Gregory. Fortune turns the wheel with a handle, and the four kings on it say: 'I shall reign', 'I am reigning', 'I have reigned', and, at the bottom of the wheel, 'I am without a kingdom'. The moral is obvious, and the image of the wheel is even more forceful visually than verbally.
Manchester, John Rylands Library, MS. 83, f. 214v.

Plate 41 Scenes of the Passion. Leaves from a Missal. Tours, *c.* 1100.
This page is one of two that were originally part of a service-book, decorating the Canon of the Mass. It is an important drawing because of the unusually elaborate series of scenes from the Passion surrounding the central Crucifixion. Reliefs showing similar scenes were often carved on church portals, and it is possible that the iconography of later sculptured cycles of the Passion was influenced by manuscripts like this.
Auxerre. Cathedral Treasury.

Plate 42 Initial H. St Augustine, Works. France, first half of 12th century.
The figure of a man attacking a florid monster had no relevance to the text, which is St Augustine's treatise on Christian doctrine. It is simply an ornamental way of forming the letter H and ostentatiously marking the start of Book IV of the work.
Cambrai, Bibliothèque Municipale, MS. 559, f. 40v.

Plate 43 Job re-established in his former state. St Gregory, Moralia in Job. France (Mosan), *c.* 1150.
In the top picture, Job, his wife and his friends are feasting; the new children God has given him are shown below. The subjects are treated without suggestion of depth or modelling and the flatness of the pictures has been used to enhance the decorative qualities of such features as the row of feet dangling beneath the table-cloth.
Paris, Bibliothèque Nationale, MS. lat. 15675, f. 8v.

Plate 44 The Donation of Richard II of Normandy to Bishop Manger of Avranches. Cartulary of Mont-St-Michel. France, *c.* 1160.
The stylised nature of Romanesque art did not prevent it from being expressive and even vivacious. Outline work especially could be full of movement. In this scene from the history of Mont-St-Michel, only the figure of the bishop is static; the others are lively and alert, despite their artificial drapery and the sameness of their faces.
Avranches, Bibliothèque Municipale, MS. 210, f. 19v.

Plate 45 St Martin and the Beggar. Bede, De locis terrae sanctae, *et al.* Tournai, *c.* 1200.
This picture does not illustrate any text in the manuscript except the few verses written on the page: it is virtually an independent drawing, and its presence in this book is probably explained by the fact that the volume belonged to the abbey of St Martin at Tournai. It depicts the legend of the saint giving half his cloak to a naked beggar he met at the gates of Amiens; that night he dreamt that Christ came to him wearing the fragmentary garment. The way in which the folds of the draperies are represented is characteristic of the earliest period of Gothic art, and suggests an imitation of Classical sculpture (compare Plate 94).
London, British Museum, MS. Add. 15219, 12r.

Plate 46 Scenes from the Life of David. Bible of St Stephen Harding. Cîteaux, 1098–9.
The story of David is told as if in a comic strip, with captions to identify the
characters and explain the narrative. The frames around the scenes not only
clarify the sequence of events, but establish a uniform scale, which is disrupted
by the vast bulk of Goliath as he breaks out beyond the picture.
Dijon, Bibliothèque Municipale, MS. 14, f. 13r.

Plate 47 Good and Bad Government. St Augustine, De civitate Dei. Canterbury, *c.* 1100
The style of the Utrecht Psalter persisted at Canterbury, although it was modi-
fied by Romanesque formalism; the vivacity of these figures is tempered by
their heavy, continuous outline and the consciously ornamental folds of their
draperies. St Augustine's book contrasts the City of God with the City of Cain,
and this drawing shows the effects of the good and wicked government they
represent, with a scene of ultimate judgement at the top.
Florence, Biblioteca Mediceo-Laurenziana, Cod. Plut. XII. 17, f. 1v.

Plate 48 The Ascension, and the Beheading of St John the Baptist. Bury Gospels. Bury
St Edmunds, *c.* 1150.
English artists quickly became fluent in the stylised idiom known as Roman-
esque, and although this did not destroy the native sympathy for outline work, it
did alter the character of their drawing, which became less calligraphic and
evocative and more concerned with delineating solid contours around flat,
almost abstract shapes. In some of the pictures in the Bury Gospels the outline has
been shaded on the inside with a band of colour, which softens the abrupt
boundary at the edge of each object so noticeable in these bare drawings.
Cambridge, Pembroke College Library, MS. 120, f. 5v.

Plate 49 The Vision of Marcus. St John Chrysostom, Sermons. Hereford, *c.* 1150.
Marcus had a vision that he was in Paradise, trying to find St John Chrysostom,
but the saint was nowhere to be seen and it was explained to him that this was
because he was in the highest heaven, surrounded by cherubim and invisible in
the blinding light. This legend, and an illustration of it, conclude a collection of
Chrysostom's sermons. The two figures at the bottom are probably Marcus,
and Macharius, who recorded the story.
Hereford, Cathedral Library, MS. O. v. XI, f. 150r.

Plate 50 St John. Bede, commentary on the Apocalypse. England (Ramsey Abbey?),
1150–75.
St John is dressed as a bishop and the scribe who copied the work kneels at his
feet. The drawing is full of the stylistic peculiarities of flat, linear decoration,
such as groups of parallel lines; but it still gives an impression of rotund solidity.
Cambridge, St John's College Library, MS. H. 6, f. iiv.

Plate 51 The Adoration of the Lamb. Apocalypse. England, *c.* 1250.
This is one of the earliest, if not the first, of the illustrated Apocalypses that were
so popular in England during the 13th century; the style of the drawing is com-
parable with the work of Matthew Paris, although it is almost certainly not by
him. The pictures incorporate numerous inscriptions and are made artificially
regular by the imposition of circles and straight lines. This page illustrates
chapters 4 and 5 of the Book of Revelation, from the moment when the door in
Heaven is opened to St John to when the elders fall down and worship the Lamb
with seven horns and seven eyes.
New York, Pierpont Morgan Library, M. 524, f. 1v.

Plate 52 The Fourth Vial. Douce Apocalypse. England, c. 1270
The manuscript was never completed; the figures in this miniature are carefully
finished, but in outline only, while the trees and rocks are merely sketched in.
The picture illustrates the 16th Chapter of the Book of Revelation, where the
fourth angel empties its vial upon the Sun. St John looks on, and the ground is
covered with the dead and dying.
Oxford, Bodleian Library, MS. Douce 180, p. 65.

Plate 53 The beginning of the Story of the First Offa. Matthew Paris, Lives of the Offas,
et al. St Albans, c. 1250.
Offa was the blind son of King Warmund; they are shown on the left of the
picture, with two courtiers. On the right is the evil Riganus, who is trying to
persuade the king to abdicate in his favour. The story is told in the text below,
but it is fully explained in the inscriptions in the picture as well. The form of the
scrolls contributes to the composition, and the two halves of the picture echo the
two columns of text, so that word and image are closely integrated.
London, British Museum, MS. Cotton Nero D.1, f. 2r.

Plate 54 St Alban and the Idolators. Matthew Paris, Lives of St Alban and St Amphibalus.
St Albans, c. 1250.
St Alban is shown standing before the governor while pagans try to make him
turn and look at the sacrifice of a goat to Apollo. The curious cross with a disk at
the top is the attribute of the saint. The frame of the picture is used not to provide
coherence and scale, as in Plate 46, but rather to add another plane and act as a
substitute for a background: when the figures overlap it, it throws them forward
from the flatness of the page.
Dublin, Trinity College Library, MS. E. I. 40, f. 34v.

Plate 55 The Apocalyptic Christ. Brother William the Englishman. England, c. 1250.
Matthew Paris could never have carried out single-handed all the writing and
illustration of the works associated with him. He had many assistants, some of
whom were more stylistically advanced than he was, while others were barely
competent; one of them was the English Franciscan who drew this picture of
Christ. It appears in the manuscript containing Matthew Paris's *Lives of the
Offas,* not as an illustration to a text, but as an independent drawing.
London, British Museum, MS. Cotton Nero D. 1, f. 156r.

Plate 56 An Archbishop. Westminster Psalter. St Albans, c. 1250.
This may be a copy after Matthew Paris or another work by one of his assistants.
Details such as hair and drapery folds are treated more decoratively than in
Matthew Paris's own drawings, and the general effect is more elegant; but this
figure of an archbishop is nevertheless a substantial and monumental
composition.
London, British Museum, MS. Roy. 2. A. XXII, f. 221r.

Plate 57 The Death of Dido. Heinrich von Veldeke, Eneit. Bavaria, 1210-20.
The *Eneit* is not a translation of Virgil, but an adaptation of a French romance
about Æneas. It treats the story in a wholly Medieval way, as an epic of chivalry,
and the miniatures do likewise. The manuscript is illustrated with 136 drawings
in brown and red ink on coloured grounds.
*Berlin, Staatbibliothek Preussischer Kulturbesitz (formerly Preussische Staatsbiblio-
thek), Cod. Germ. fol. 282, f. 17v.*

Plate 58 Scenes from the Anticlaudianus. Alanus de Insulis, Anticlaudianus. Bavaria, 1322-56.
Alanus's allegorical poem is here narrated entirely in pictures with short captions. Unlike the page shown in Plate 46, the sequence is to be read vertically. The work tells of the creation by Nature of the perfect man, and the pictures shown here illustrate the story from its beginning to the construction of the chariot in which Phronesis rides to heaven to obtain a soul, which Nature cannot make. The horses which draw the chariot, shown in the last scene at the bottom right, represent the Senses.
Pommersfelden über Bamberg Schlossbibliothek, Cod. 215,f. 161r.

Plate 59 Gylfi and the three Gods. Snorri Sturluson, Prose Edda. Iceland, c. 1300.
Gylfi was a Swedish King who journeyed to Asgard to test the wisdom of the Gods. There he found three deities seated one above the other, whose names were High One, Just-as-High and Third. He questioned them about the deeds of the Gods. Their answers as recorded by Snorri Sturluson provide the classic account of Norse mythology. Scandinavian art maintained close connections with England, and the drawing shows the influence of Matthew Paris.
Uppsala, Universitetsbiblioteket, Cod. Dg. 11, quarto,f. 26v.

Plate 60 The Battle of Issus. Orosius, Historia adversum paganos. Southern Italy, c. 1050.
The scribe who copied this account of Alexander the Great's victory over Darius evidently did not intend it to be illustrated. The artist had to do the best he could with the spaces left in the margins and this involved turning half the scene sideways. The battle is shown on the left and the capture of Darius's women at the bottom. Scenes like this lacked the established iconography of religious art and artists either adapted old compositions or invented new ones.
Biblioteca Apostolica Vaticana, MS. lat. 3340, 21v.

Plate 61 Points for cauterisation. Herbal. Italy, 9th century.
Cauterisation was one of the commonest forms of medical treatment in the Middle Ages; it consisted of creating ulcers on the patient's skin, into which diseased fluids were supposed to drain. The ulcers were usually caused by burning with a hot iron, and medical manuscripts included charts to show where the iron should be applied for any given illness.
Florence, Biblioteca Mediceo-Laurenziana, Cod. Plut. 73, 41,f. 128v.

Plate 62 Cauterisation. Treatise on medicine, the calendar and astronomy. Durham, 1100-27.
Cautery charts were often only rough diagrams, but some manuscripts were illustrated with really fine pictures. This one still shows the influence of the Classical style that depends on manuscripts like the Utrecht Psalter.
Durham, Cathedral Library, MS. Hunter 100,f. 119r.

Plate 63 Operations on cataracts and adenoids. Medical treatises. Liège, 1150-75.
More complex operations were also illustrated, but rarely with the kind of scientific precision that inspires confidence in the skill of the physician. This drawing occurs in the middle of a practical medical text, but seems too elegant to have been part of a doctor's reference library; it belongs rather to a theoretical work for a cultivated scholar.
London, British Museum, MS. Harl. 1585,f. 9v.

Plate 64 The onset of a fatal illness. A pictorial case-history. England, *c.* 1270.
The upper scene shows a lady taken ill, and the doctor giving instructions to her attendants; in the lower picture she has fainted and attempts are being made to revive her with a feather soaked in inhalent. Subsequent scenes show the lady ignoring the doctor's advice, her decline and death, the humiliating experiences of her corpse, and a considerable increase in the number of female patients for the obviously sage doctor. The eight pictures have been bound in with practical medical texts; their original purpose is not known.
Oxford, Bodleian Library, MS. Ashmole 399, f. 33r.

Plate 65 The constellation of the Centaur. Astronomical texts. England (Winchester?), *c.* 1150.
This manuscript contains not only the Classical treatise of Aratus, but also astronomical material from Arabic sources and, for the first time in England, an allusion to the significance of astrology. But these additions to Aratus's poem, which were to become so important later in the Middle Ages, are not illustrated. Such was the conservatism of Medieval artists that copies of the old pictures are made to serve the whole book without modification.
Oxford, Bodleian Library, MS. Digby 83, f. 65r.

Plate 66 Cosmological diagram. Byrhtferth, Manual. England, *c.* 1110.
This drawing enumerates and correlates the Zodiac, the Months, the Seasons, the Elements, the Four Ages of Man, the Cardinal Points, and the Winds. It is a summary of Time and Nature. The outer lozenge with the Elements at its points is the germ of the diagram; it incorporates the other quaternities of the Winds, Seasons and Ages. Within this frame are the exclusively mundane concept of direction and the qualities of hot and cold, moist and dry that the Elements embody. Around the outside, in the segmental forms, are the signs of the Zodiac. The design is as functional as a craftsman's tool, but makes a visually pleasing composition as well.
Oxford, St John's College Library, MS. 17, f. 7v.

Plate 67 The Four Elements. Tractatus de Quaternario. England, *c.* 1100.
The Elements, out of which everything was made, were extremes, but each had one quality in common with another of the four: Fire shared its heat with Air and its dryness with Earth; Water shared with these two respectively its dampness and coldness. Thus each element was linked to another with which it would combine most easily, and a knowledge of these combinations was essential to the study of physics. There were a number of ways of illustrating this dogma diagrammatically; one was by a series of overlapping units. Here the four linked circles have been invested with ornamental flourishes which almost conceal their structure.
Cambridge, Caius College Library, MS. 428, f. 21v.

Plate 68 Canon table. Gospels. Jumièges, 1050-1100.
Gospel Books generally began with tables of concordances to the Evangelists. The uninspiring sight of four columns of index was commonly enlivened with an architectural frame, but here the artist has gone further and reduced the columns and arches to decorative ribbons, filling them with clambering angels and beasts. Pages like this are basically utilitarian, but have been cleverly exploited to provide an impressive beginning to a book.
London, British Museum, MS. Add. 17739, f. 2r.

Plate 69 The genealogy of the children of Shem. Bible. France, 14th century. This Bible
begins with Peter of Poitiers' *Compendium veteris testamenti,* a summary of secular
and profane history built around a huge genealogical tree, which extends over
twenty-five pages. The tree shows the descent of the historical figures concerned,
and the main events of the time are chronicled around it. Here the author's use of
the tree as a framework for his history has been emulated by the artist, who uses
it to give the page a formal structure. To add further variety to the composition,
there is a picture of the Tower of Babel at the appropriate place in the narrative.
London, British Museum, MS. Roy. 1.B.X, f. 10v.

Plate 70 The Tree of Porphyry. Porphyry, Isagoge, *et al.* Paris, *c.* 1140.
This page has been added to a collection of philosophical texts. It shows a personi-
fication of Dialectic and four philosophers: Plato, Aristotle, Socrates, and
Adamus de Parvo Ponte. The serpent in Dialectic's left hand is her traditional
attribute, a symbol of sophistry; in her right she holds the *Arbor Porphyrii.* This
was a diagram demonstrating how each member of a class could be divided into
smaller members and become a class itself. Such a process of division could go on
infinitely, and was suitably represented by the branches and twigs of a tree. The
Arbor Porphyrii is a simplified version of this system, and allows for only two
divisions at each stage. The 'root' is at the top.
Darmstadt, Hessische Landesbibliothek, MS. 2282, f. 1v.

Plate 71 The Tree of Consanguinity. Isidore of Seville, Etymologiae. Regensburg,
c. 1150.
This is a pictorial version of the Table of Kindred and Affinity. The closest pro-
hibited relationships come at the centre, where the stem joins the formalised
branches; there are shown mother and father, son and daughter. The further out
one goes towards the perimeter the more distant the kinship becomes. The
figure supporting the tree is probably Isidore of Seville, who devised the
system.
Munich, Bayerische Staatsbibliothek, Clm. 13031, f. 102v.

Plates The Tree of Vice and the Tree of Virtue. Speculum Virginum. Austria
72, 73 (Andernach), 1100–50.
The *Speculum Virginum* was a book of spiritual instruction for nuns; each of its
twelve chapters was illustrated with a picture which summarised its lesson and
provided an object for meditation. These two pages show how the Vices and
Virtues grow and multiply from the roots of Pride and Humility. The Tree of
Vice has seven main branches representing the seven deadly sins and leaves
inscribed with subsidiary vices which droop downwards. At the top of the tree is
Adam. The Tree of Virtue is similar in form, but its leaves turn upwards, and it
is coloured green, for hope. Christ, the New Adam, is at the top.
Cologne, Historisches Archiv, MS. W. Fol. 276, f. 11v, 12r.

Plate 74 The Tower of Wisdom. Collectanea Spiritalia. German, 1425–50.
This pictorial guide to ethics was devised by Franciscus Bonacursus in the 13th
century. The foundation of the building is humility. It is raised above the ground
on four piers, the cardinal virtues, and the door, inscribed 'patience' and
'obedience', is reached by ascending steps marked 'prayer', 'confession',
'penitence', and so on. Most of the structure consists of a grid-like rectangle of
bricks in 12 rows: the brick on the far left of each row is a virtue, and the 9 bricks
to its right are inscribed with 9 appropriate moral precepts. Other architectural
features, such as battlements and windows, are endowed with symbolic
meanings, and the roof is defended by five virgins. The drawing is primarily
a tabulated summary, and each horizontal series of units is identified by a letter
of the alphabet on the left. The features that turn the diagram into a castle
do not interfere with its clarity, but make it easier to remember and more
attractive to look at.
Rome, Biblioteca Casanatense, MS. 1404, f. 10v.

32

Plate 75 Philosophia. Boethius, De consolatione philosophiae. Canterbury, 975-1000.
Boethius tells how Philosophy came to console him in prison in the person of a
magnificent lady. The figure he describes is full of symbolic meaning, but this
artist has ignored most of the allegorical attributes and conveys the mystery and
splendour of Philosophy by her demeanour alone.
Cambridge, Trinity College Library, MS. O. 3. 7, f. 1r.

Plate 76 Grammatica. Martianus Capella, De nuptiis Mercurii et Philologiae. France,
c. 1100.
Martianus's poem is an allegory of learning, in which the Seven Liberal Arts are
personified as women carrying symbolic attributes. Grammar, the beginning of
education and the first of the women to be introduced, should according to him
be holding a scalpel and various medicines; surgical equipment is shown in the
round box at her left hand. The recondite symbolism of these may be effective in
a literary essay, but a visual allegory requires something more direct, so the artist
has also given her a book, writing implements, a bench full of pupils, and a whip.
Florence, Biblioteca Mediceo-Laurenziana, Cod. S. Marco 190, f. 15v.

Plate 77 The Four Elements. Pseudo-Bede, De ordine ac positione stellarum, *et al.*
Prüfening, *c.* 1200.
The Elements of Water and Earth had a long tradition of personification, as a
river-god and as Mother Earth giving suck. Air and Fire lacked any familiar
visual types; here the artist has given them an inflated bladder and a burning
torch, and seated them upon an eagle and a suitably fierce lion. Water is repre-
sented like the Zodiac sign of Aquarius, riding on what is presumably a sea-
monster, and Earth is sitting on a centaur which preserves the ancient
iconography by drinking from her breast.
Vienna, Oesterreichische Nationalbibliothek, Cod. 12600, f. 30r.

Plate 78 The Winds. Collectanea. Salzburg (or Prague?), *c.* 1150.
The Medieval wish to impose order on the universe extended even to such
variable and disorderly elements as the winds. These were 4, 8 or 12 in number,
and were usually represented in a circular arrangement, inscribed with their
names and a description of their characteristics; here they are personified as wild
human beings.
Vienna, Oesterreichische Nationalbibliothek, Cod. 395, f. 34v.

Plate 79 The Year. Astronomical treatise and martyrologium. Swabia, *c.* 1180.
The personification of the Year sits in the centre of the circle of the Months; he
holds the Sun and Moon, and is flanked by Night and Day. The months are
represented by the occupations proper to them and by Zodiacal signs. The
seasons are shown in the corners of the frame, and the four Times of Day are
outside the frame at top and bottom. Thus a physical form is provided for every
major unit of time.
Stuttgart, Württembergische Landesbibliothek, Cod. hist. fol. 415, f. 17v.

Plate 80 Allegory of Music. Liber pontificalis. France (Rheims?), *c.* 1170.
Music in the Middle Ages was not just something perceived by the human ear; it
was the principle of universal harmony, and songs and instrumental tunes were
believed to be only a poor reflection of the celestial music. This picture shows
Arion, Pythagoras and Orpheus, the three most distinguished performers and
theorists of mundane music, surrounded by the Nine Muses, representing the
Music of the Spheres. A personification of the Element of Air, through which
music is perceived, embraces the whole diagram; the Four Winds are at his hands
and feet.
Rheims, Bibliothèque Municipale, MS. 672, f. 1r.

Plate 81 The Microcosm. Solomon of Constance, Glossarium. Regensburg, *c.* 1150.
The figure is based on a passage from Honorius Augustodunensis, which begins
with the statement that man's body is created out of the four Elements. These are
represented at the corners of the frame. From the Element of Fire man receives
his sight, from Water his taste, from Earth his sense of touch, and from Air his
hearing and sense of smell. The seven openings of his head are equivalent to the
planets, his breast is like the atmosphere, his stomach like the sea, and his feet,
which support everything, are like the earth. The figure of the man, which is the
core of the design, is both a graceful representation of the human form and a
diagrammatic exposition of a scientific theory.
Munich, Bayerische Staatsbibliothek, Clm. 13002, f. 7v.

Plate 82 The Zodiac Man. Astronomical manuscript. England, 14th century.
The signs of the Zodiac were believed to rule over different parts of the body,
and it was considered dangerous to operate on the area controlled by the sign
through which the Moon was passing at the time. Diagrams showing which
parts were governed by which signs were therefore an essential item of the
doctor's equipment and a matter of general interest. One method of presenting
this information was to draw the figure of a man inside a circle inscribed with the
Zodiac and produce lines from each part of the body to the appropriate sign. A
more vivid way, which made the connection between man and the stars more
immediate, was to show the Zodiac signs actually lodged on his body.
Oxford, Bodleian Library, MS. Ashmole 5, f. 34v

Plate 83 The Marriage of Christ and the Church. Opicinus de Canistris Avignon, 1335-6.
The marriage of Christ and Ecclesia is shown in the semicircle above the Cruci-
fixion. The large figure surrounding them is the mystical body of Christ. The
crown of words at his head and the three other blocks of writing between his feet
and at either side of his arms are acrostics, spelling out the names of the Evangelists
and their symbols, which are on the outside of the oval frame. The mortal body
of Christ is shown on the Cross, and the Virgin and St John represent the sacra-
mental and corporal aspects of the Church. Many of Opicinus's drawings are
based on maps; in this one the shapes of the countries are not drawn in, but their
names are inscribed in their relative positions and the drawing is set out like a
plan on a grid of thin lines.
Biblioteca Apostolica Vaticana, MS. Pal. lat. 1993, f, 10r.

Plate 84 Autobiographical schema. Opicinus de Canistris. Avignon, 1335-6.
The diagram consists of 40 concentric circles representing the years 1296 to 1336.
They are divided radially into 366 days. The autobiography begins with
Opicinus's conception, on 24 March 1296, and ends on 3 June 1336 with an
announcement of the completion of this drawing. The intervening events of his
life are precisely inscribed in their relevant positions in each circle. The Four
Ages and the symbols of the Evangelists are around the outside and in the centre
are the Virgin and Child and a map of the Mediterranean.
Biblioteca Apostolica Vaticana, MS. Pal. lat. 1993, f. 11r.

Plate 85 Allegorical map. Opicinus de Canistris. Avignon, 1337-41.
Opicinus's later work is less symmetrical, and the cartographical element in it
becomes more predominant. The shaded areas in this drawing are the Black Sea
and the eastern Mediterranean. The land-masses surrounding them become four
human figures, with smaller figures superimposed in circles. The inscriptions
explain the meaning of the allegory, which is both personal and cosmic.
Biblioteca Apostolica Vaticana, MS. lat. 6435, f. 61v.

Plates 86, 87 Two pages of models. Adémar de Chabannes, Model-book. Limoges, early 11th century.
The drawings of Adémar de Chabannes form the earliest known collection of traditional types and useful models such as every Medieval artist would need for his work. The pictures include astronomical, allegorical and ornamental subjects, as well as Biblical scenes. The pages illustrated show the Descent from the Cross, the Nativity, and *exempla* of figures in motion. Each drawing is a self-sufficient unit, so the confused order in which they are juxtaposed does not matter.
Leiden, Bibliotheek der Rijksuniversiteit, Cod. Voss. Lat. Oct. 15, f. 2v, 3r.

Plate 88 St Gregory and St Benedict. Einsiedeln Model-book. Einsiedeln (?), first half of 12th century.
The model-book consists of only three leaves; the rest of the manuscript is an unrelated religious text. The drawings are done in brown ink and the lines are reinforced with brown paint, which gives them a very rich appearance. This glowing quality of the surface texture combined with the hieratic posture of the two figures, gives them an appearance remarkably close to that of Byzantine mosaics.
Einsiedeln, Stiftsbibliothek, MS. 112, p. 2.

Plate 89 'Mechanical Arts'. Reun Model-book. Austria (Reun), early 12th century.
This model-book too is attached to a series of texts. It has been suggested that the page illustrated shows the Mechanical Arts, a corollary to the Liberal Arts developed by Hugh of St Victor, and Hugh's text appears later in the manuscript. But the arts he describes cannot be identified with the pictures, and the theme behind this series of drawings is obscure. They seem to show a variety of secular and religious occupations – on this page those of the hunter, the cook, the painter and the priest – presided over by a figure holding the tools of the trade or their equivalent.
Vienna, Oesterreichische Nationalbibliothek, Cod. 507, f. 2v.

Plate 90 Simon Magus. Vercelli Roll. Vercelli, early 13th century.
When the Romanesque frescoes in the church of S. Eusebio began to disintegrate, the Chapter ordered that a record of their appearance be made so that they could eventually be restored. The frescoes are now destroyed, but the roll on which they were copied survives, with 18 drawings of the Acts of the Apostles, and an inscription explaining why it was made.
Vercelli, Biblioteca Capitolare.

Plate 91 King Ethelbald's visit to Guthlac's shrine. Guthlac Roll. Croyland, c. 1200.
The purpose of this nine-foot roll with tinted drawings in circles is not known. There is no text except for the inscriptions in the pictures. They may have been models, possibly for a stained glass window. They have in fact been used in a modern window in a church in Lincolnshire. The picture shows the king and 12 other benefactors of Croyland Abbey visiting St Guthlac's shrine; the scrolls record their donations. On the right is a lunatic, healed at the saint's tomb.
London, British Museum, Harl. Roll Y. 6.

Plate 92 The Creed. Joinville, Credo. Champagne, late 13th century.
The historian Joinville devised a pictorial version of the Creed, incorporating relevant incidents from the Old Testament to illustrate each article. The page shown deals with the fifth article: 'he descended into Hell; and the third day he rose again from the dead, and ascended into Heaven'. The drawings may have been models for wall-paintings.
Paris, Bibliothèque Nationale, MS. lat. 11907, f. 231r.

Plate 93 Christ and Zaccheus; Two Saints. Single leaf. Alsace, late 12th century.
This page was bound into a later manuscript as a fly leaf. The original context of the drawings is unknown. Both upper and lower groups show Byzantine influence, though the picture of the two saints has been considerably modified by the contemporary Western styles. They may be copies, more or less direct, from southern Italian model-books.
Freiburg im Breisgau, Augustinermuseum, Einzellblatt.

Plate 94 A Classical tomb. Villard de Honnecourt, Model-book. France, 1230-40.
Villard's caption says that this is a picture of a Saracen's tomb that he had once seen; it is presumably a copy of a Roman sarcophagus relief. The drawing concentrates on indicating masses and general forms: the only features shown in any detail are ones peculiar to Classical art, such as the muscular formations of the nude body and the folds of draperies which were not familiar in normal Medieval practice.
Paris, Bibliothèque Nationale, MS.fr. 19093,f. 6r.

Plate 95 A bell-tower. Villard de Honnecourt, Model-book. France, 1230-40.
On the reverse of Villard's picture of a Roman tomb he drew something else he saw on his travels and wrote beside it that it would provide a model for anyone who wished to build a bell-tower. From the description he gives, it seems that what interested him most was the way the stages of different plan are united into a harmonious whole. An example of an ornamental initial S is shown next to it.
Paris, Bibliothèque Nationale, MS.fr. 19093,f. 6v.

Plate 96 Schematic figures. Villard de Honnecourt, Sketch-book. France, 1230-40.
The object of this drawing is to show not so much how different figures can be constructed out of geometric shapes, but rather how geometry underlies all art. The page facing this says that the pictures demonstrate the art of drawing as geometry teaches it, and Villard shows how his drawings can be reduced to geometric figures; how for instance, both the linked men blowing horns on the left and the man with his hands on his hips opposite them are basically five-pointed stars.
Paris, Bibliothèque Nationale, MS.fr. 19093,f. 19r.

Plate 97 Map of Jerusalem. Passional. Zwiefalten, c. 1150.
There is a close resemblance between this map and Medieval scientific diagrams; they share the same regularity, the frequent inscriptions, and the combination of abstract and objective forms. The drawing is not a map in the modern sense, but a selection of the most important visual and doctrinal features of the Holy City, arranged according to a preconceived plan. In this case it is that of a Roman camp.
Stuttgart,Württembergische Landesbibliothek, Cod. Bibl.fol. 56,back endpaper.

Plate 98 Plan of a monastery. Aachen? St Gall? c. 820.
The plan covers an area of about 500 by 700 feet, and shows the layout of a monastic community with living quarters, farm buildings, gardens and an imposing church. It was possibly devised at a council held at Inden in 816, and this copy may have been made for Abbot Gozbert of St Gall, who was invited to the meeting but could not come. The regularity of the design suggests an ideal solution rather than a working plan, but its arrangement is logical and probably typical of a large 9th-century monastery.
St Gall, Stiftsbibliothek, MS. 1092.

Plate 99 Façade elevation for Strasbourg Cathedral. Strasbourg, *c.*1260.
Strasbourg cathedral was begun in about 1240, and the façade reached its present state in 1439. A number of architectural drawings have been preserved showing different projects for the West front and towers. This is the first, which was never used; it is also the earliest surviving architectural elevation.
Strasbourg, Musée de l' Œuvre Notre-Dame.

Plates Design for North tower of Strasbourg Cathedral. Ulrich von Ensingen.
100, 101 Strasbourg, *c.*1402.
The towers of Strasbourg were still unfinished in 1400; it had at one time been planned to have a single tower in the centre of the West front, but Ulrich von Ensingen, who began work on the cathedral in 1399, decided to place it asymmetrically on the North of the façade. This is probably his drawing for it, though it has been suggested that this elevation was drawn later by his son Matthias. It was followed as far as the spire; this last part of the work was completed to another design.
Berne, Historisches Museum.

Plates Illustrations to the Gospel of St John. Gospels of Matilda of Tuscany. Northern
102, 103 Italy, *c.*1100.
Work on this manuscript got as far as the gilding of the pictures, but only one miniature was ever painted. Nevertheless it is a splendid volume, and the effect of the dark outline and the unburnished gold edged with red is no less grand than paint. The single coloured miniature is prosaic compared with this rare and beautiful combination. The two pages illustrated preface the Gospel of St John and show the Evangelist writing, John the Baptist with the priest and Levites, the Wedding at Cana, and Christ cleansing the Temple.
New York, Pierpont Morgan Library, MS. Morgan 492, f. 83v. 84r.

Plate 104 Scenes from Maccabees. Winchester Bible. Winchester, 1140–60.
There are only two full-page pictures in this, the greatest of the English Bibles, and both are in outline only, presumably unfinished. Why a school of illuminators which had been quite content with historiated initials elsewhere in the book should suddenly introduce two large compositions towards the end and then fail to complete them is a mystery. The artist who did these pictures also drew one initial. Apart from that, these pages are unique in the Bible and in English art.
Winchester, Cathedral Library, Bible, f. 350v.

Plate 105 A tournament. Manesse Codex. Zurich, 1313–30.
The Manesse Codex is an anthology of German poetry illustrated with pictures of poets and scenes of courtly life. In all but one of the pictures the figures are painted, though set against a plain background. The single unfinished miniature shows the technique used for the underdrawing: the lines are thin, precise and characterless; they tell the painter exactly what should be shown in the picture, but leave him free to give the completed painting as personal a style as he could wish.
Heidelberg, Universitätsbibliothek, Cod. Pal. lat. 848, f. 196r.

Plate 106 The Election of Henry VII. Balduineum. Germany, *c.*1330.
This picture chronicle describes the expedition of the Emperor Henry VII to Rome. The lower picture shows Henry being elected Emperor in 1308; the upper one shows his brother Baldwin, Archbishop of Triers, at table. The drawings demonstrate how German artists had overcome their dependence on Byzantium and fully assimilated the French Gothic Style.
Koblenz, Staatsarchiv, MS I. c. I, p. 3.

Plate 107 Abraham and Hagar. Velislav Bible. Bohemia, *c.*1340.
 The Gothic idiom penetrated as far east as Prague; this Bible in pictures is drawn
 in a style similar to that used in the courts of western Europe. The delicate, rather
 consciously pretty figures are characteristic of later Bohemian drawing.
 Prague, University Library, MS. XXIIIC. 124 lob. 412, f. 21r.

Plate 108 Scenes from the Life of Jacob. Egerton Genesis. England (?), late 14th century.
 Little is known about this mysterious manuscript. It is an illustrated version of
 the Book of Genesis, and unlike anything else in appearance and content. The
 artist seems to have delighted in depicting the least savoury incidents of Biblical
 history in a style which is both exquisite and disturbing. The figures in the earlier
 pictures are lightly tinted, but the later ones have been left in outline only. This
 page shows Jacob wrestling with the Angel, Jacob and Esau embracing, Jacob at
 Shalem, and Shechem raping Dinah.
 London, British Museum, MS. Egerton 1894, f. 17r.

Plate 109 The Creation of Eve. Petrus Comestor, Historia Scholastica. Utrecht, *c.*1440.
 The 'Scholastic History' was a version of the Bible which collated Scripture with
 the ideas of pagan philosophers and with secular history. This drawing is hatched
 and gilded, giving a rich but restrained effect. The moon was originally silver,
 but has oxidised. In the margin on the left is a very faint sketch for the figures of
 Adam and Eve, showing the position of their limbs but no details.
 London, British Museum, MS. Add. 38122, f. 9v.

Plate 110 Joseph and Potiphar's Wife. Queen Mary's Psalter. England (East Anglia?),
 early 14th century.
 Psalters were often prefaced by a series of Biblical scenes. Queen Mary's Psalter
 has 223 such pictures, drawn in pen and ink with a wash of colour, and captioned
 in French. The upper scene shows Pharaoh hunting, and in the lower one his
 wife is taking advantage of his absence and attempting to seduce Joseph. (Accord-
 ing to Genesis, the unfortunate husband was Potiphar, one of Pharaoh's officers.)
 London, British Museum, MS. Roy. 2.B.VII, f. 16r.

Plate 111 The Judgement of Solomon. Windmill Psalter. England (East Anglia?), early
 14th century.
 The first word of the first psalm is *Beatus*, and it was customary to begin the
 Psalter with a magnificent initial B, sometimes occupying a whole page. In the
 Windmill Psalter the second letter has a page to itself as well, with the B on the
 left-hand page facing it; the rest of the word is written on the scroll held by the
 angel. On the bar of the E Solomon is seated, giving judgement to the two
 women who both claim the same child, and above him is the windmill which
 gives the Psalter its name. While the figures are painted, the background is a
 carpet of red and blue pen-work.
 New York, Pierpont Morgan Library, MS. 102, f. 2r.

Plates Moralised New Testament scenes. Bible moralisée. French, early 14th century.
112, 113 The *Bible moralisée* was a completely illustrated Bible with an equally complete
 set of illustrations drawing a moral lesson from each incident depicted. The work
 of painting all these miniatures was enormous; even a simple outline version was
 a vast undertaking, and the pages were divided among many different artists.
 The pages reproduced here show part of the Gospels. At the top left, Christ is
 submitting to his parents after his return from the Temple. The scene below
 moralises this episode, explaining that its lesson is that members of religious
 orders owe obedience to their bishop. The next scene down shows John the
 Baptist in the wilderness, and the moralising picture at the bottom of the page
 contrasts the sanctity of the solitary life with the temptations and distractions of a
 worldly existence. This procedure is followed throughout the Bible, for 892
 episodes from the Old and New Testament. The other scenes on these pages deal
 with the preaching of John the Baptist.
 London, British Museum, MS. Add. 18719, f. 246v, 247r.

Plate 114 Typological scenes. Biblia Pauperum. Austria, *c.* 1320.
The New Testament incidents are depicted in circles, framed with scrolls held by prophets. On each side of the circles are Old Testament events which prefigure in some way the life of Christ: the sacrifice of Isaac and the Brazen Serpent are related to the Crucifixion, and the creation of Eve from Adam's rib and Moses striking the rock and producing a stream of water foreshadow the piercing of Christ's side. A short text explains the connections between the events.
Vienna, Oesterreichische Nationalbibliothek, Cod. 1198, f. 7r.

Plate 115 Typological scenes. Biblia Pauperum. Bavaria, 1414.
A later version of the same page shows another arrangement of the material: the scenes are no longer crowded together, but isolated in separate frames. This provides greater clarity, but the implied unity of the incidents is less obvious. This manuscript is not, like many of the 'Bibles of the poor', a cheaply-made, popular production, but a luxurious work with a splendid copper and enamel binding. The drawing is very fine, and has been influenced by Bohemian art.
Munich, Bayerische Staatsbibliothek, Clm. 8201, f. 86v.

Plate 116 Allegorical figures. Biblia Pauperum. Bavaria, 1414.
In the same manuscript are these allegorical figures, representing the Church as the Bride of Christ, the Daughter of Babylon, St Benedict, and the World. Each part of the figure of the World represents a different vice, and her left leg, about to sever the claw-like right one, is Death. She is offering St Benedict the cup of Lechery, but the scroll he is holding says: 'Get thee behind me, Satan'. Figures like this were not normally part of the *Biblia Pauperum*, but they have the same kind of graphic appeal to the understanding.
Munich, Bayerische Staatsbibliothek, Clm. 8201, f. 95r.

Plate 117 Typological scenes. Speculum humanae salvationis. Alsace, *c.* 1350.
The *Speculum humanae salvationis* is a more expansive version of the *Biblia Pauperum* compiled by a Dominican friar. The text is much longer and the pictures are arranged in a row above it. There are three types to each antitype, spread across two pages. The three types for the scene of the Damned in Hell are David destroying Rabba, Gideon destroying Succoth, and Pharaoh and his army drowned in the Red Sea. Only the first page is shown here. The drawings are very roughly done and are clearly practical aids to understanding rather than elegant embellishments.
Munich, Bayerische Staatsbibliothek, Clm. 146, f. 43v.

Plate 118 Typological scenes. Concordantia Caritatis. Austria (Lilienfeld), 1345-51.
The subject of the page is Christ's prayer: 'Father, forgive them, for they know not what they do', which is inscribed in the large roundel by the Crucifix. In the four smaller circles are busts of prophets voicing appropriate utterances; for instance, Isaiah, at the top on the right, quotes from his prophecy: 'He bare the sin of many, and made intercession for the transgressors'. Below are two Old Testament types, Moses and Aaron praying to God: 'Shall one man sin, and wilt thou be wrath with all?' and Samuel, who 'mourned for Saul, and the Lord repented'. At the bottom are two types from nature: the lion, whose roaring makes all animals stop, as Christ's intercession stops God's wrath, and the swan, which sings most sweetly at its death.
Lilienfeld, Zisterzienserstift, MS. 151, p. 95.

Plate 119 Uzziah entertaining Achior and the Elders to a banquet. Nicholas of Lyra, Postilla perpetua in universam S. Scripturam. Germany, 1400-05.
Nicholas of Lyra disagreed with the typological method of interpreting the Bible as exemplified in the *Biblia Pauperum,* and concentrated on revealing the exact literal meaning of the text. The picture in manuscripts of his work were consequently simple illustrations of the narrative. This one shows an episode from the Book of Judith. It is an example of the late Medieval German style of drawing on paper, which was similar in appearance to early woodcuts.
Basle, Öffentliche Bibliothek der Universität, MS. A. II. 5, f. 182v.

Plate 120 The Death, Assumption and Coronation of the Virgin. Pen and wash on parchment. France, *c.* 1400.
This large and carefully finished drawing has been attributed to André Beauneveu, but it seems to be a copy after an original which has not been fully understood. It is one of the earliest drawings to show a whole composition rather than single figures. It may have been intended as a model – the shape suggests a panel of painted glass – or it may have been a contractual drawing, establishing the appearance of a commissioned work.
Paris, Musée du Louvre, Cabinet des Dessins, Inv. no. 9832.

Plate 121 Crucifixion. Circle of Altichiero. Pen and chalk on paper. Padua, *c.* 1400.
The composition is similar to two late-14th-century frescoes in Padua by Altichiero, Avanzo and assistants, but the vigorous, dramatic style of the drawing is close to northern art. It was probably done by a Tyrolean artist working in Padua.
Cleveland, Museum of Art, Delia E. and L. E. Holden Funds, John L. Severence Fund, No. 56. 43.

Plate 122 Three drawings of the Virgin and Child. Silver-point heightened with white on grey paper. France or Burgundy, *c.* 1400.
These are not so much three views of the same subject as three different iconographical types: the Virgin nursing the Child, the Virgin and Child enthroned, and the Virgin embracing the Child, or *Panagia eleousa.* They are therefore closer to the drawings found in model-books than to figure-studies. Nevertheless they are more finished than earlier *exempla,* and they are arranged symmetrically, not disposed at random wherever they can be fitted in. The page is intentionally a work of art as well as a piece of practical equipment.
Basle, Kupferstichkabinett der öffentlichen Kunstsammlung, U.XVI.I.

Plate 123 Two models for St Christopher carrying Christ. Brunswick Sketchbook. Bohemia, 1375-1400.
The drawings are not two views of an identical subject, but the differences between them are slighter than those between the Madonnas in Plate 122. They are iconographically the same, and which model the artist used would depend only on the direction in which he wanted the saint to wade across the river. The prominent folds and deep shadows in the draperies suggest that the drawings have some connection with Late Gothic sculpture.
Brunswick, Herzog-Anton-Ulrich Museum, Kupferstichkabinett 63.

Plate 124 Four heads. Vademecum. Austria or Bohemia, 1425-50.
This strange model-book is made of 14 maple-wood panels, hinged together and cased in a leather box. Each tablet has four pieces of green paper glued to it, and on these the artist has drawn a series of heads in silver-point, pen, and red and white paint. Some of the heads are fantastic, while some belong to easily identifiable religious scenes. Others are studies of animals, but again only the heads are shown – except for a spider, which appears, understandably, with body and legs.
Vienna, Kunsthistorisches Museum, Sammlung für Plastik und Kunstgewerbe, Inv. no. 5003, 5004.

Plate 125 A figured alphabet. Giovanni de' Grassi, Model-book. Lombardy, late 14th century.
Giovanni de' Grassi's model-book is one of the so-called *carnets lombards*: the subjects are mostly animals, and they are studies from nature rather than traditional patterns. The pages with the alphabet composed of animal forms were added to the original book and seem to be earlier in date. They may even be German. They certainly exhibit a different attitude to the representation of animals from that shown in the naturalistic drawing in the rest of the book. They are done in fine pen-work, and the pages illustrated show the letters A to G.
Bergamo, Biblioteca Civica, Cod. Delta VII. 14, f. 26v. 27r.

Plate 126 Models for figures. Pepysian Sketchbook. England, late 14th century.
The only surviving English model-book once belonged to Samuel Pepys; the catalogue of his library called it 'an ancient book of Monkish drawings and Designs for Church use'. It is uncertain whether it was drawn by a monk or a secular artist, but the book does include several monastic figures. Nor is it known to what if any 'Church use' it was put. The animal drawings may have provided patterns for embroideries, for which England was famous, but the drawings of figures seem to relate to manuscript illuminations or even to wallpaintings.
Cambridge, Magdalene College Library, MS. 1916, f. 4r.

Plate 127 Models for animals. Pepysian Sketchbook. England, late 14th century.
The drawings in the Pepysian Sketchbook are by several hands. Some of the animals, especially the birds, are nature-studies comparable to those in contemporary Italian books. Others are represented in outline only, and are shown in a stylised side view like heraldic beasts. They are similar to the traditional patterns found in earlier model-books.
Cambridge, Magdalene College Library, MS. 1916, f. 9v.

Plate 128 The Hunt of Dido and Æneas. Virgil, Æneid. Italy, 14th century.
The animals capering in the margins are clearly of the same type as those in model-books. They are shown in profile, each is a separate unit without regard to scale and space, and they are composed on simple formulas; the substitution of horns for ears is enough to turn a hare into a stag. Here they are used to illustrate an episode from Virgil, but without any attempt to disguise their origin.
Biblioteca Apostolica Vaticana, MS. lat. 2761, f. 36v.

Plate 129 A page of sketches. Pen on parchment. Tuscany, 1350-75.
The drawings on this sheet include normal model-book subjects, such as animals and allegorical figures, but they lack the clear layout commonly used when depicting patterns. The studies of draperies and figures in motion are more like trial sketches than examples of established types.
New York, Janos Scholz.

Plate 130 A lady, and human and animal heads. Page from a sketchbook. Austria, 1415-20.
There are drawings on both sides of the sheet, some little more than scribbles. The figure and animal subjects belong to the model-book tradition, but the individual way in which they are treated and the fragmentary nature of some of them suggest that they are part of an artist's personal sketchbook.
Nuremberg, Germanisches Nationalmuseum, Hz. 41.

Plate 131 Three ladies. Pen and wash on parchment. France or Bohemia, *c.* 1400.
The German name for the International Style is *weicher Stil*, soft style. The reason can be seen in this elegant, rather sentimental drawing of three ladies. The swaying, elongated forms are still Gothic, but the figures are more natural and substantial than in earlier Medieval art.
Paris, Musée du Louvre, Cabinet des Dessins, Inv. no. 3811.

41

Plate 132 St Jerome in his study. Bible moralisée. Burgundy, 1410-16.
This, perhaps the most ambitious and elaborately finished of all Medieval draw-
ings, was at one time attributed to Pol de Limbourg. Although this no longer
seems likely, the picture is in many ways comparable with the famous miniatures
in the *Très riches Heures du Duc de Berri*. It represents a new attitude to drawings,
as independent works of art which could emulate the finest paintings in exquisite
workmanship and grandeur of conception. This attitude is appropriately
demonstrated by the fact that a characteristically lavish *Bible moralisée*, made for
the Duc de Berri and illustrated with over a thousand painted miniatures,
should have had this drawing added to it as a frontispiece.
Paris, Bibliothèque Nationale, MS.fr. 166, f. 1r.

Bibliography

Although there are many books on Medieval art and several on the history of drawing, there is no comprehensive work on Medieval drawing. However, as most of the former deal with drawing and some of the latter begin with the Middle Ages, further information can be found in the relevant sections of both. Works on Medieval art are too numerous to list, but the most useful of those on drawing include the following:

Degenhart, B.
Europäische Handzeichnungen. Berlin–Zürich, 1943 (Atlantis-Verlag).

Meder, J.
Die Handzeichnung. Vienna, 1919 (Anton Schroll).

de Tolnay, C.
History and Technique of Old Master Drawings. New York, 1943 (H. Brittner & Co.).

More specialised literature:
a. *The nature of Medieval drawing*

Degenhart, B.
Autonome Zeichnungen bei mittelalterlichen Künstlern. Münchner Jahrbuch I, 1950, p. 93.

Oertel, R.
Wandmalerei und Zeichnung in Italien. Mitteilungen des Kunstgeschichtlichen Instituts in Florenz, V, 1940, p. 217.

Panofsky, E.
Das erste Blatt aus dem 'Libro' Giorgio Vasaris. Staedeljahrbuch, VI, p. 25 (especially pp. 28-32, which are omitted in the English translation of this essay in 'Meaning and the Visual Arts', p. 169).

b. *Drawing in different periods and places*

Benesch, O.
Die Zeichnung. Europäische Kunst um 1400 (exhibition catalogue, Vienna, 1962), p. 240.

Drobná, Z.
Gothic Drawing. Prague (Artia). Translated by Jean Layton.

Lavallée, P.
Le Dessin français du XIIIe au XVIe Siècle.

Scheller, R. W.
A Survey of Medieval Model-books. Haarlem, 1963 (De Erven F. Bohn N.V.).

van Schendel, A.
Le Dessin en Lombardie. Brussels, 1938 (Editions de la Connaissance).

von Schlosser, J.
Zur Kenntnis der künstlerischen Überlieferung im späten Mittelalter. Jahrbuch der Kunsthistorischen Sammlungen des allerhöchsten Kaiserhauses XXIII, 1902, p. 279.

Wormald, F.
English Drawings of the Tenth and Eleventh Centuries. London, 1952 (Faber & Faber).

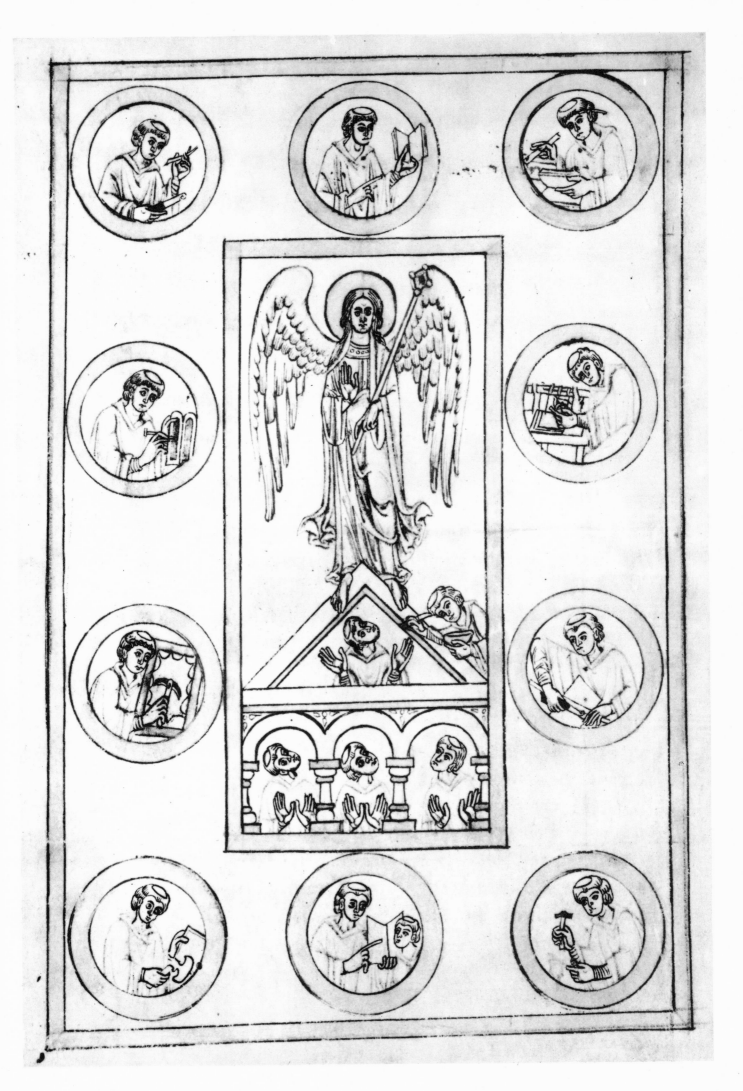

Plate 1

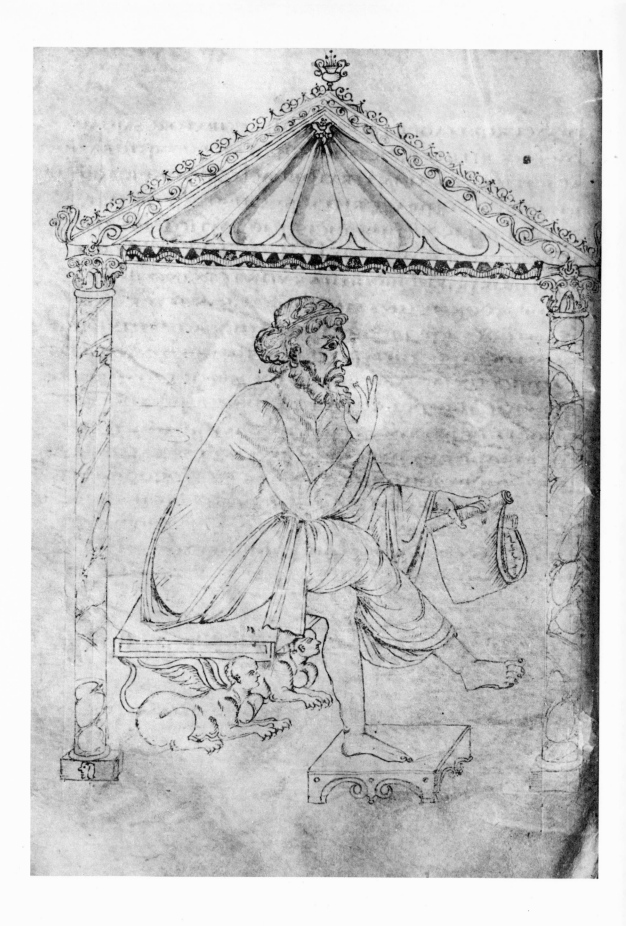

Plate 2

4 de antonino .
435 Theodosio xvi . & ualent. uii
Hís cons̃ eruus magist̃ mili
ru patriciuſ factuſ ē non
ſept rauen .

436 Isidore ſenatore .
437 fauſto ii . & ſigimul .
Hís cons̃ ualentiniañ ina
ugurauit ad orientē diū
die igiſ hora iii . κα ce
p̃ uxore ūκ ueniſſ.

Valentiniano & anthoio
ciy uic cons̃ +ii
de ncoro & eudoxio . . . +i.
. n . epheriro . +
Hís cons̃ terre moruſ heiſ
& xu . κal gnouī
rauen hora noc̃ . uiii .

Opilone & uico uello
uetio & italio .
Hís cons̃ occiſi ſe rome patric
& boetiuſ prefat . xb

Plate 3

Plate 4

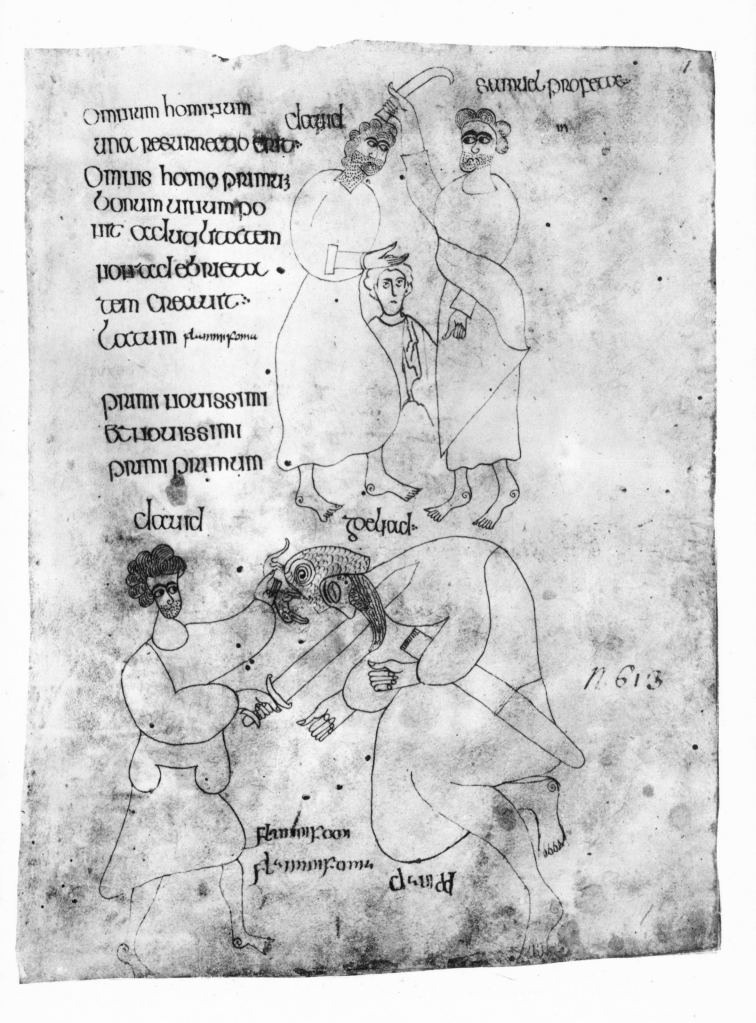

Plate 5

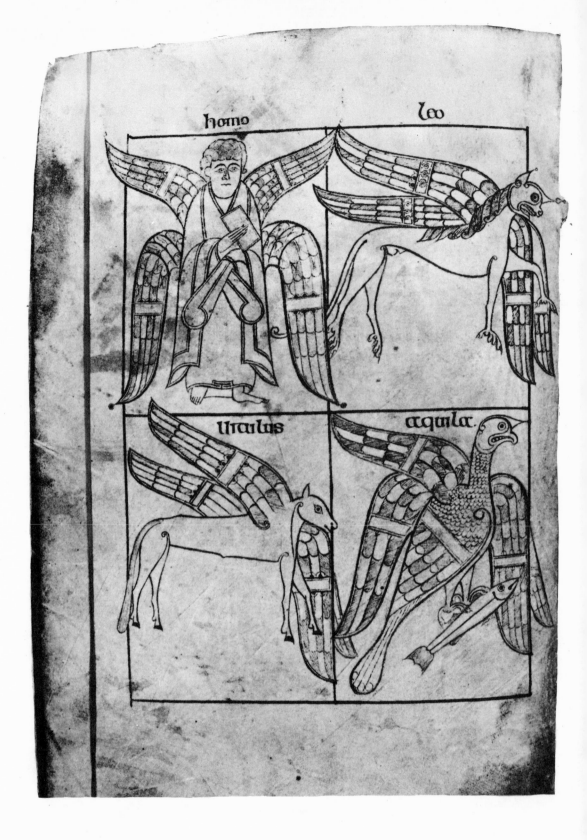

Plate 6

Plate 7

heu male gustato regni dum blanda uoluptas
oblectat iuuenem iurataq; sacra resoluit
Sed quia peruicax nec sors lacrimabilir illa est
nec angunt patrias sententia sacua secures
En ego sobrietas si conspirare paratis
pando uiam cunctis uirtutibus ut malesuada
Luxuries multo stipata satellite poenas
cum legionesua xpo subiudice pendat

SOBRIETAS · CRUX IMPEDIT OBITVM CURRU LUXVRIAE

Sic effata crucem dni feruentibus offert
Obuia quadriugis lignum uenerabile inipsos
Intentans frenos quod ut expauere feroces
cornibus ob pansis & summa fronte coruscum
Uertunt praecipitem cecas formidine fusi
Per praerupta fugam fertur resupina reductis
Hequisquam loris auriga comanq; madentem
puluere foedatur tunc & uertizo rotarum
In plicat excussam dominam nam prona sub axem
labitur & lacero tardat sufflamine currum

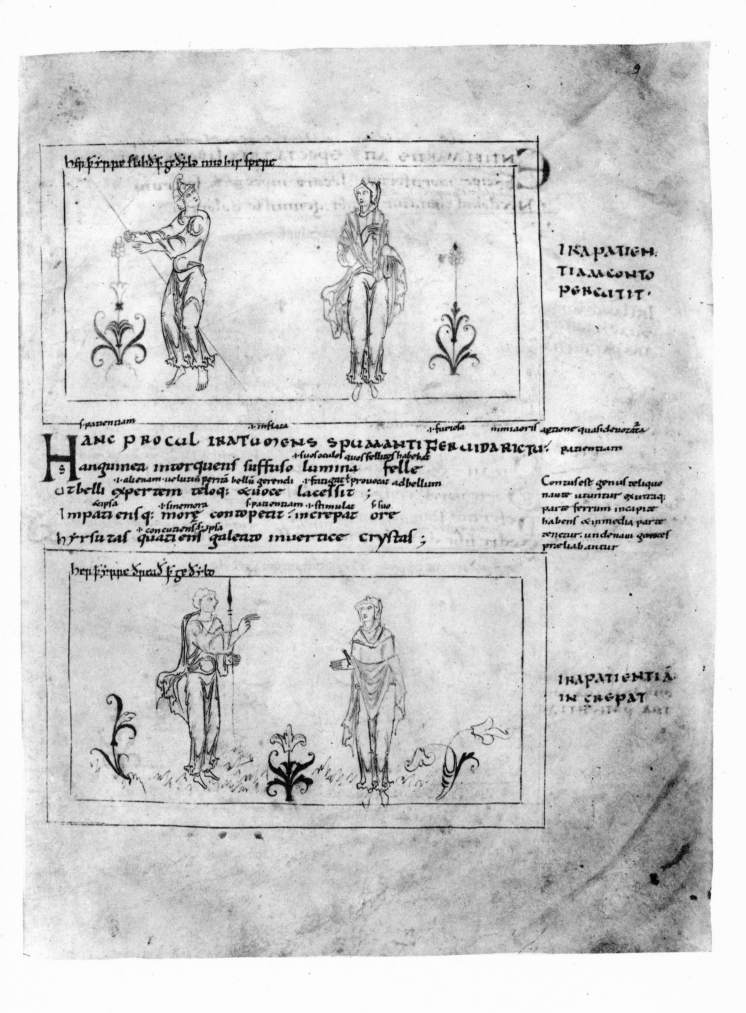

hec scrippe sub et gedi to nio hic spepe

IKA PATIEN. TIAM CONTO PERCITIT.

s. patientiam · r. inflata · s. furiosa nimia orif agione quasi deuorata

HANC PROCAL IRATUOIENS SPUMANTI FERUIDA RICTU: patientiam

s. Hanquinea intorquens suffuso lumina felle

· r. alienam uelutii perita bellu gerendi · r. furigat prouocat adbellum

Utbelli expertam teloq: & uoce lacessit;

· eipsa · r. sinemora s. patientiam · r. stimulat s. suo

Impatiensq: mora conupetat increpat ore

· r. concutiens s. ipsa

hirsutas quatiens galeata inuertice crystas;

Contusi est genus reliquo nauto utuntur excutiaq; parte ferrum incipie habens & inmedia parte tenetur. unde nam gamices praelabantur

hec scrippe dprad et gedi to

IKA PATIENTIA IN CREPAT

48

Plate 10

GNA · TRA · THA · PAR · EUNUC CHEREA · VIRGO ·

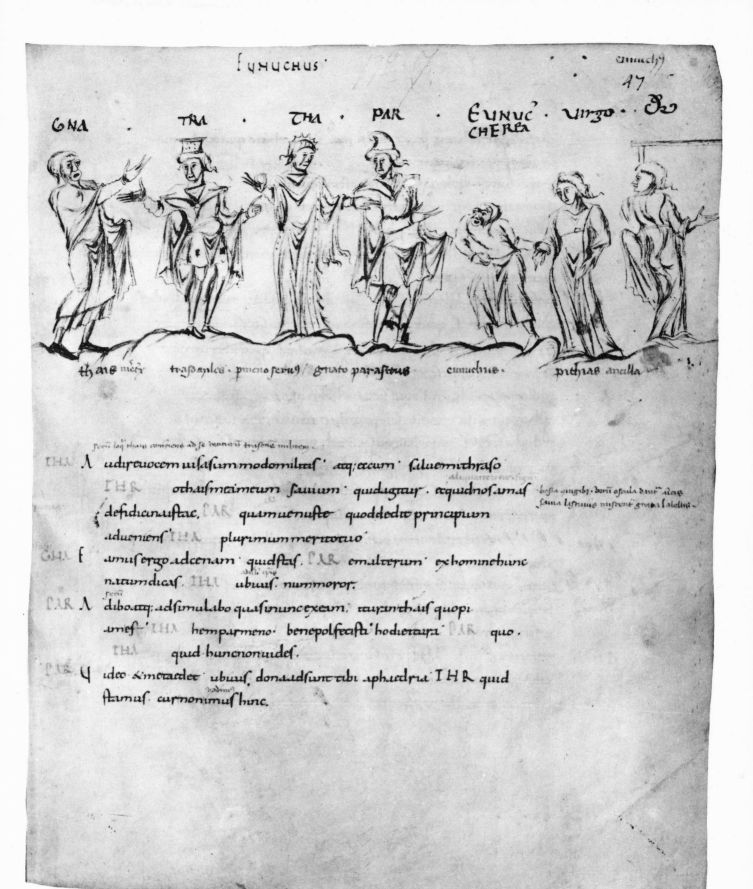

thais mer · tra saniles · pueno serus / gnato parasitus · eunuchus · pithias ancilla

THA Audite uocem uisa sum modo militis· atq eccum· saluere thraso
IHR o thais mea meum sauium· quid agitur· ecquid nos amas
desidia nusta· PAR quam uenuste· quod dedit principium
adueniens THA plurimum merito tuo·
GNA E amus ergo ad cenam· quid stas· PAR em alterum· ex homine hunc
natum dicas· THA ubi uis· nummoros·
PAR A di boni atq; ad similabo quasi nunc exeam· taurinthias quo pi
ames· THA hem parmeno· bene pol fecisti· hodie taita· PAR quo·
THA quid hunc non uides·
PAR U ideo & me taedet· ubi uis· donat sunt tibi aphaedria IHR quid
stamus· cur non imus hinc·

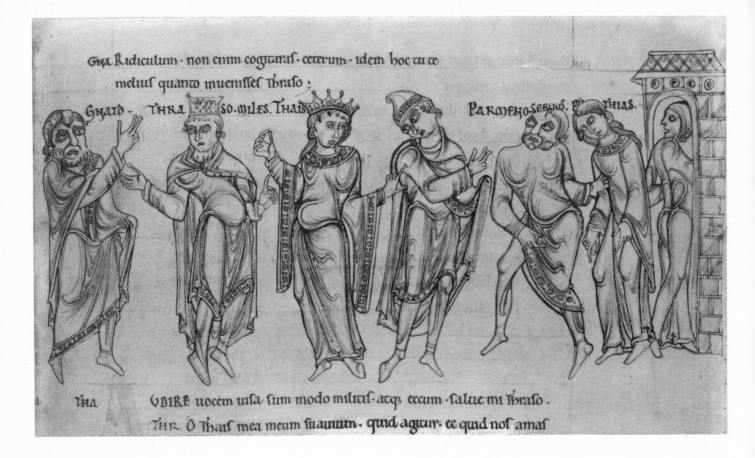

Plate 12

H Inutrisq· genib· r&or
tis 11· Inutroq· armo
1· Inutroq· pede ante
riore 1· Sunt omnes
xx1111· Fertur tene
re sicut superius sig
gna uimus insinistra
manu arma & lepo
rem· Indextra uero
bestiam· & aquib; da
hydriã ac&· que
hab& stellas incauda
11· Insumo pede poste
riore piidam 1·
& inspino nidam 1
& inanteriore pede
splendida 1· & subt°
pede ipso 1· Incapite
111· Sup̄t om̄s· Viiii
intotũ uero xxxvi·

S in humeros medio cęlo centaurus habebit·
I pseq· cerulea contectus nube feretur
A tq·aram tenui caligans uesti& arcumbra
A t signorũ obitu uis é metuenda fauoni
I lle aut centaurus inalta sede locatus·
Q uasese clare conlucens stor pius infert
H ac subt̄ parte p̄portans ipse uirilem·
C edit equi partis properat coniungere chelis·
H icdextram porgens quadrupes quauastatenet
Q uam nemo cerbo donauit nomine graium·
T endit & illustrem truculent° cedit adaram·

S erpens sup cui°cau
dam·coruũ sedere
dicunt· & mmedio ur
nam habere asserunt·
fertur eñi ut cãput
sumitatur cancro· &
caudã ad centaurũ
tendat· qui hab& stel
las 111· Inuertice
1· Inpectore 1·
muentre 1·

Plate 13

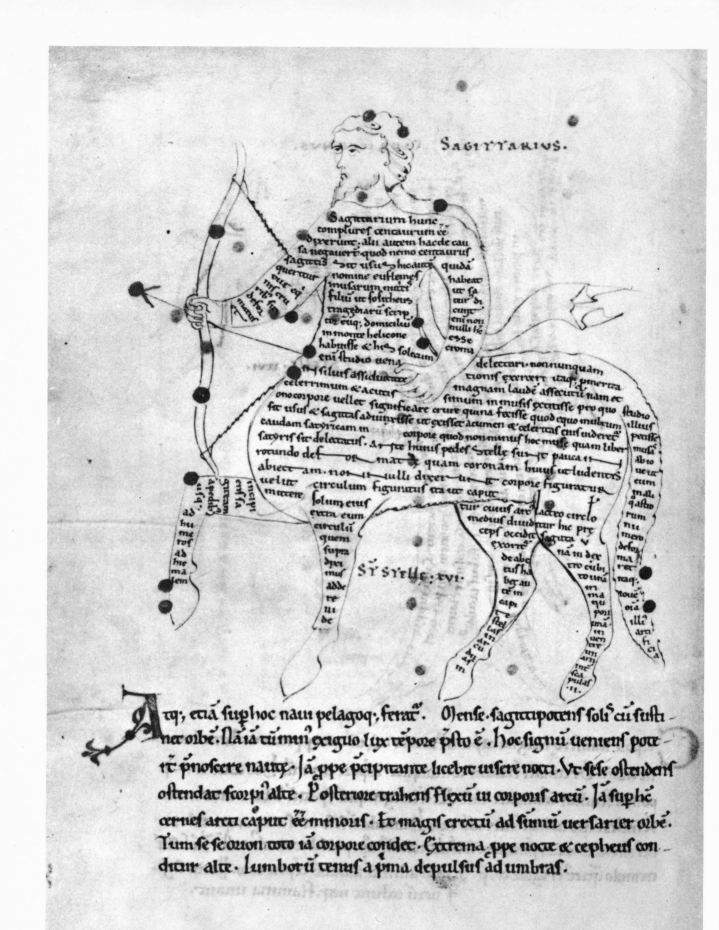

Atq; etiā suphoc nau pelagoq; ferat. Ostense sagittipotens solis cū susti-
net orbē. Nasaia tumeni exiguo lux tēpore pisto ē. Hoc signū ueniens potē-
rit pnoscere nautē. Iā ppe pcipitante licebit uisere noctī. Vt sese ostendens
ostendat scorpi alte. Posteriore trahens flexū in corporis arcū. Iā suphc
cernes arcti caput ee minoris. Et magis erectū ad sūmū uersarier orbē.
Tum se se orion toto iā corpore condet. Extrema ppe nocte & cepheus con-
ditur alte. Lumborū tenus a pma depulsus ad umbras.

Plate 14

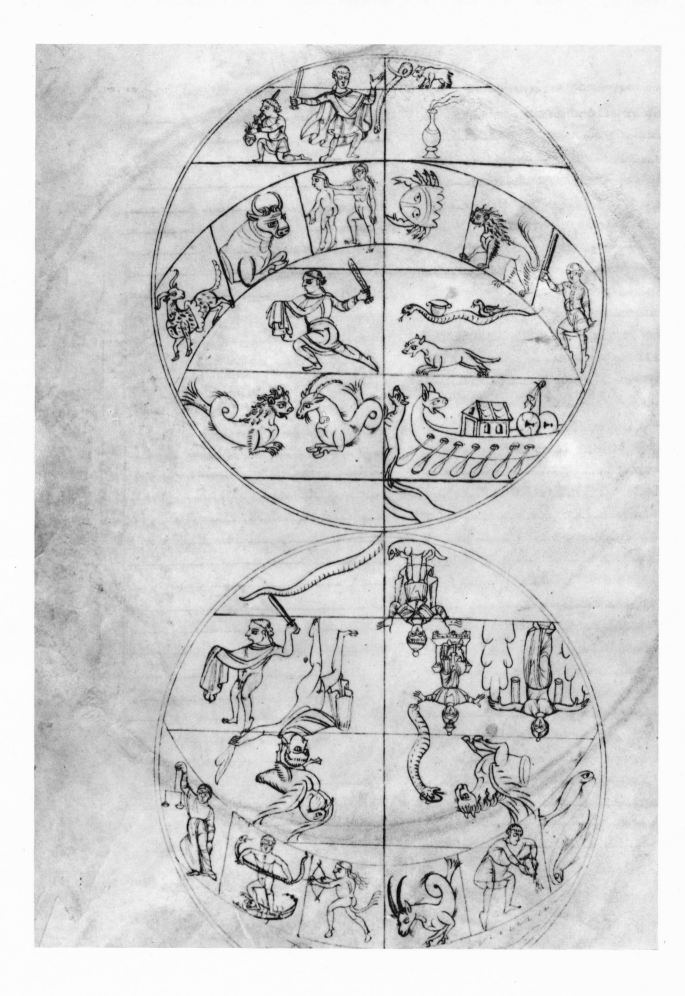

Plate 15

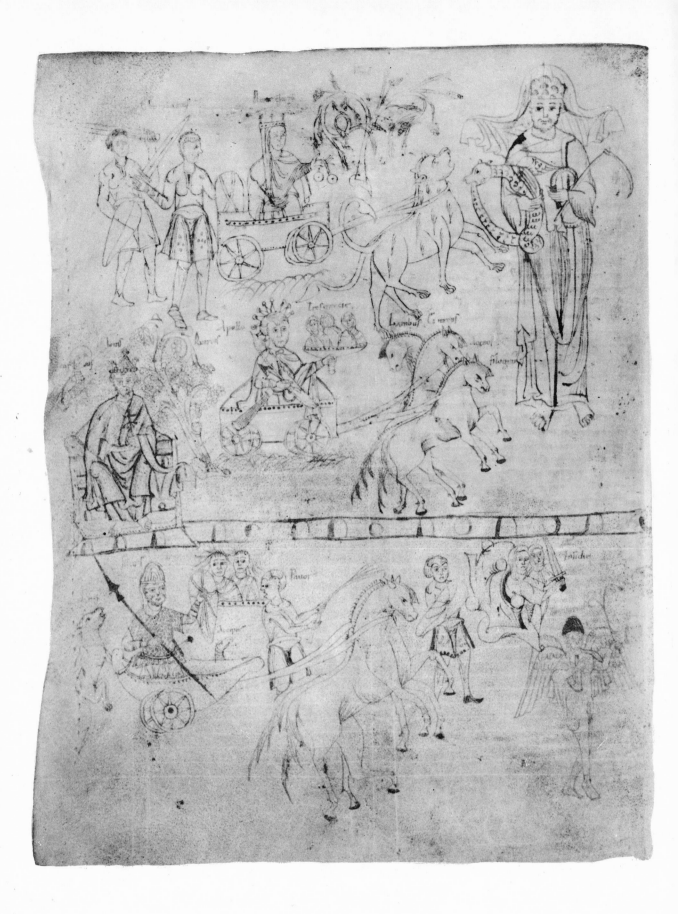

Plate 16

cuius se inpfundum mgant : tamen in natando repunt. un
ydauid ait. hoc mare magnu & spaciosu manib; illic repti
lia quru non est numer. Anphitia sunt quedam gena piscui dicta
quod ambulandi in terris utum y natandi in aquis officium
habeant. Anphi eni gre. utrumq; dr. i. qa in aqs y itris uiuunt.
ut phoce. cocodrilli. ypotami. hoc est equi fluctuales.

Plate 17

Plate 18

MVSEVM
BRITAN
NICVM

Plate 19

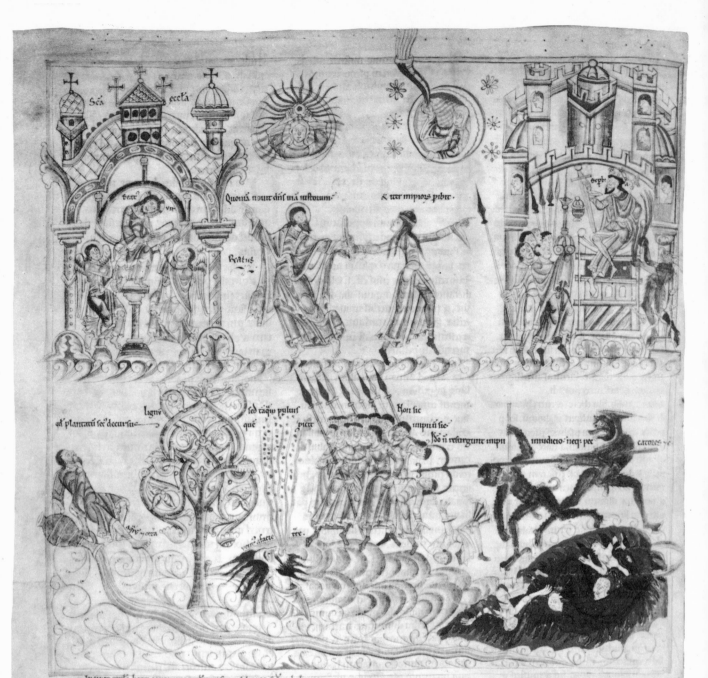

Sca ecclia · Scā · beatꝰ vir · Quonia̅ nouit d̅n̅s viā iustorum · & iter impiorꝝ pibit · seph

lignū · sed tāqm puluis que̅ picit · Hon sic impii sic · no̅ ñ resurgunt impii · in iudicio · neq; pec catores ·
qd plantatu̅ s̅ē decursus · A ṡ͛ē ꝼta · a facie t͛re

Eusebi̇ Jeronimus sophronio suo salute dicit. Scio quosdam putare psalterium in qinq; libros ee diuisum. ut ubicunq; apud septua ginta in̅ceptis scriptum est. kꜷ ωιτωc kꜷ ωιτωc. id est fiat fiat finis libros sit. ꝓ quo in hebreo legitur amen amen. Nos autem hebreorum auctoritatem secuti & maxime aplos qui semp in nouo testamto psalmorum librum nominant unū uolumē asserimus. Psalmos quoq; omnes eorum testam̅ auctorum qui ponuntur in titul'. dauid scale; & asaph. & idithun filiorum chore. eman. ezrate moyysi & Salomonis. & reliquoꝝ qs ezras uno uolumine comphendit. Si enim amen ꝓ quo aquila transtulit. kꜷ ιcτ ω ꜷ ωc. infine tantum librorum ponit. & non interdum aut in exordio aut in calce sermonis siue sentenție; nunquam & saluator in euangelio loqueretur. amen amen dico uob. & pauli epli in medio illud ope contineretur. moyses quoq; & ieremias & ceteri in hoc mo

dum multos haberent libros. qui in medus uoluminib; suis amen frequ̅ interierunt. Sed & numerus xxii librorum hebraicoꝝ & misterium eiusdem nu meri co̅mutabitur. Ha̅ & ratul'ipse he braicus sephar tallun q̅ in̅cipitꝰ uolumē hymnoꝝ aplice auctoritati congruens. non plures libros s;. unum uolumen osten dit. Qina q̅ nup cu̅ hebreo disputans quedam ꝑ domino saluatore de psal mis testimonia ꝓtulisti. uolensq; ille te illudere psermones pgne singlos as serebat ñ ita habere in hebreo. ut tu de lxx. in̅ꝑb; opponebas. studiosissime postulasti ut p aquila̅ & simmacum & theodotione noua edicionem lati no sermone tra̅sferre. Aiebas. n. te ma gis in̅ꝑū uarietate turbari. & amo re q̅ labis ut tra̅slatione ut iudicio meo. ee contentu̅. Vn impulsa te au q̅que possu̅ negare non possu̅; me

obrectatoꝝ tacratib; tr̅didi. malens; te uir̅ po̅ meas q̅m uoluntate̅ iam inimicog q̅rere. Certe co̅fidens dica̅. & multos huî opis testis citabo me inch du̅ taxat sciente de hebrai ca ueritate mutasse Sic ubi q̅ edicio mea a ueteri̅b; discrepat : in̅roga quelib3 hebr̅ eoꝝ & liqido puides me abemuir̅ frustra ar̅ q̅ male co̅tendere iudi̅ ꝓclara q̅ discat. puerissimi hoies. Ha̅ cu̅ sep noua exspec tent uoluptates. & quile eoꝝ in̅cuna maria ñ sufficiat. i solo studio scr̅ptaꝝ ueti sapore ctā fē. Hoc hoc dico ut ꝓcessores meos in̅ dea. aut q̅q̅ de hī arbitrer de tendū q̅s tr̅nslatione diligentissime ca̅dara olime tin̅ lingue hoib; dederi. s; q̅ aluit̅ sit in̅ medii x ardenuū psalmos legr̅. aluit̅ rudes singla uba calu̅pniatib; responde. Qd' opti̅ in̅ea si in̅greū ut polliceris tr̅stulerī. a• r̅q̅a rιkꜷ τωβια cꝝpωυcꝝ & ipse inꝑ doctissimos uiros quosꝫ; testū facit uolue ris: dicat illud orationū in̅ silua ne licna feras. n̅ qd s̅ habes solam̅ fi̅ labore co̅ti̅n̅ in̅tellig q̅ in̅ & laude̅ & uru̅paco̅e uir̅ ee co̅munē. uale i d̅n̅o ιhu. Cupio te meminisse men.

posuerunt hierlm inpomorum custodia·

P osuerunt mosticina seruorum tuorum escas

uolatilib: caeli· carnes scoq tuoq bestiis terrae·

E ffuderunt sanguinem eorum tamquam aquam

in circuitu hierlm· & non erat qui sepeliret

F acti sum opprobrium uicinis nris· subsannatio

& inlusio his qui incircuitu nostro sunt·

V squequo dne irasceris infinem

A ccenditur uelut ignis zelus tuus·

E ffunde iram tuam ingentes quite nonno

uerunt· & inregna quae nomen tuum

non inuocauerunt:

Q uia comederunt iacob

& locum eius desolauerunt

N e memineris iniquitatum nostrarum antiquaq

cito anticipent nos misericordiae tuae

quia pauperes factisumus nimis

A diuuanos ds salutaris noster· ppter glam

nominis tui dne libanos· & ppitius esto

peccatis nostris ppter nomen tuum·

N e forte dicant ingentib: ubi est ds eorum·

& innotescat innationibus coram oculis nris

V ltio sanguinis seruorum tuorum qui effusus e

Plate 21

Plate 22

ense numo in... io solidi sic sids aquarii
e mediu rein... iam sidus aquarum
mine... at numero bis denis octo die bus
una frequens feruet februus simul unde erigens
uae nis nonis de... se... up kalendis
FEBR. HABET MDS XXVIII LUNA XXIX.

FEB loria scottorum brigida sostria kalendis
N o... i nagdris ... xpo templo ducueris archel
... i ... nunonis Laurencii en ... altus
... i i die ... saure merois nomine magnus
... onas sacra agatha format in ustice uirgo
... idibus octauis commoure d austra adusti
... ncipiunt ueris exordia ... priso
... rimiter incepit ... luna adoium
... ... le ... alexander quinis remisit
... rorarum ... quadris deducere ad astra
... ... pia ... ternas ... idus
... idie danua uirgo eur eloine pulsar
... dusouae ... iulinus moire reddicus
... ndo ualerinus sexdenis ... kalendis
... isei culis phoephus recurus
... uns in quadris iuliana refocur abimis
... res decimus felix eris cantus incorat adauli
... le nis siluanus duo denis scandic ad astra
... ndonas ... iulianus moribus aptus
... ormit ... denis ... moire calestis
... oruelis ac nonis eleuis conscende nisus
... er orie ac... erum bis quadris sede sacra
... eque ... septenis sep... refolure
... uadrantum sede mediano congrutt almo
... eque caput quinis diuere
... carius merois oransiure caruia quadris
... ... serorum... caput incernis ofendic arius
... ormnat hic februus eclebris ei nomine sacru
NOX HOF VIII

D emonce quod anno bissexcali lune februarii xxx dies compucus
ut tamen luna marcii luna xxx dies habeto sic semp habe no
paschalis clene ratio uacillec

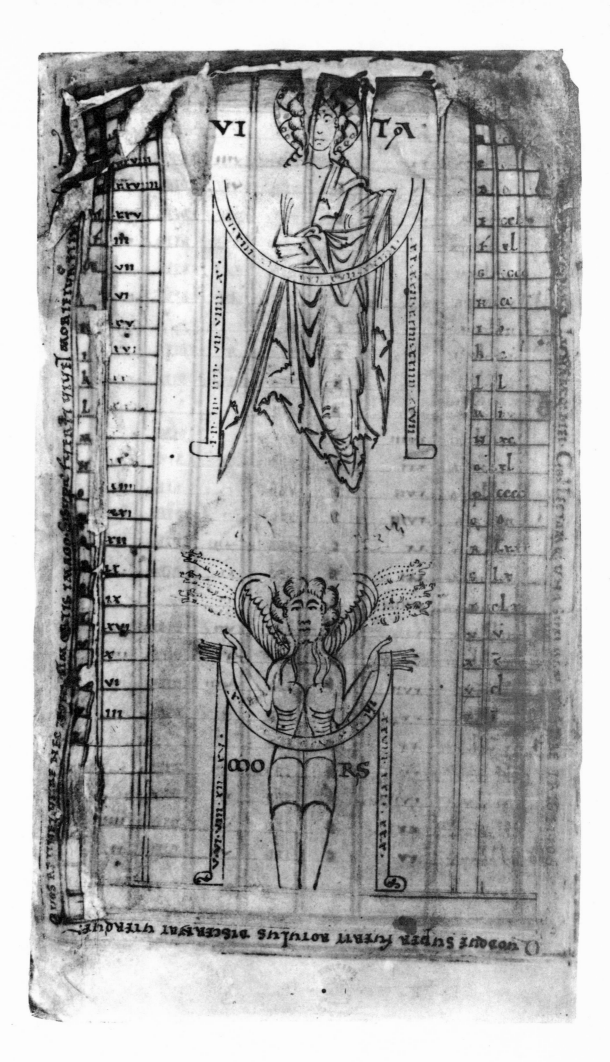

Plate 23

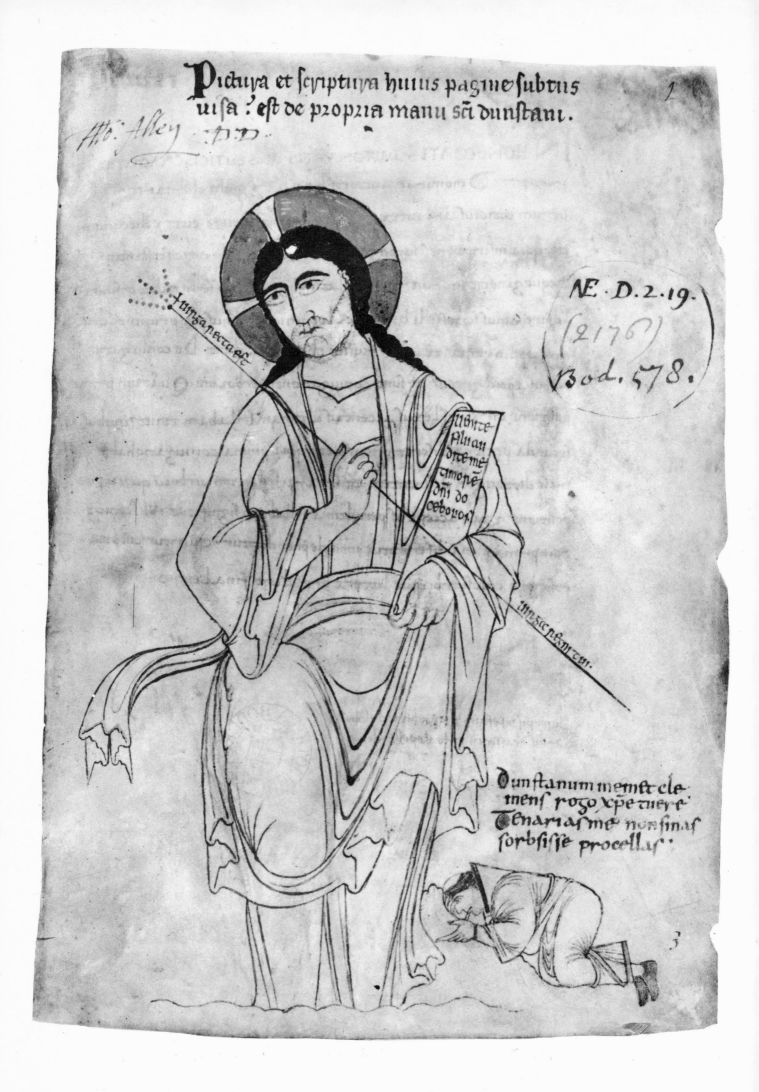

7-

Plate 25

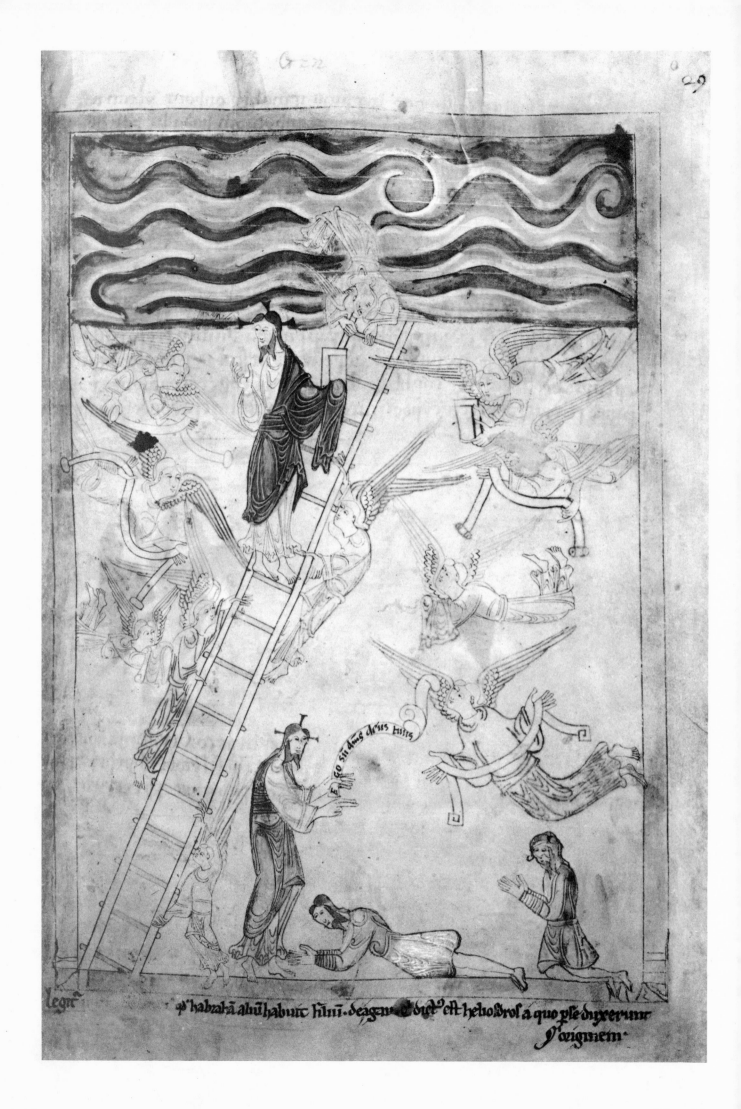

Ego sū dūs deus tuus

legit

q̄ habrahā aliū habuit filiū. deagar e̅ buā̄ est heliossros a quo p̄e dixeruū
p̄ originē·

Plate 26

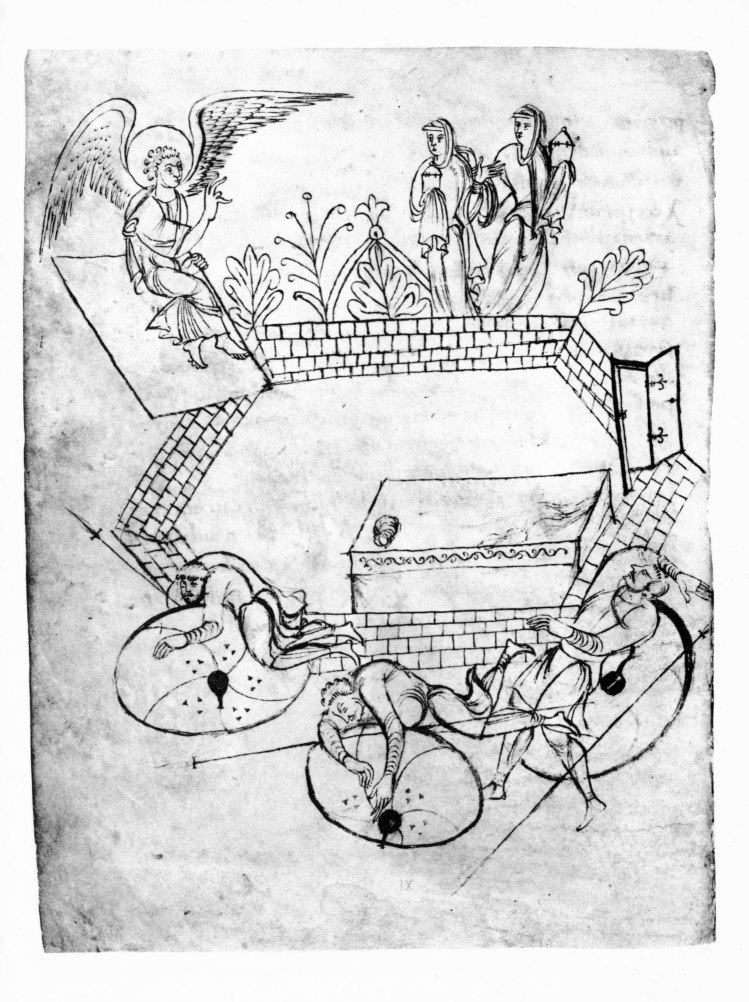

Plate 27

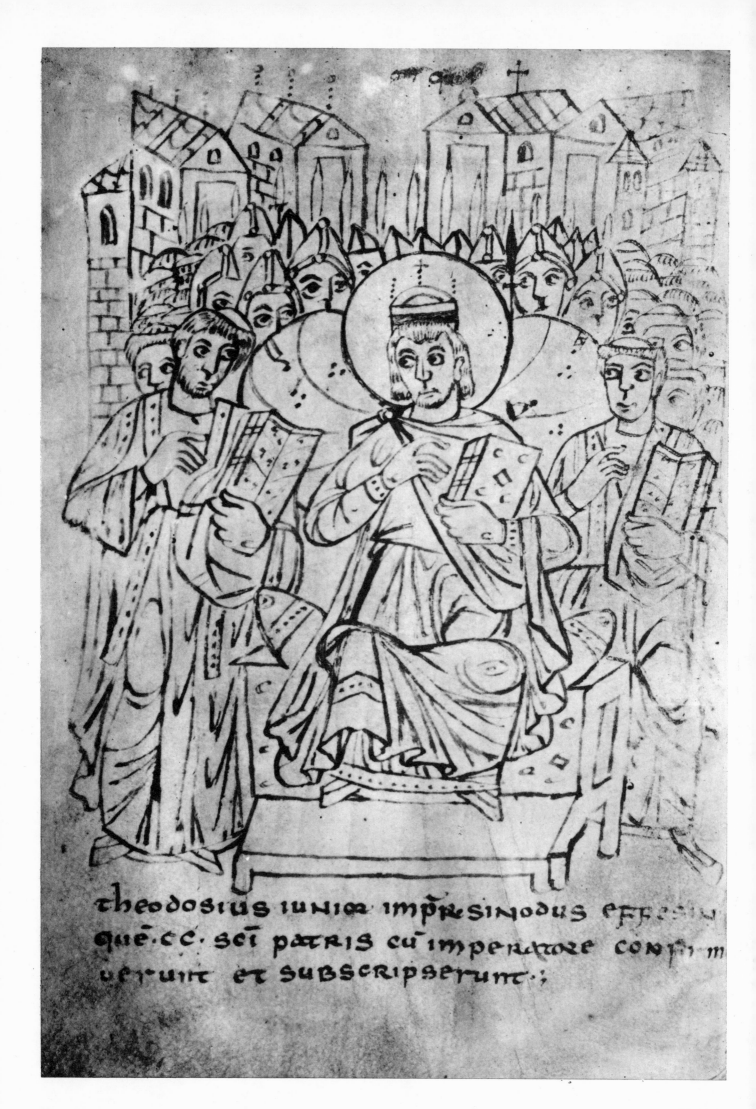

theodosius iunior impr sinodus effesiu
que cc sci patris cu imperatore confir m
veruit et subscripserunt :;

Plate 28

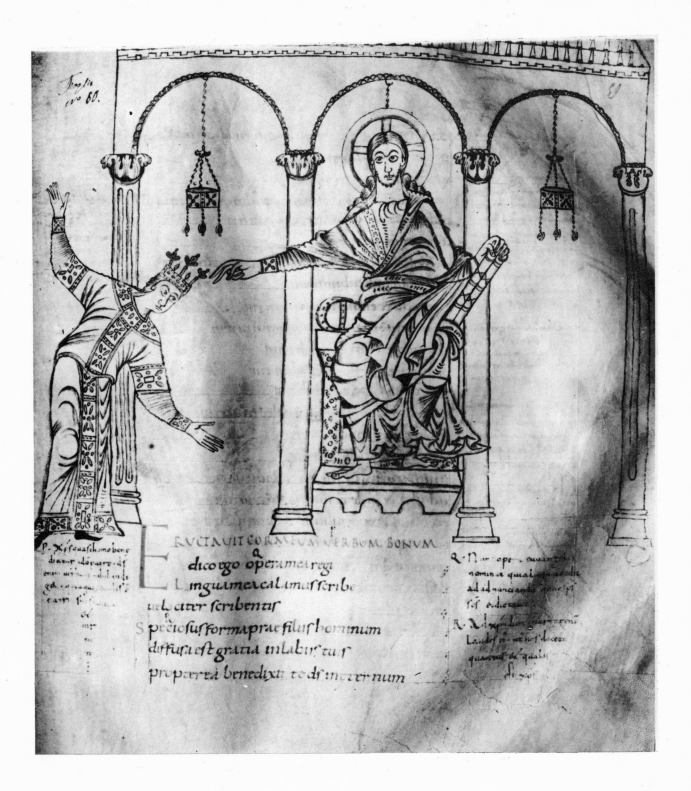

ERVCTAVIT COR MEVM VERBVM BONVM
dico ego opera mea regi
Linguam ecalamus scribe
uelociter scribentis
Speciosus forma prae filijs hominum
diffusa est gratia in labijs tuis
propterea benedixit te ds inaeternum

Plate 29

Plate 30

ANNO dñice incarnationis sexcentesimo·v·beat gregorius.
A post quã sedē Romane & apłice eccłe tredecī annos.
·menses·vi·& dies·x·gloriosissime rexit defuncł est.
Atq; ao ẽnã regni celestis sedē ĩns latus esʳ·;

Plate 31

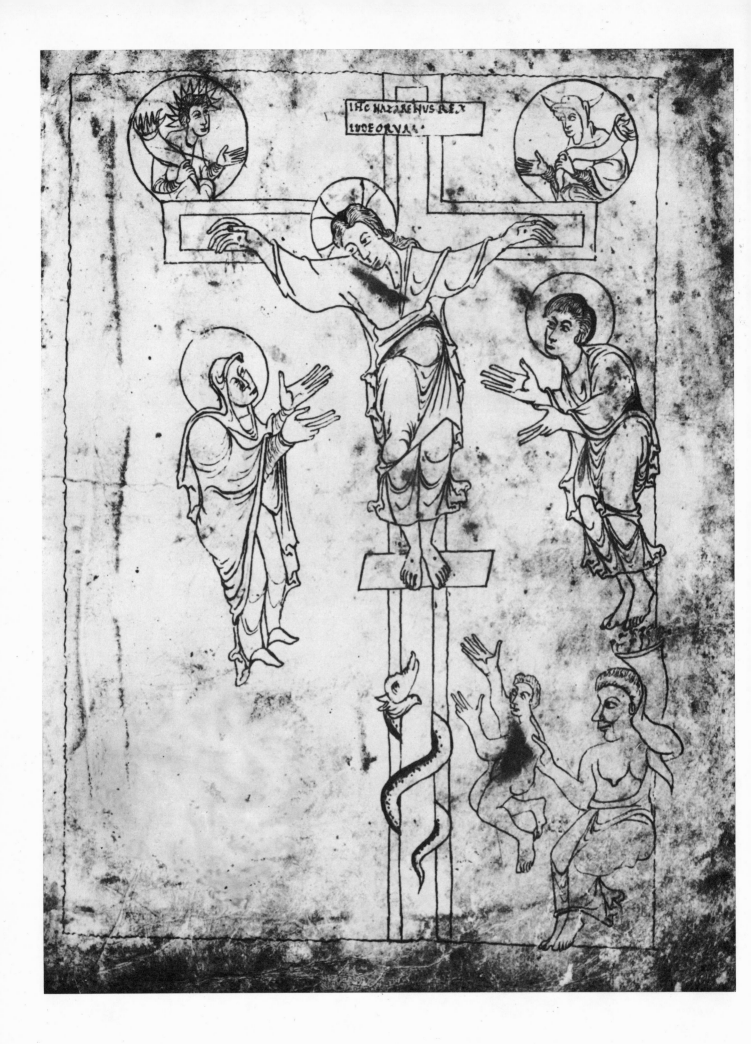

Plate 32

Plate 33

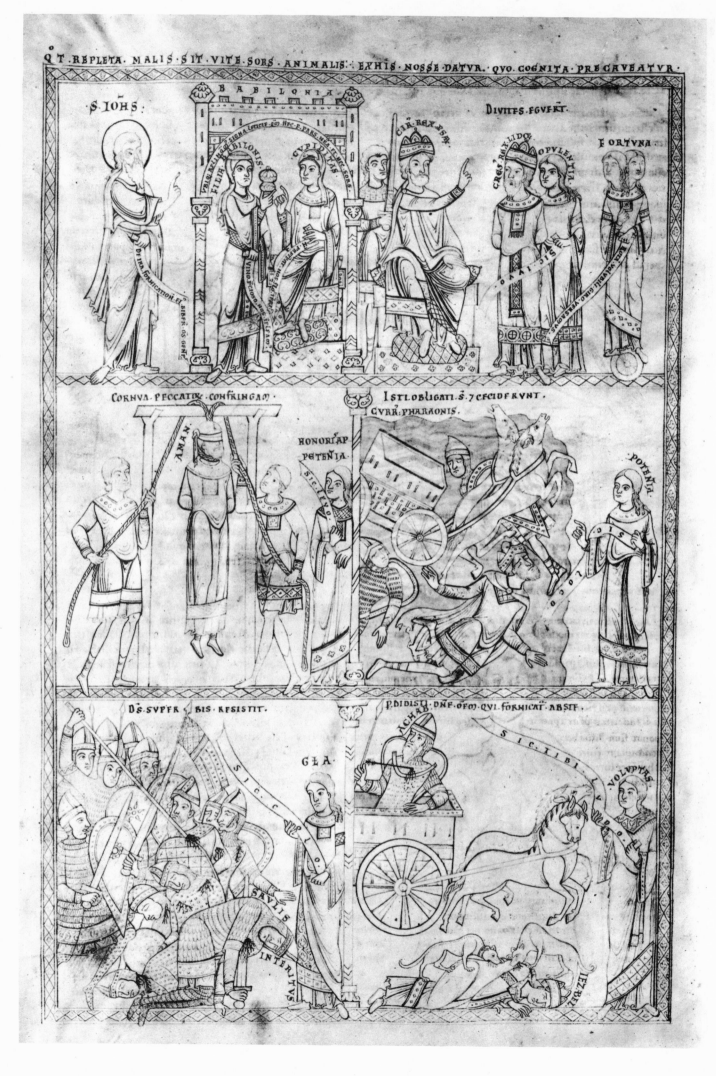

Plate 34

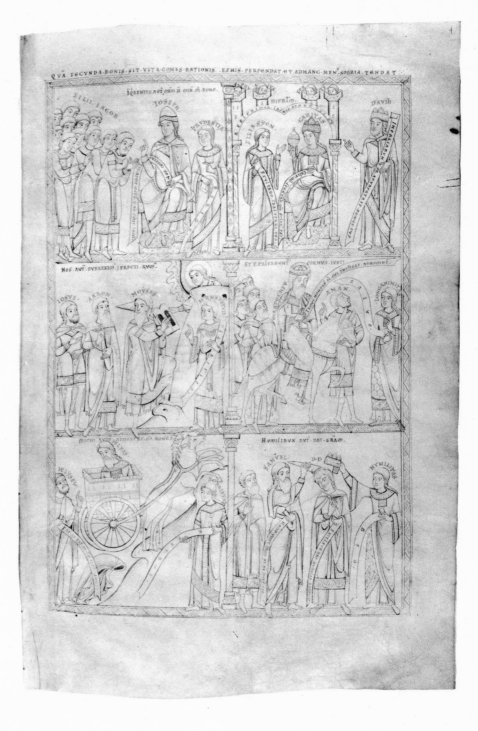

Plate 35

In natal' Sancti Iohannis Euangle . 7 apli .

Ualde honorandus est beatus Iohannes qui
supra pectus domini in cena recubuit . Inuitat .

Adoremus regem apostolorum qui priuilegio amoris Io
hannem dilexit apostolum . In i noct . a . Qui uicerit faci
am illum columnam meam in templo meo dicit dominus .

a Hic est discipulus ille qui testimonium phibuit scimus quia
uerum est testimonium eius . a Sic eum uolo manere donec
ueniam tu me sequere . a Cibauit eum dominus pane uite
& aqua sapientie potauit eum . a Spiritu sapientie salutaris
repleuit eum dominus & intellectus . a Dedit illi dominus

EVOVAE

EVOVAE

EVOVAE

EVOVAE

EVOVAE

EVOVAE

EVOVAE

Plate 36

quã prius ei subtraxit cũ obculpã abea se auertit. Ana
gogyce aut erecta adsupna suspirans addilectũ se euer
tit. cũ demundo adcelũ migrabit. & ipse se adeã euer
tet. cũ eã insocietate angeloẓ recipiet. Huc usq; syna
goga intrauit. iã mandragora insequentibz intrabit

...ub iiii sponsa aglonis. scilz ñ mandragora.

OSTQVAM TOTVS COMITA
TVS SVA OSITIS SCAVLAM
Regis õ receptus & regalibz nuptiis
admissus ecce abaglone noua sponsa
cũ magno apparatu scilicet mandrago
ra sine capite sponso adducit. cui abeo aurũ

Plate 37

Plate 38

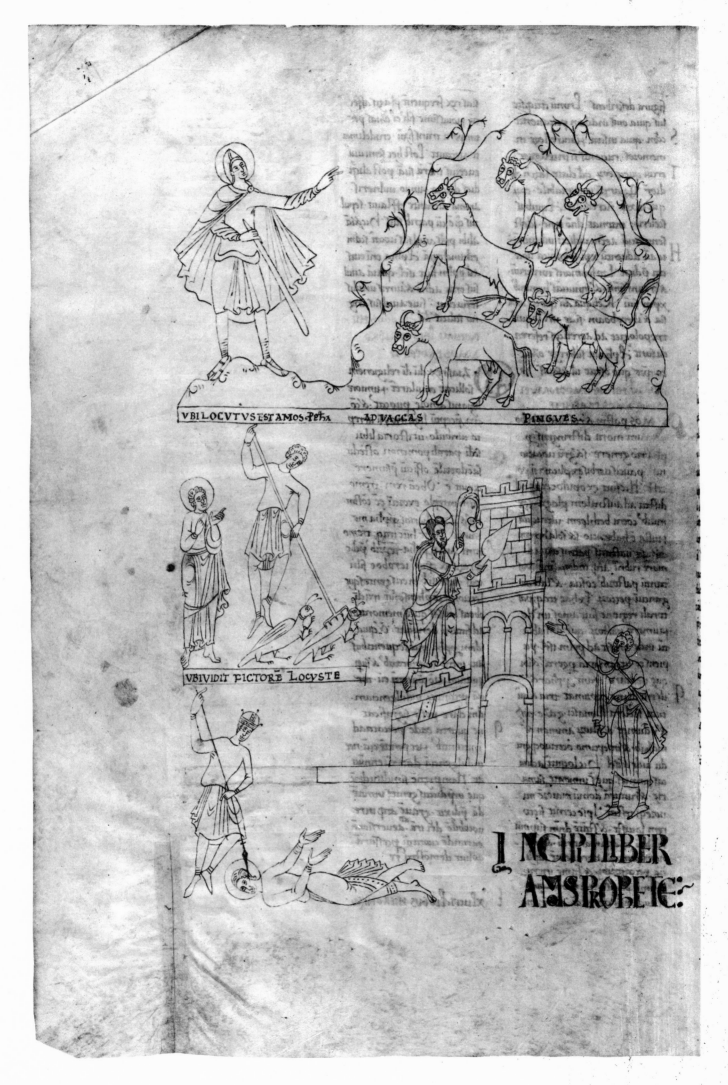

UBI LOCUTUS EST AMOS P[ro]ph[et]A AD VACCAS PINGVES.

UBI VIDIT FICTORE[m] LOCUSTE

INCIPIT LIBER AMS P[ro]P[he]TE:

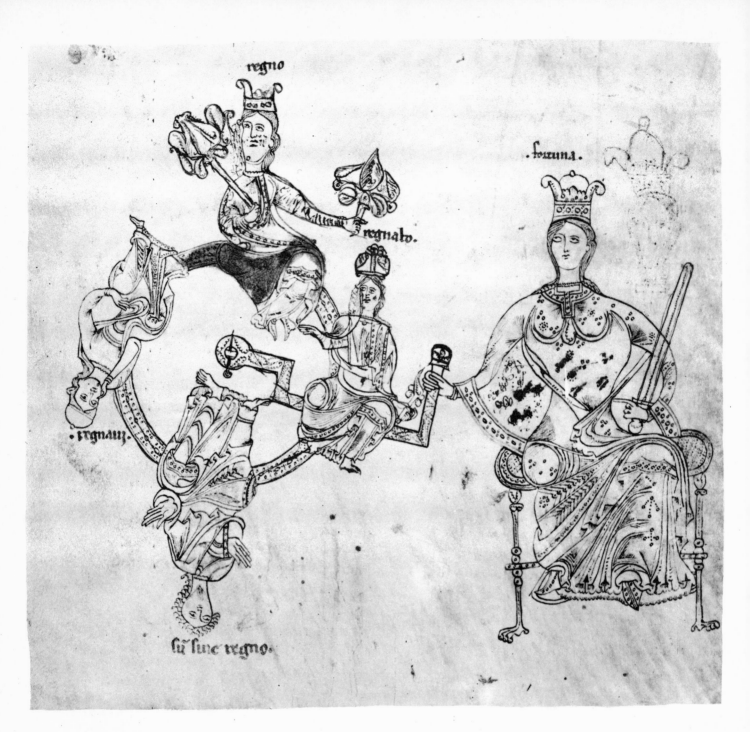

Plate 40

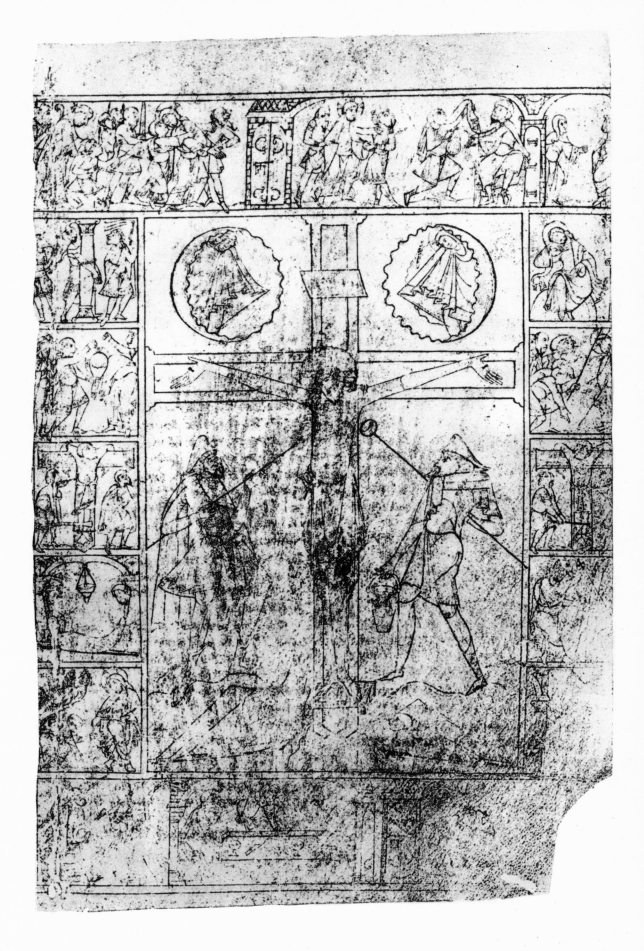

Plate 41

ut a
ius
enit.
it ubi
itllect.
elh
inui.
ti sius
uiro
erbis
um.
de fr.
ctopi
o m
cusq;
i. ñ so
uena

oc opus nrm quod inscribit de doc
trina xpiana . in duo quedã fuerã
prima distributiõe paratus. Nam
post permum quo respondi eis q
hoc erant reph'ensuri. due sunt res
inquam . quib; nirit omis tracta

Plate 42

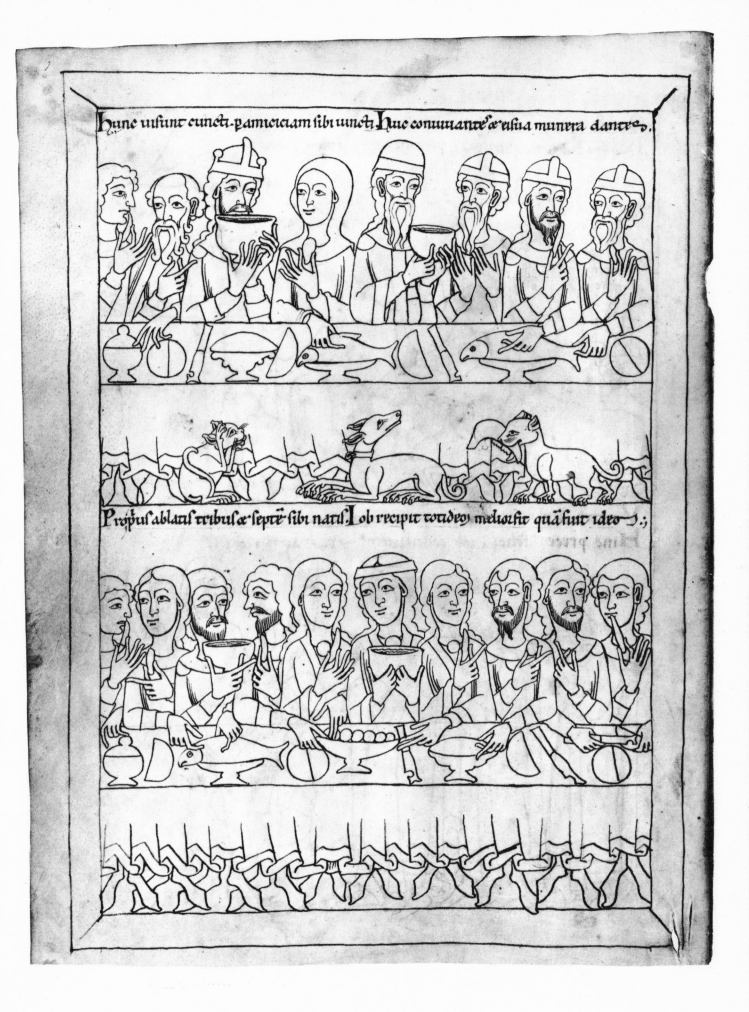

Hunc ursunt cuncti· pariciciam sibi uincti Huic conuiuiance et eisua munera dantes·

Proprius ablatis tribus et septe sibi natis· Iob recipit totideos meliorsit qua siut ideo

Plate 43

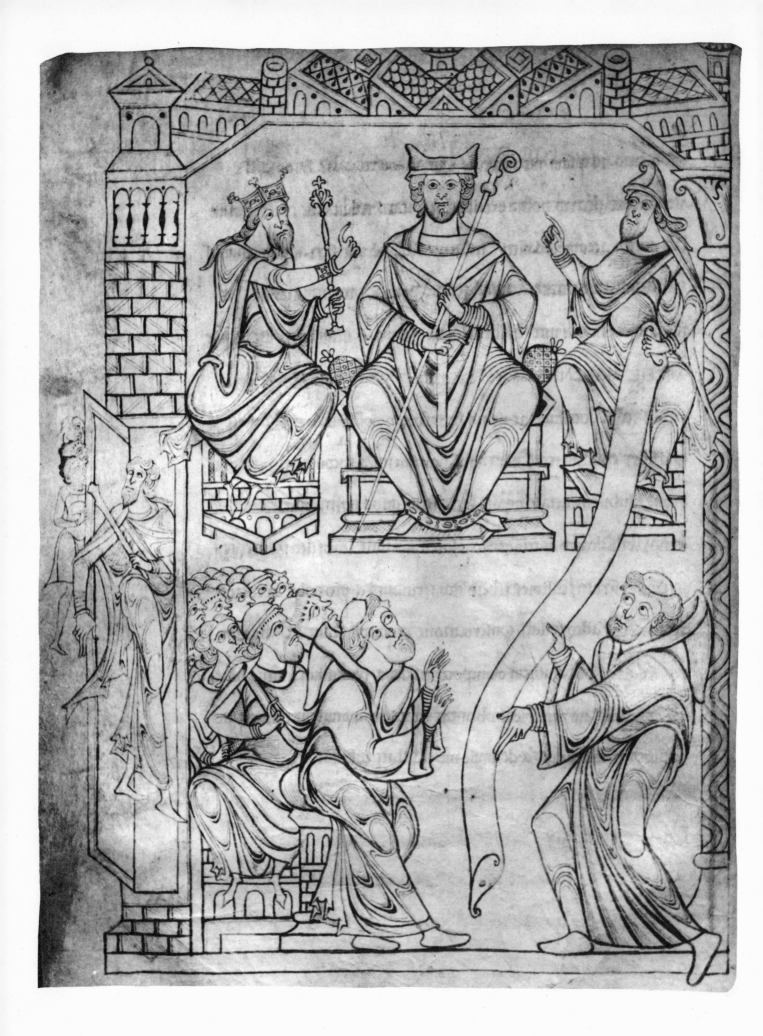

Plate 44

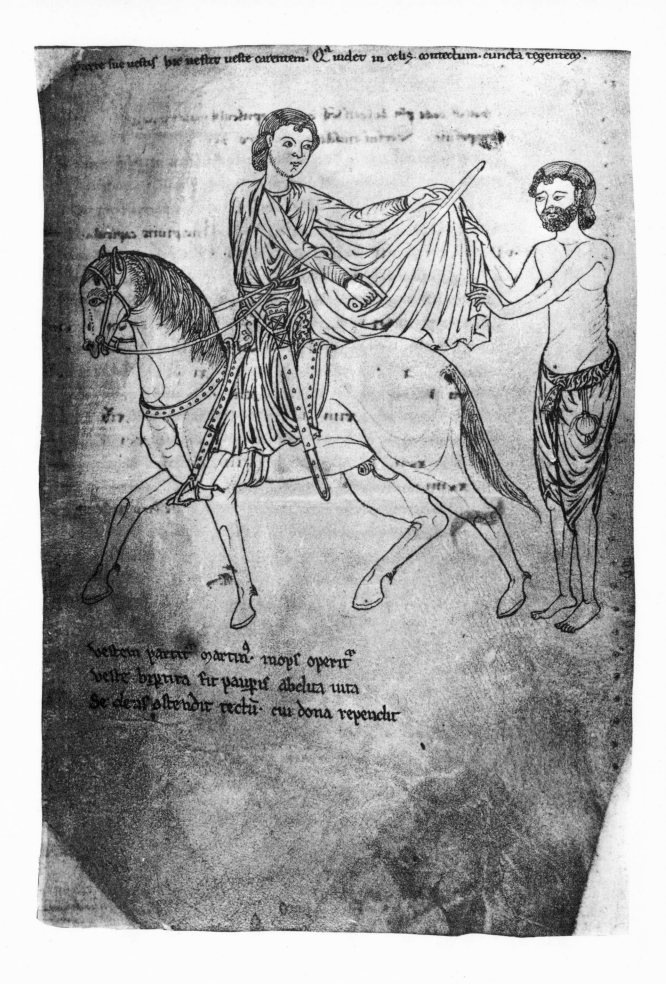

Vestem partit̃ martiñ mops operit̃
Veste brenita fir paupiis abelita uita
Se deus ostendit rectũ cui dona rependitr

Plate 45

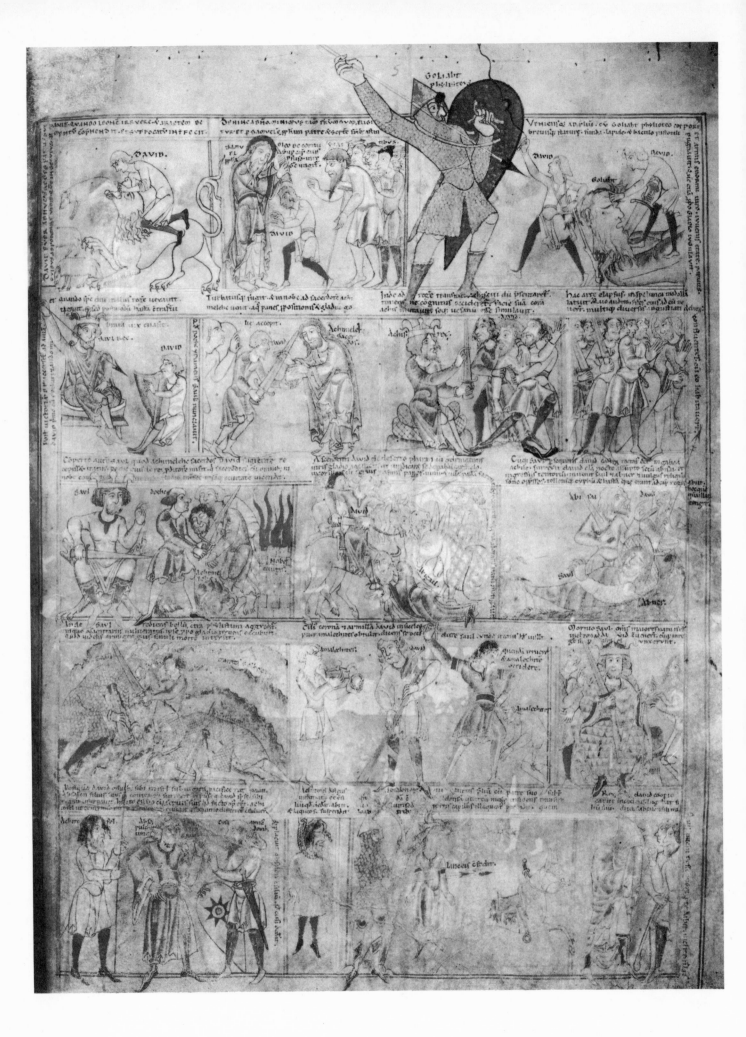

Plate 46

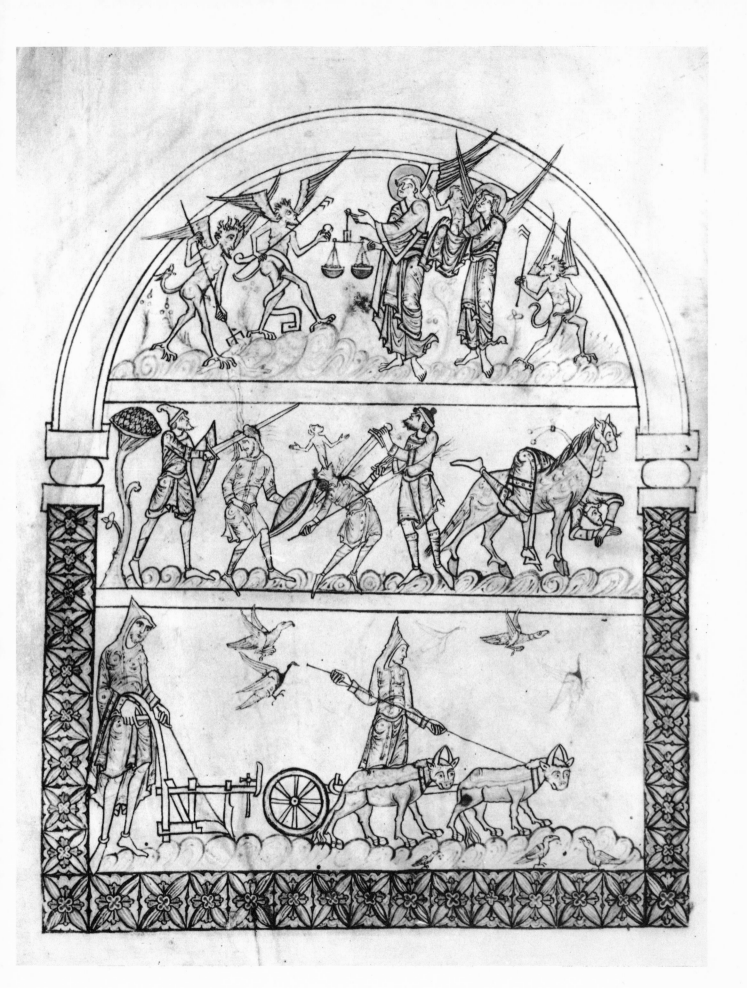

Plate 47

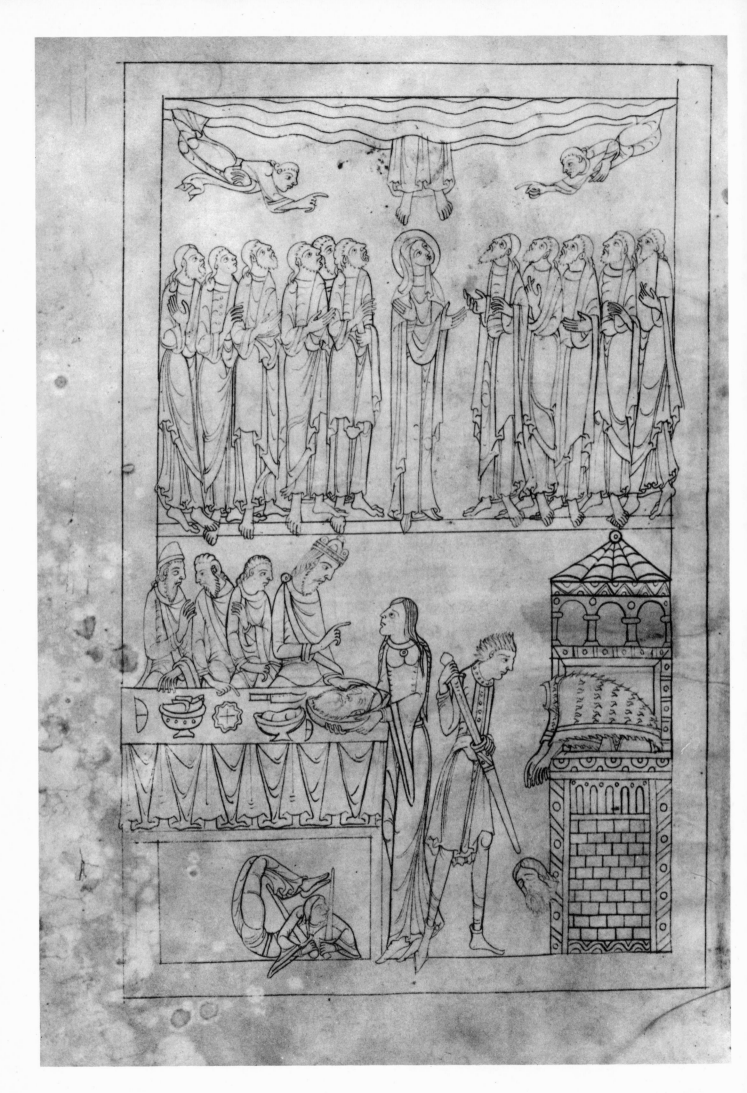

Plate 48

abalnſ uiſa memoriɇ ſcribendo tradidit. Requieſcit ū ſcm cor
puſ beatiſſimi patriſ ioħiſ conſtantinopoli· in ecctia ſcōɹ apłōɹ
reliquiſ ꝑcipue conſecta. cuſ uirtutiſ & doctriɇ totū implent orbɇ tʹa
rū. ꝑſtante dūo nͬo iħu xꝓ. q̃ ꝑſtat oib; ſciſ omē głā & gaudui iɳ ſctā
ſcłōɹ.

Plate 49

Scriptor libri. ueniā precatur

Plate 50

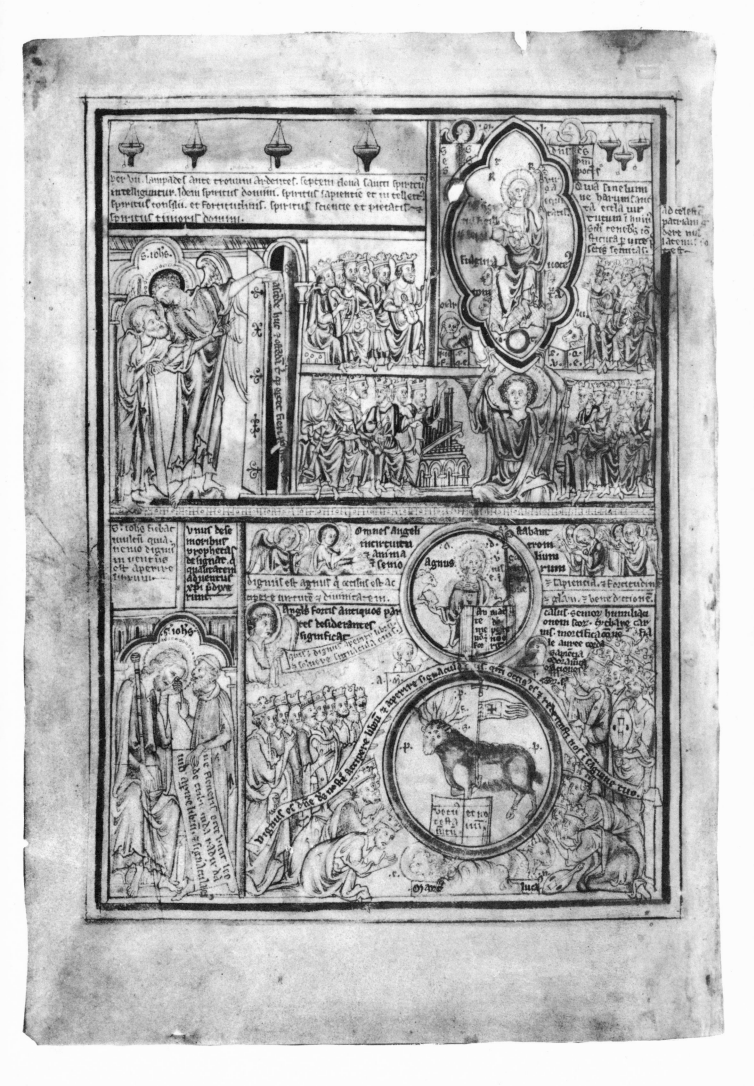

Plate 51

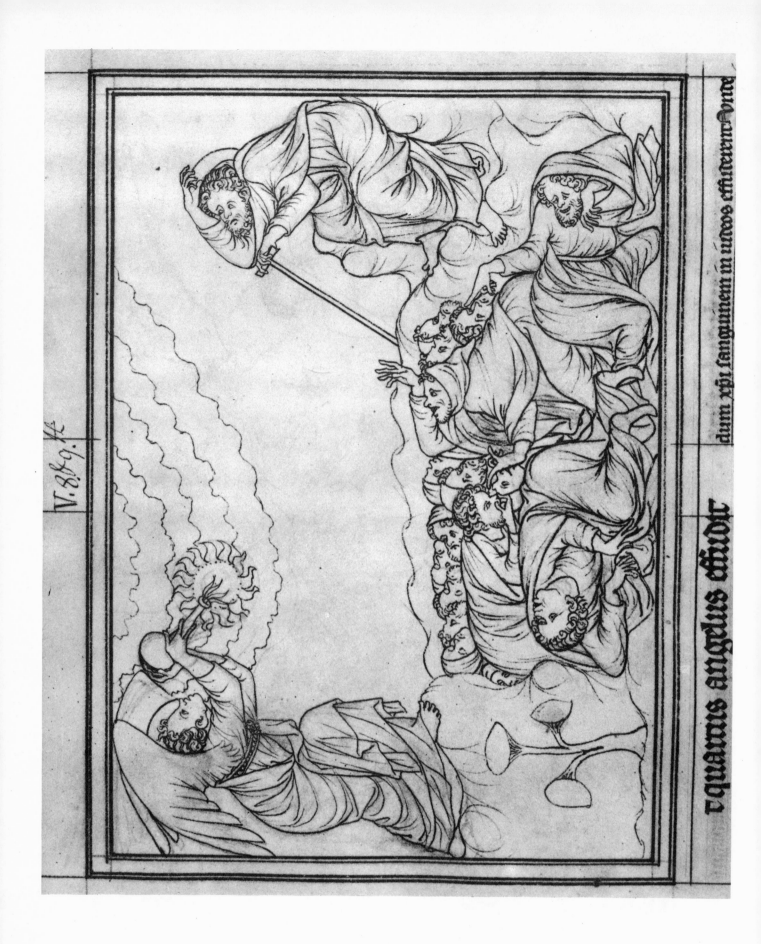

Plate 52

Platè 53

Plate 54

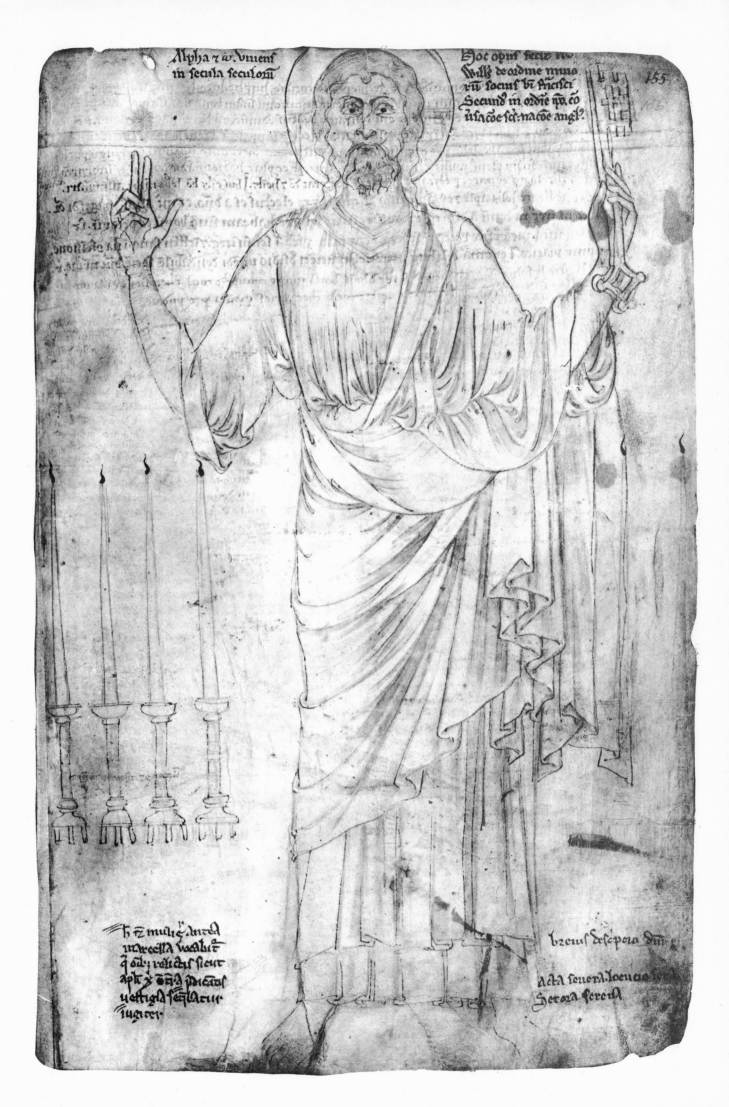

Plate 55

Plate 56

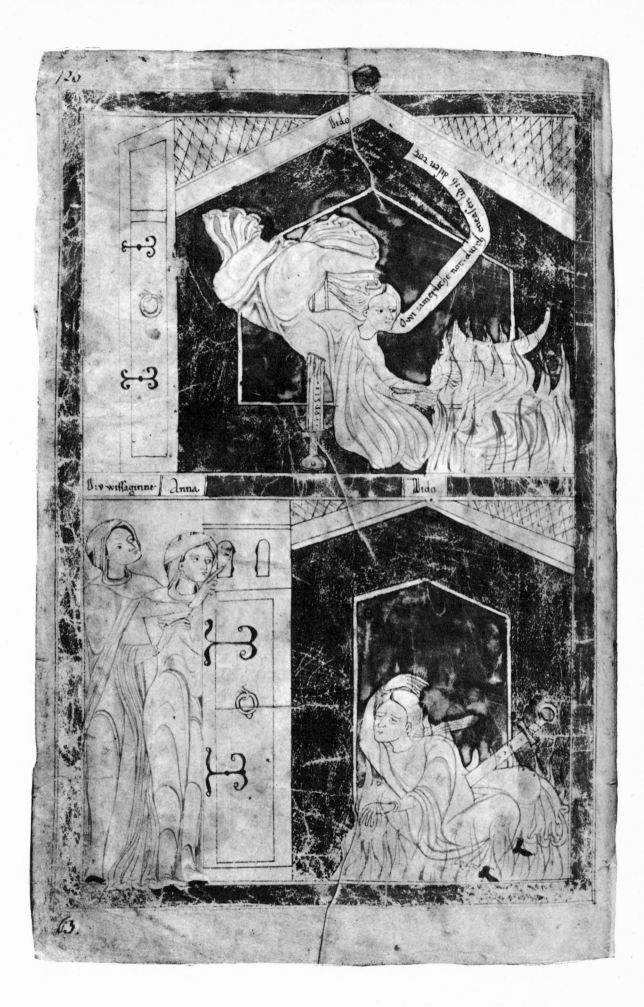

Plate 57

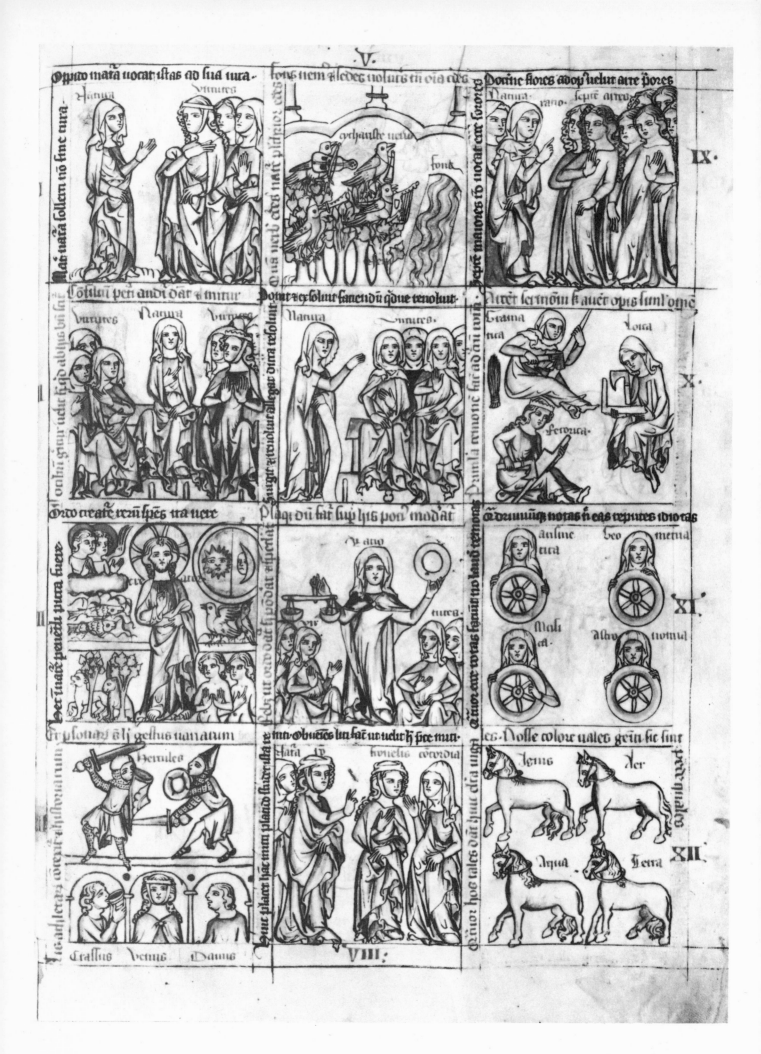

Plate 58

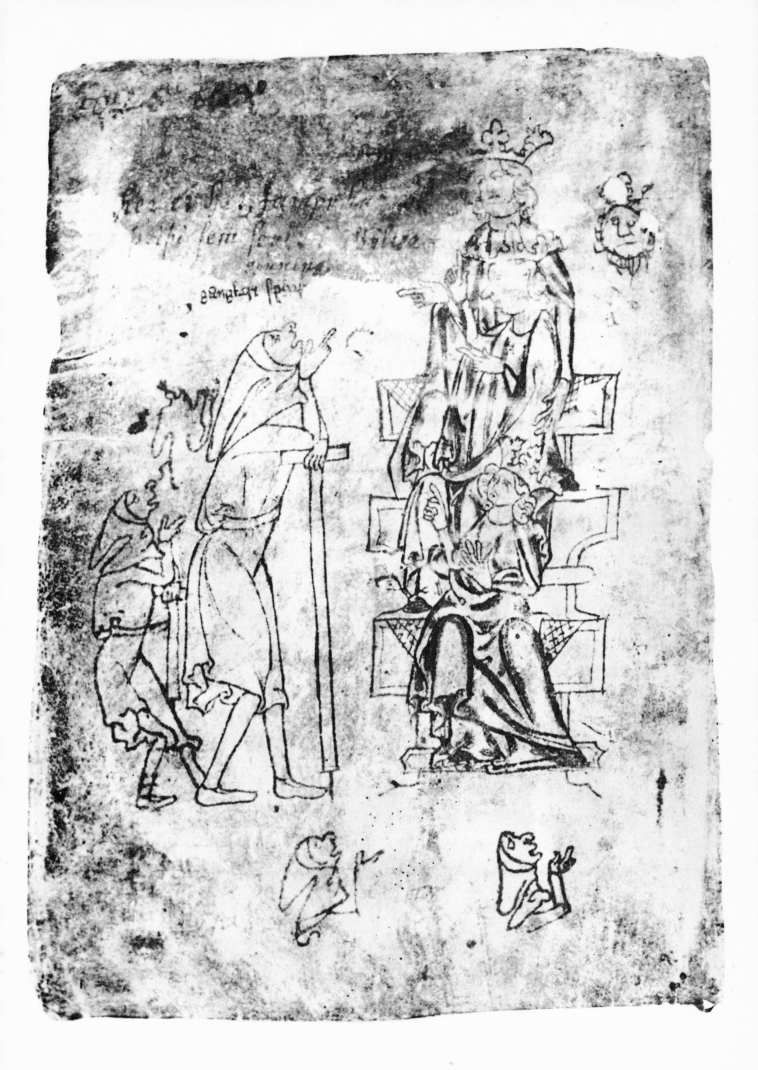

Plate 59

Plate 60

addolofer excumoref genuclu
lotum expedium Incendiatur
sic

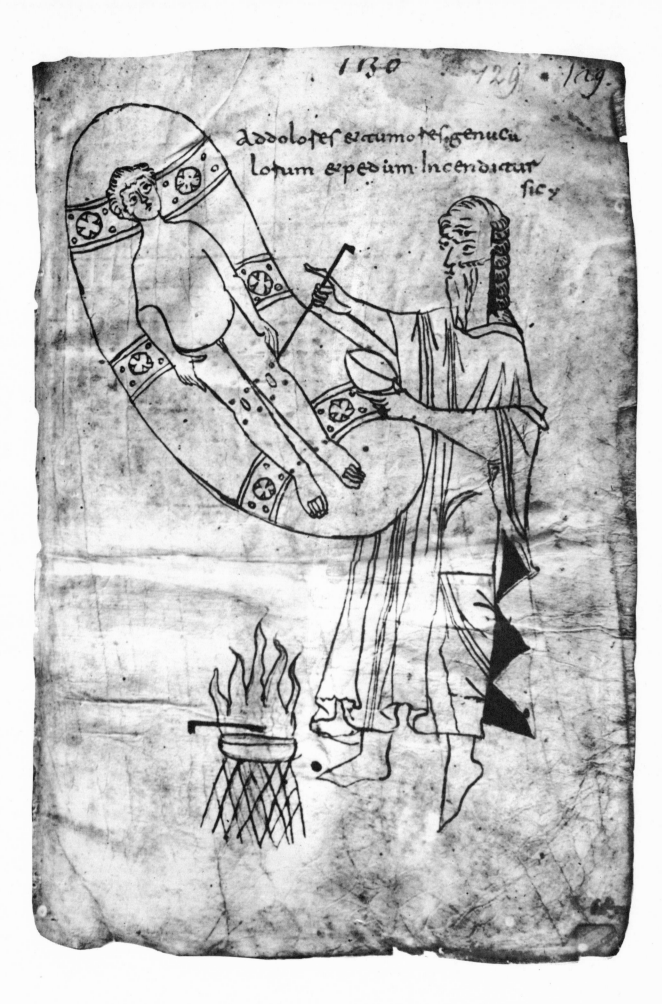

Plate 61

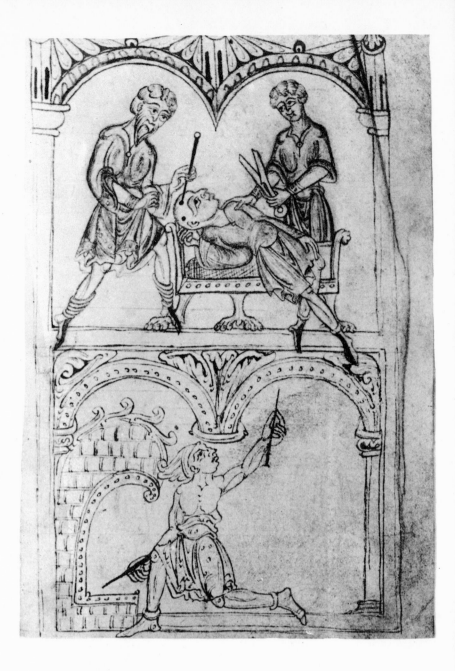

Plate 62

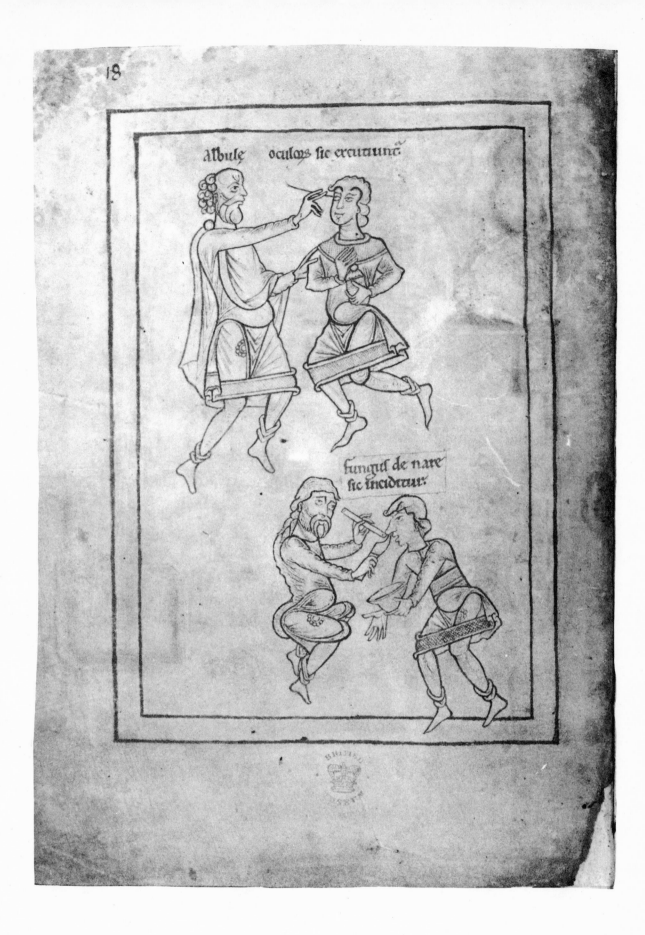

Plate 63

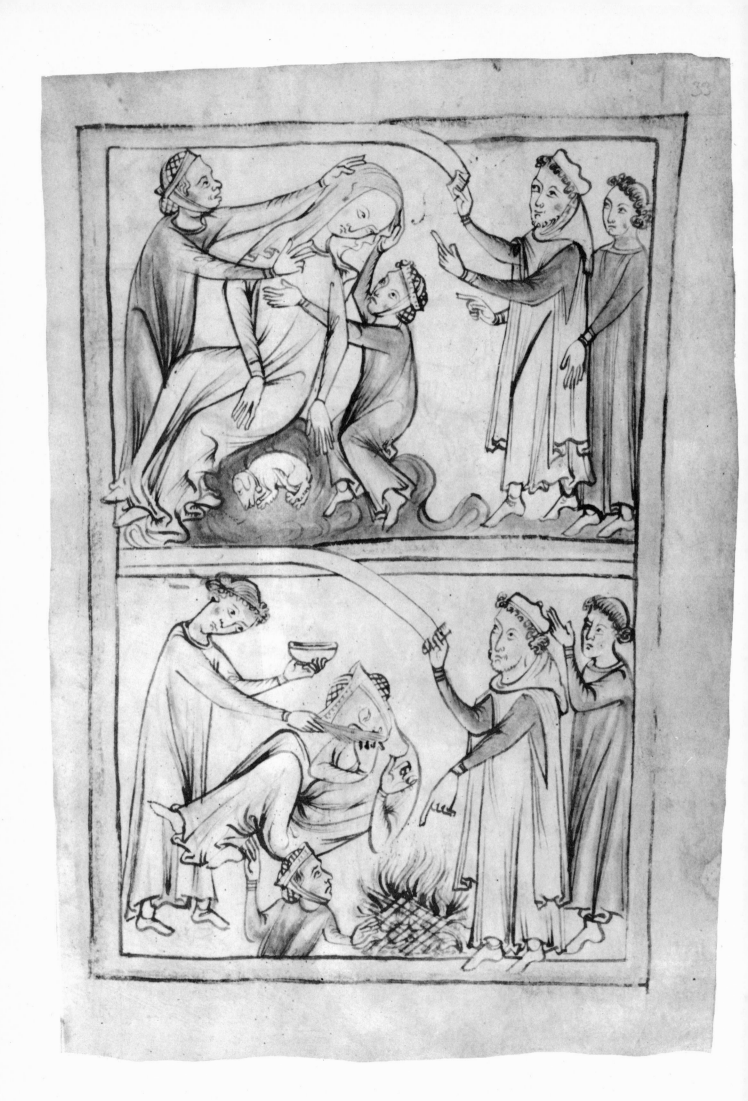

Plate 64

.dbent colocatã. Centauri auté crura dreliquo corpoze dtundit
arcalus qñ lacteus nocat. Hic spectans ad ort signoz:
totus occidit. aquario & piscib? exortis. Orit auté cu scorpioe
& sagittario. Habet auté stellas supra caput .iii. obscuras. In
utrisq; humis singlas claras. In sinistro cubito unã. In manu
.i. In medio pectore equino unã. In pozib? poplitib? sigulas.
Inr scapulas .iii. In uentre duas claras. In cauda .iii. In liubo
equino unã. In genib? ptericeib? singlas. In poplitib? singlas.
Omio sunt .xx.iiii. Hostia auté bõ in cauda stellas duas.
In posteriore pede pmo unã. Inr utrosq; pedes unã. Inter
scaplas unã clara. In pozi anciozis parte pedis unã. Infra
altã. In capite .ui. dispositas. Itaq; sunt .x. Hic dr noie
chiron. satni & physllire fili? eé. qui ñ in cetos centauros

led hoies qq;
uncia spans.
ãsculappzum
& achylle nutri
se castimaé.
Pietate & di
ligencia & esseé:
ut in castra
numeraz.

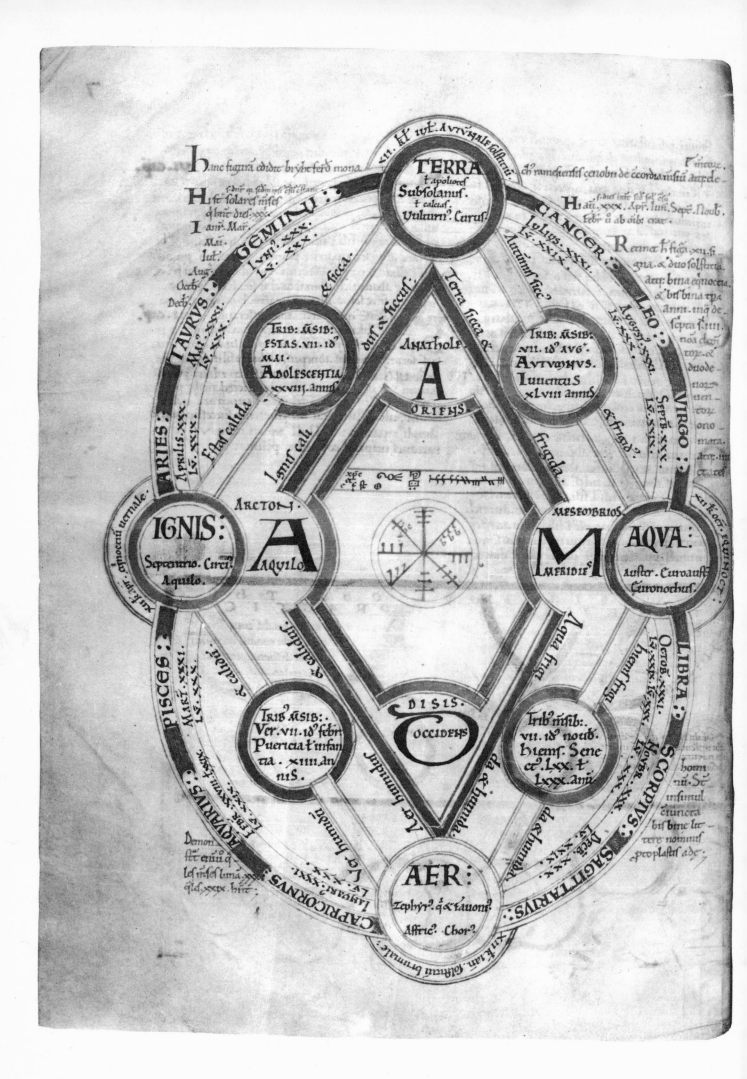

Plate 66

duo latera id est breues, et ab alio id est vltimum latus
id est breue, vnde hic venit dicat. Adhuc quia modum
quod elementa qualitatibus equilata et per partem aliam lon-
gioribus, trinis motum elemento veritate. Ignis
et subtilis acutus mobilis. Terra autem obtusa et immobi-
lis et hebes. Iuxta igitur itaque aer, ex igne treque
benificos qualitatibus, quod sunt et inter iacet ab igne et
mobilis acutus Aqua autem et hebes, vt dicat aer mobi-
lis acutus hebes. Aqua tum quod propter terram suam et iuxta
aerem Aqua obtusa et hebes, ab igne immobilis
vt dicat. Aqua mobilis hebes obtusa licet sic et concor-
di pace hec quattuor elementa sine mutuo repugnantia
benignus ligauit elementa, vt subiectum subiecta
docet de cetero in presenti o;

obtusa	obtusa	obtusa	subtilis
hebes	hebes	acut	acut
mobilis	mobilis	mobilis	mobilis
TERRA	AQVA	AER	IGNIS

TERRA AEQVILA TERRA CONTRA IGNI

Plate 68

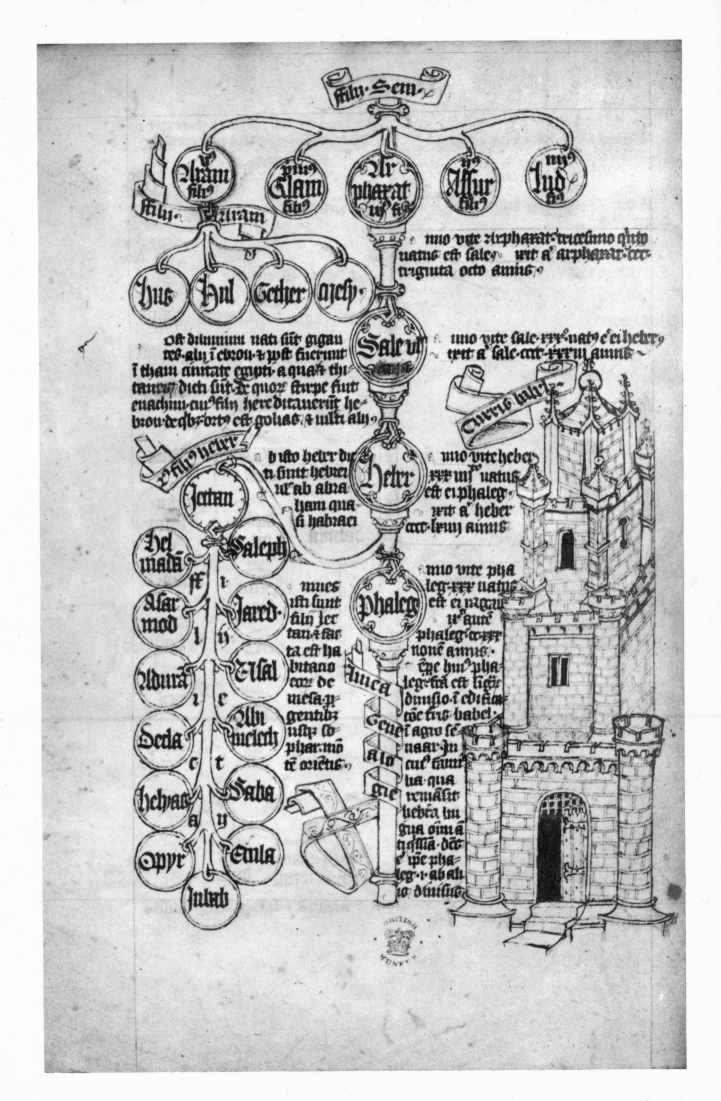

Plate 69

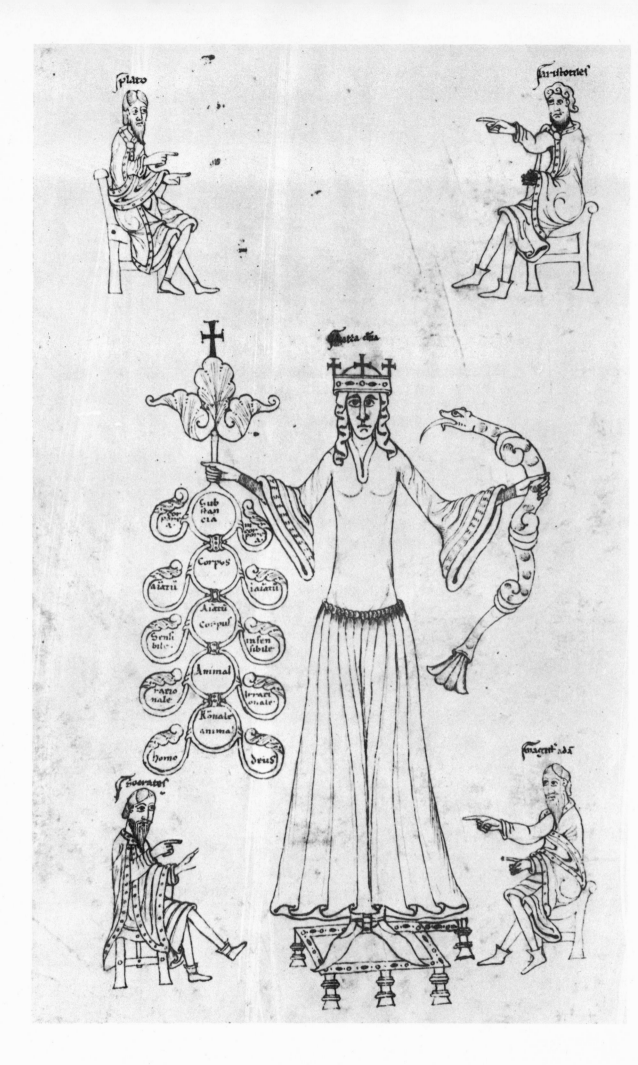

Plate 70

Plate 71

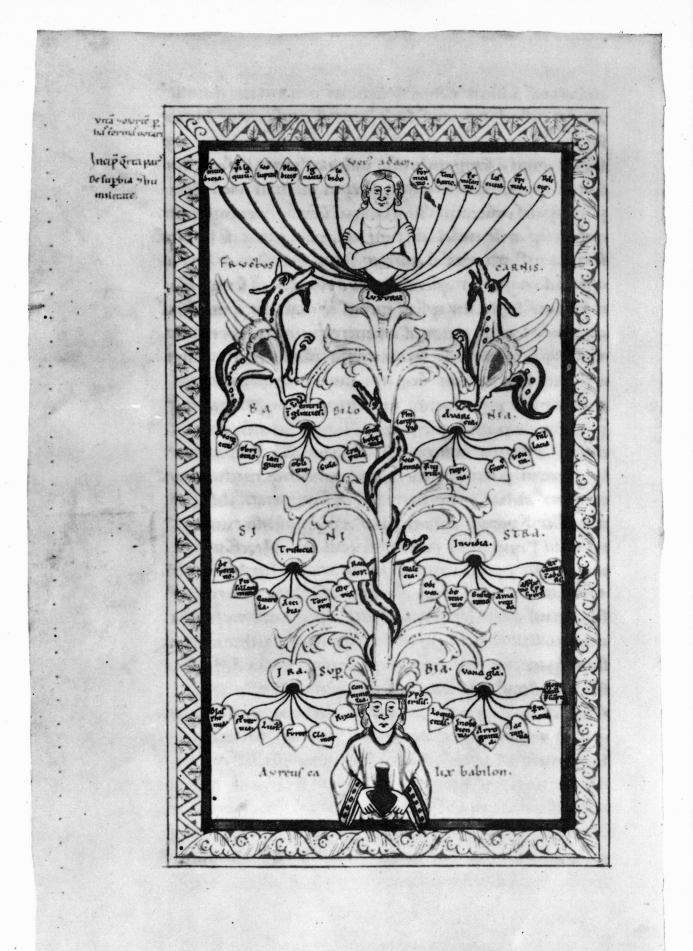

Plate 72

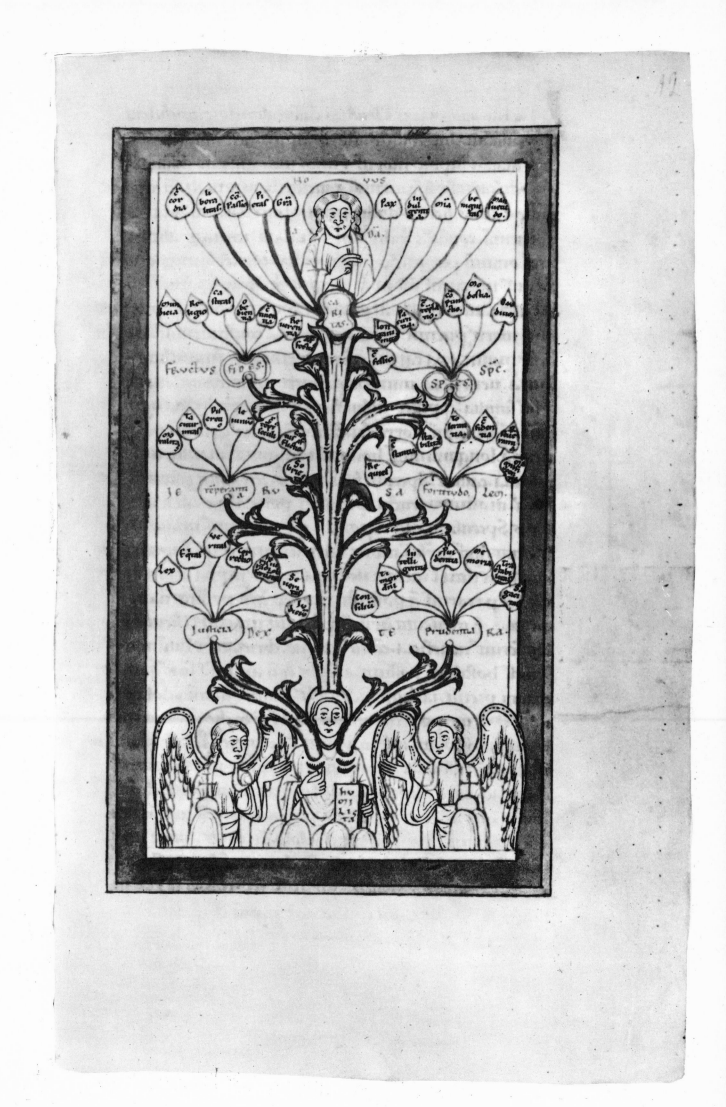

Plate 73

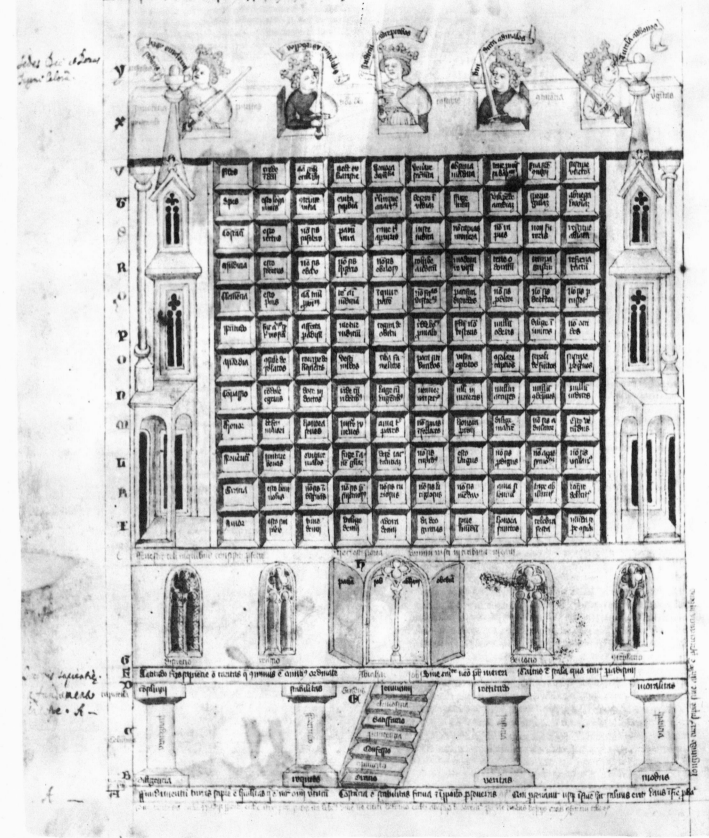

Plate 74

Plate 75

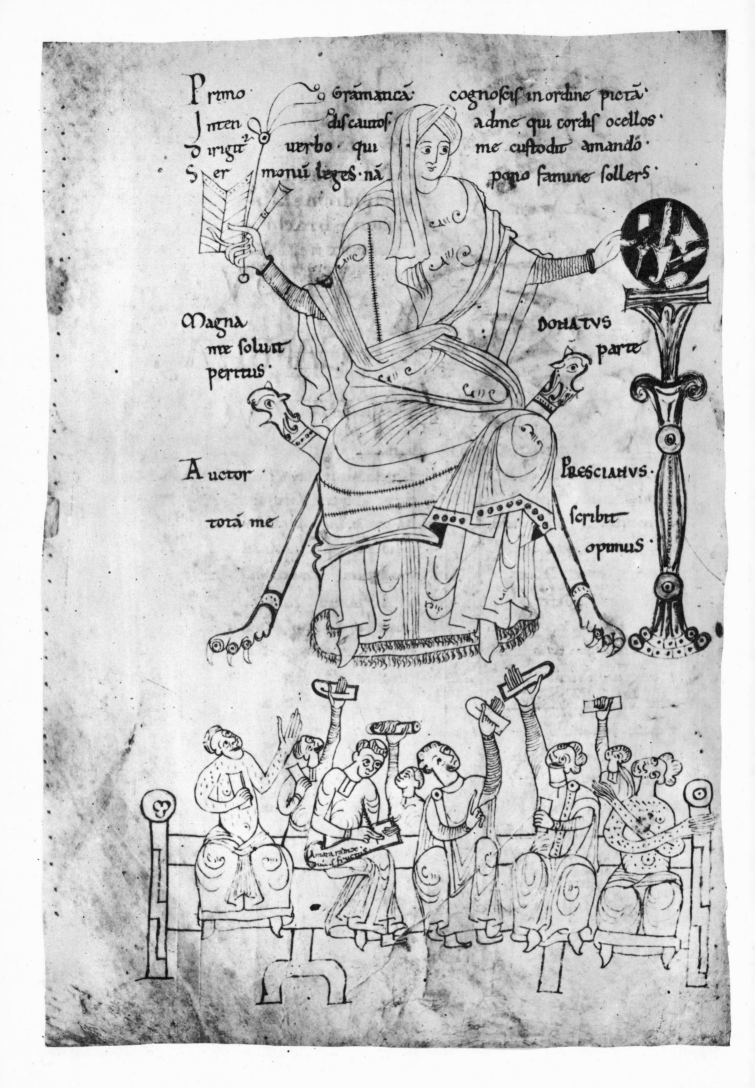

Plate 76

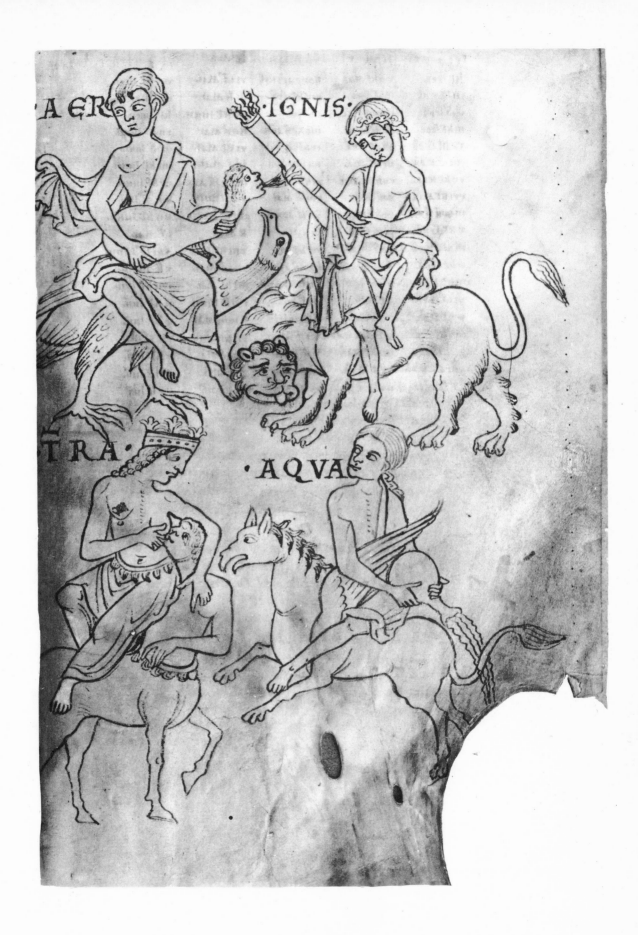

Plate 77

& ut baptizatum lunat prbr̄: & ꝯstituit ut nullus sue crimen clerici eo
audeat inferri �5 dalmaticis ingeclia uti. & ut palliolis leua eoꝝ tegeret
scilicet diaconos: �5 statuit ut nullꝰ clericus ꝓpr causam qualibet incurꝛ
utroueret nec ante iudicē causā eiceretur ñ ingeclia tam lulu ꝓp tempore
ꝛsummat ꝛ altaris sacrificiū in sindone linea celebrare. Senonas f. cohibe
v̄. quē superato igne gladio cesi ē. Item Senonas beatoꝝ Sabini ꝛ Po
tentiam. qui abecis aplis adꝓdicandu ꝯuerti ꝓfatā urbem mri ꝥ sui
confessione illustrem F̄ f̄

Plate 78

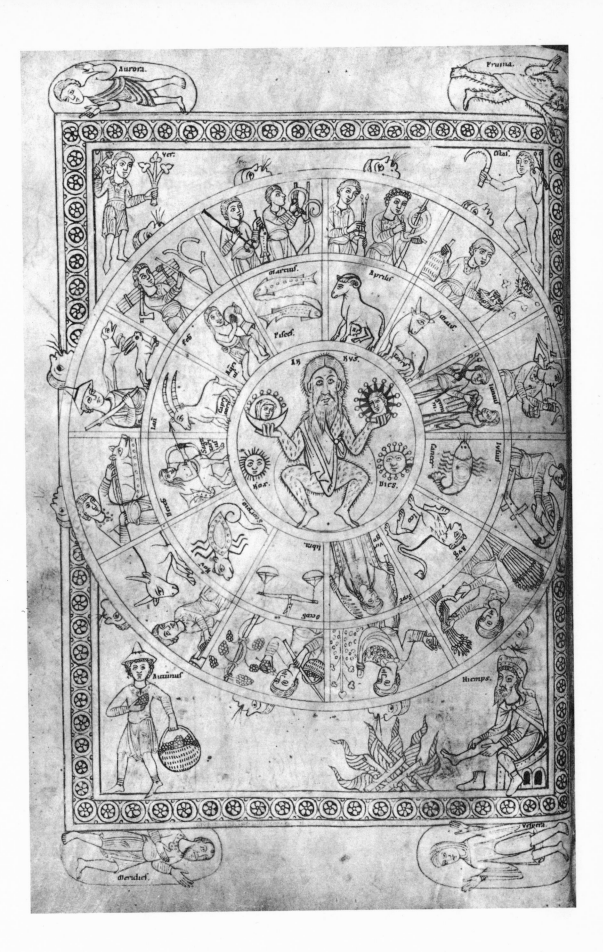

Plate 79

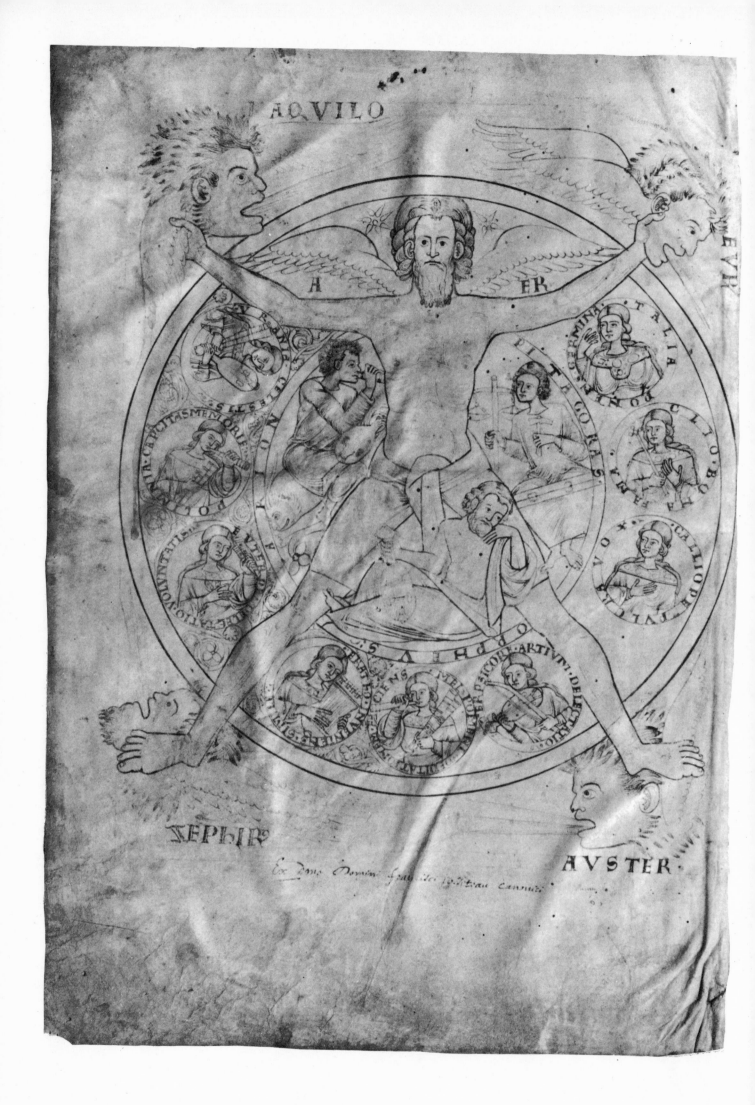

Plate 80

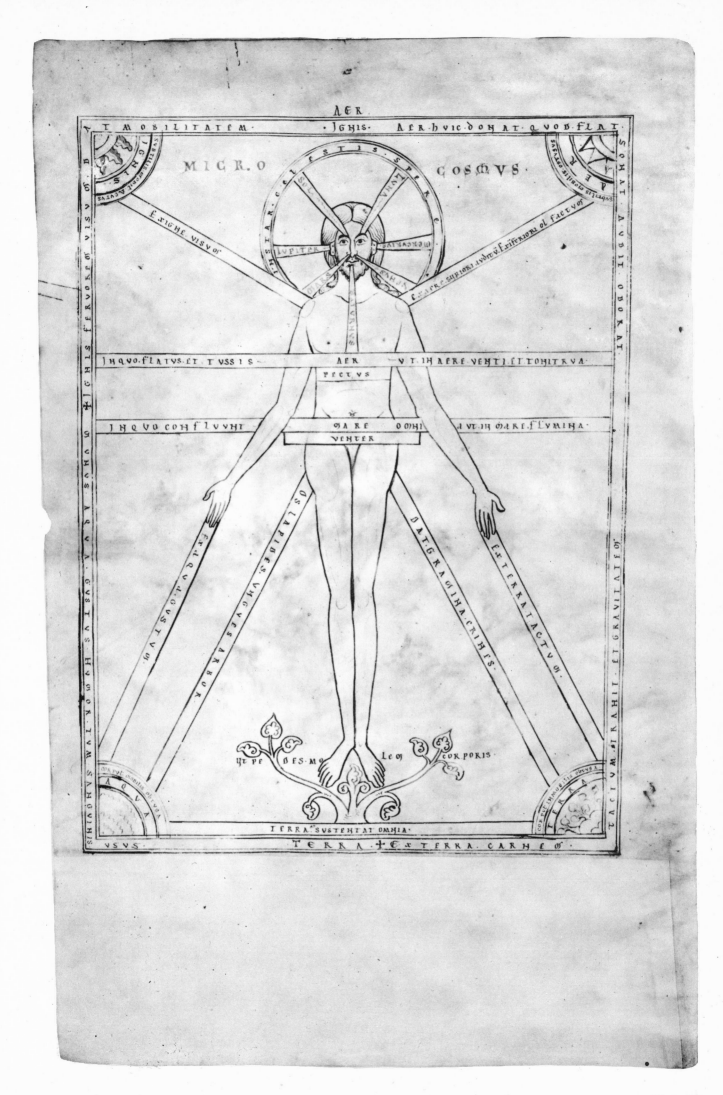

Plate 81

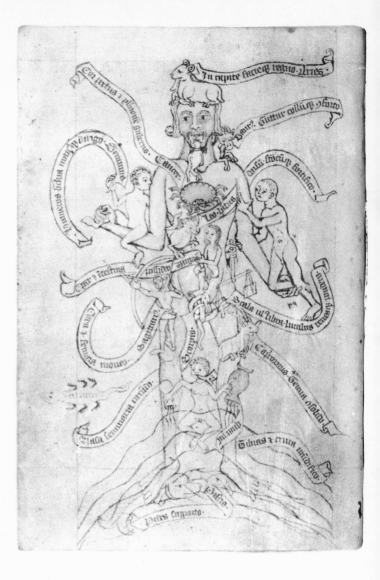

Plate 82

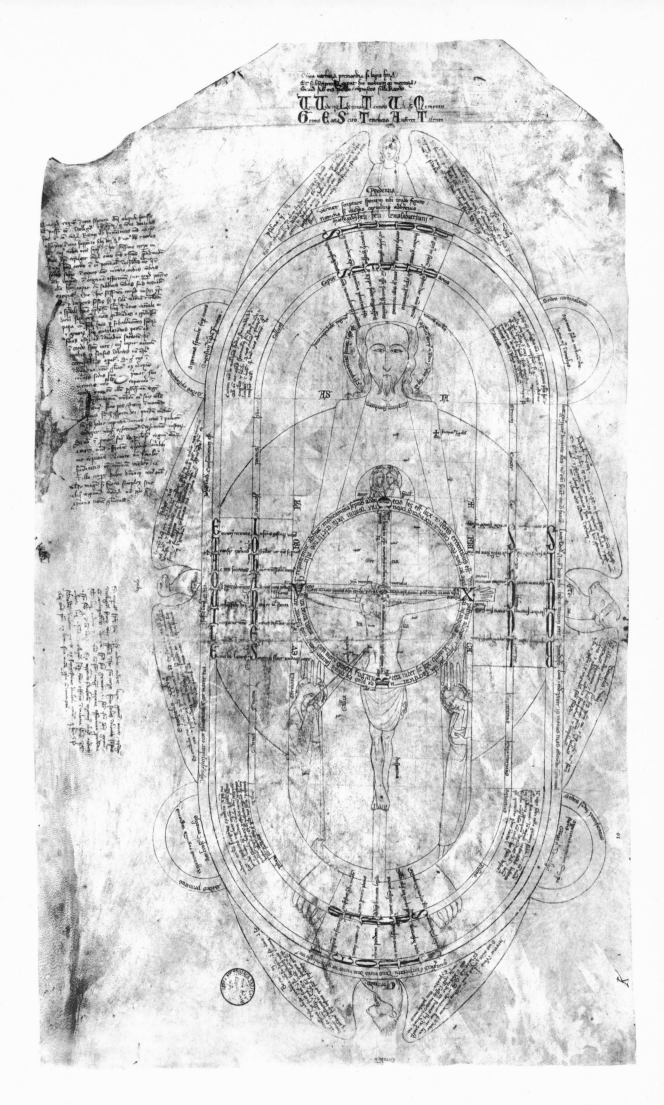

Plate 83

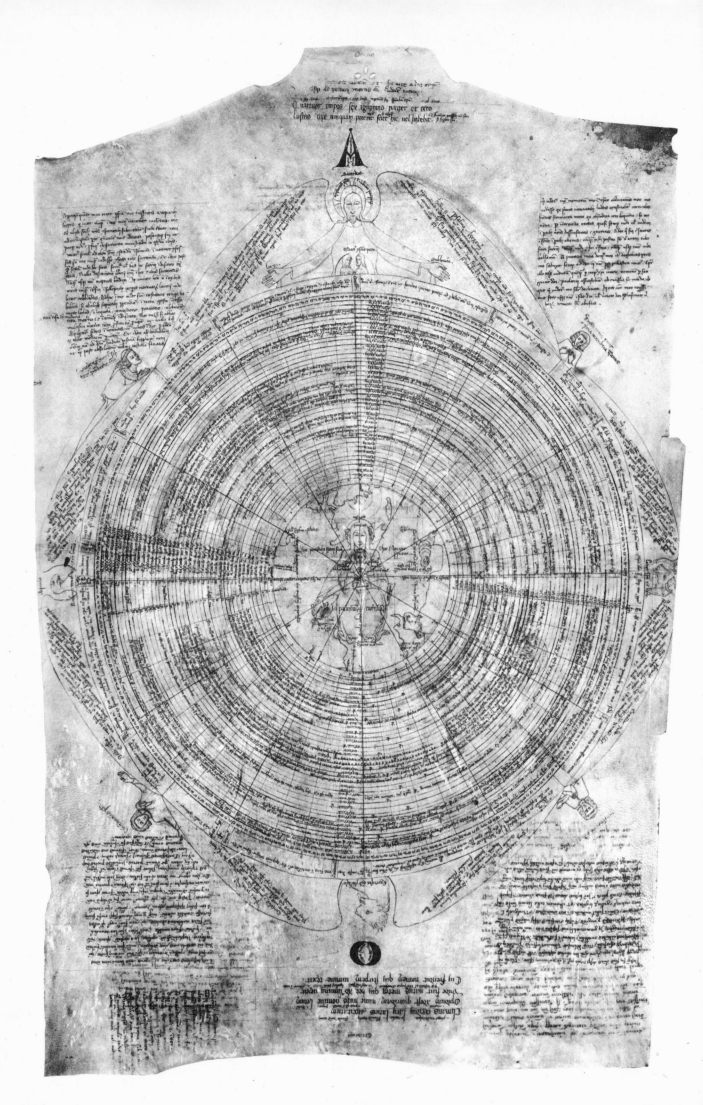

Plate 84

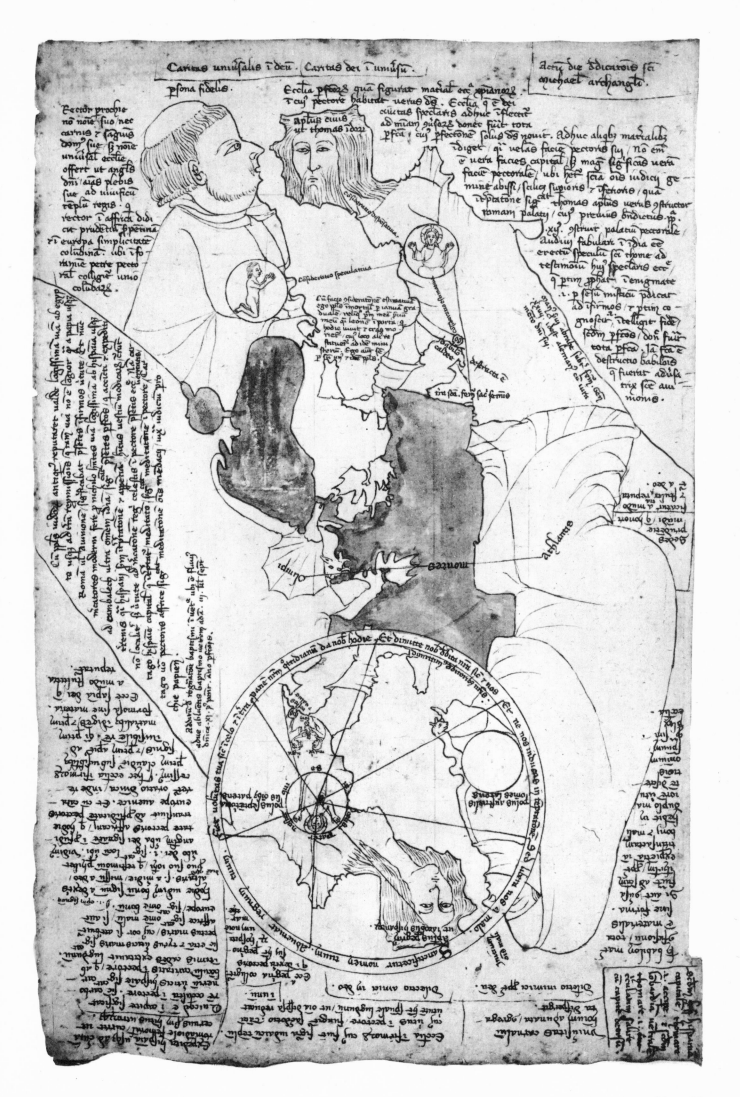

Plate 85

Plate 86

Plate 87

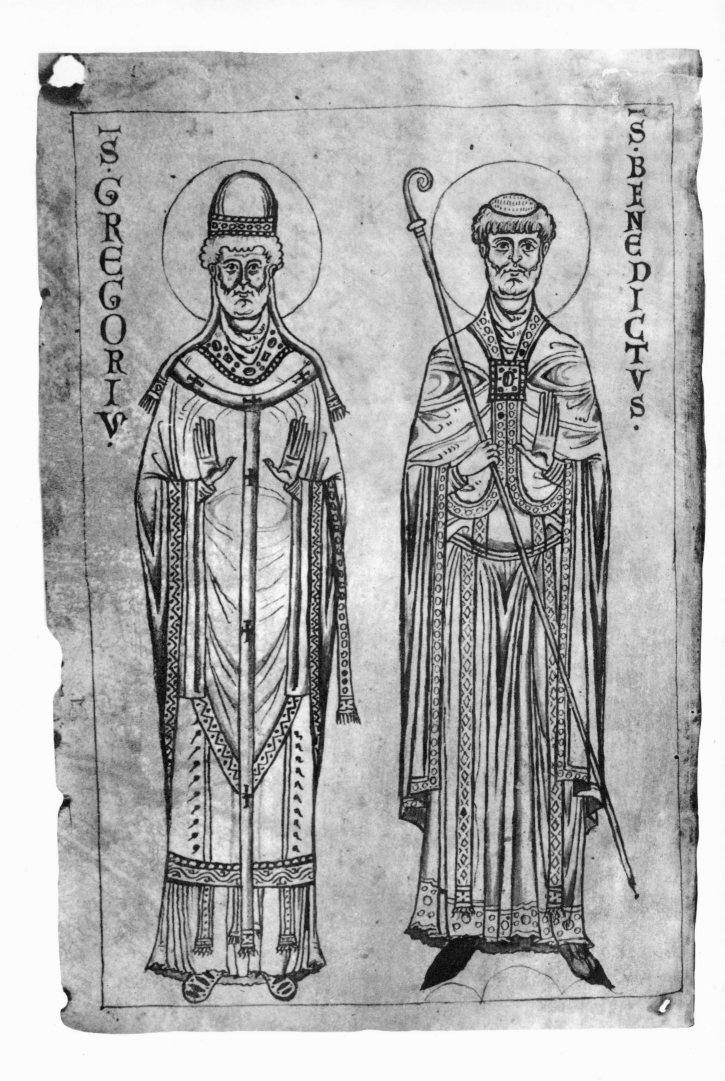

Plate 88

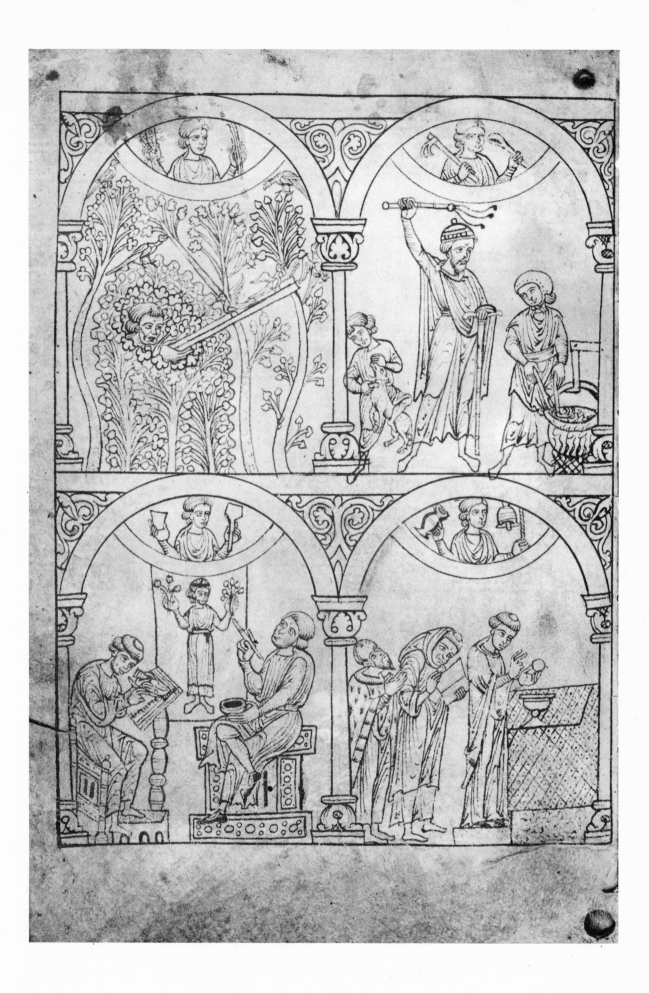

Plate 89

Plate 90

Plate 91

n° 299

DESCENDIT AD INFERNA :HELIAS:

:SANSON:

DIVISIT PALIVM SVV HELISEO :HELISEV:

ANGELVS :IONAS:EXIT:DE:

VENTRE CETI:

LISARADINS DIT AVBARONS PRIS A NEGITE

TERCIA DIE RESVRREXIT AMORTVIS ASCENDIT AD CELO

RESVSCITATO LE VNGVLI

DAVID

Plate 92

Plate 93

De tel maniere fu li sepouture d'un
sarrazin q̃ io ui une fois

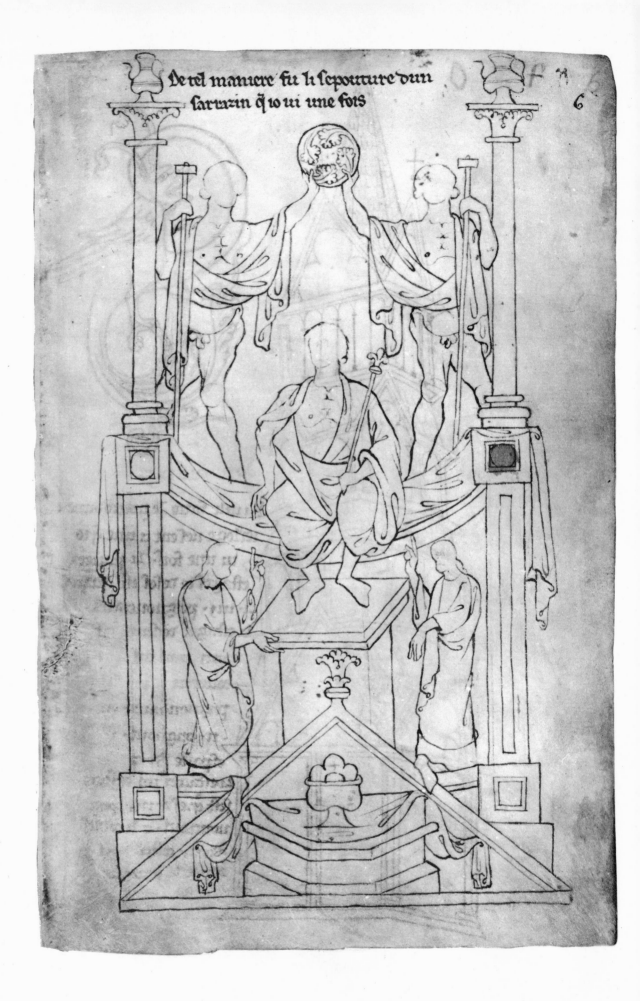

Plate 94

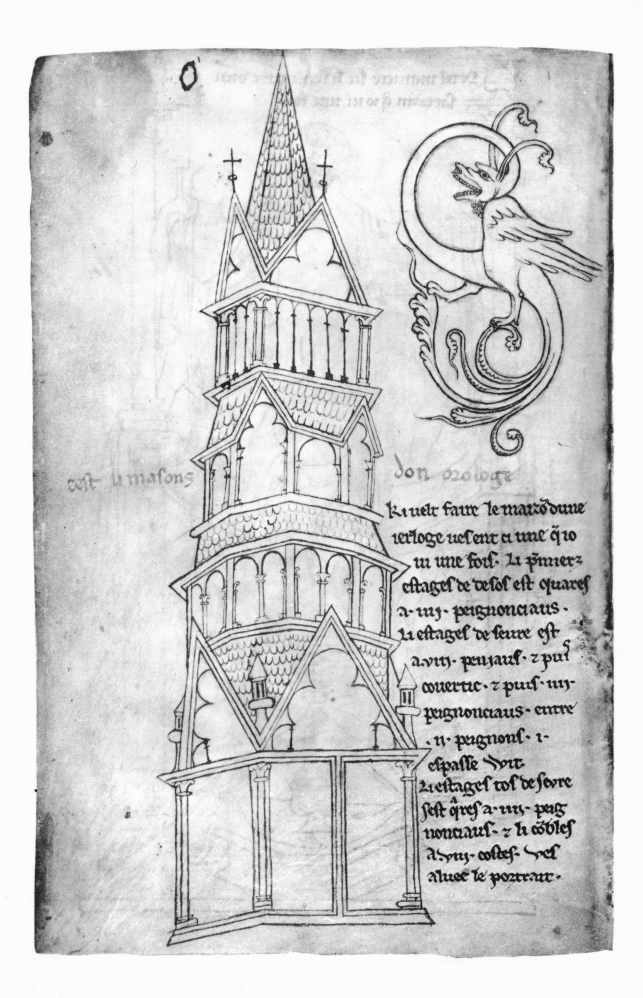

cest li maſons

don oꝛologe

Ki uelt faire le maꝯ dune
ꝰloge uesent a une q̇ io
m une ſoiſ. Li pꝰmierz
estageſ de deſoſ est q̇uareſ
a·iiij· peꝛgnonciaus·
li estageſ de ſeure est
a·viij· penꝛauſ· ⁊ puſ
couertte· ⁊ puiſ·iiij·
peꝛgnonciauſ· entre
·ij· peꝛgnonſ· ⁊·
eſpaſſe ſoit
li estageſ toſ de ſeure
ſeſt q̇reſ a·iiij· peꝛg
nonciauſ· ⁊ li cōbleſ
a·viij· coſteſ· veſ
aluec le poꝛtrait·

Plate 95

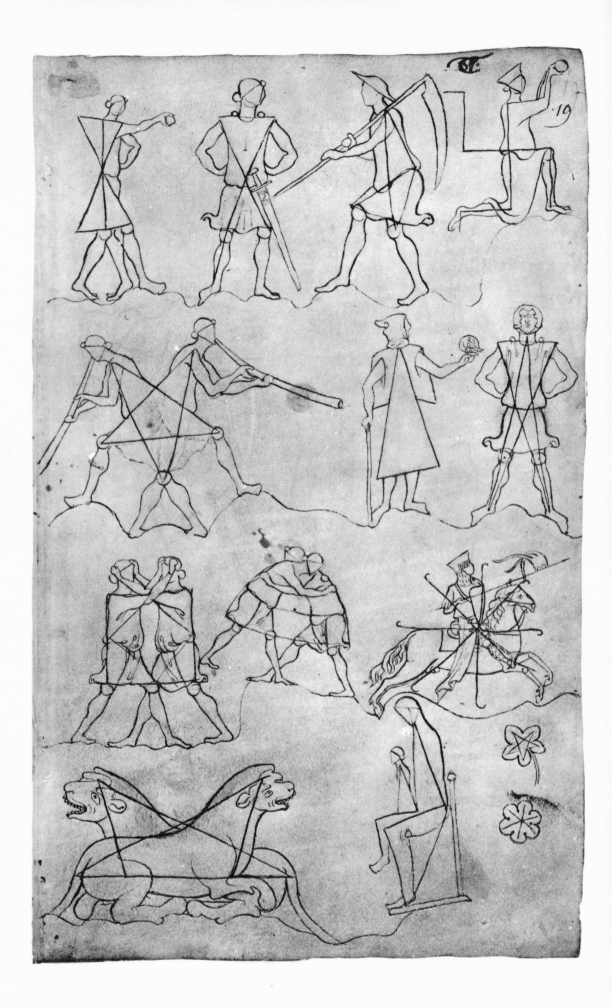

Plate 96

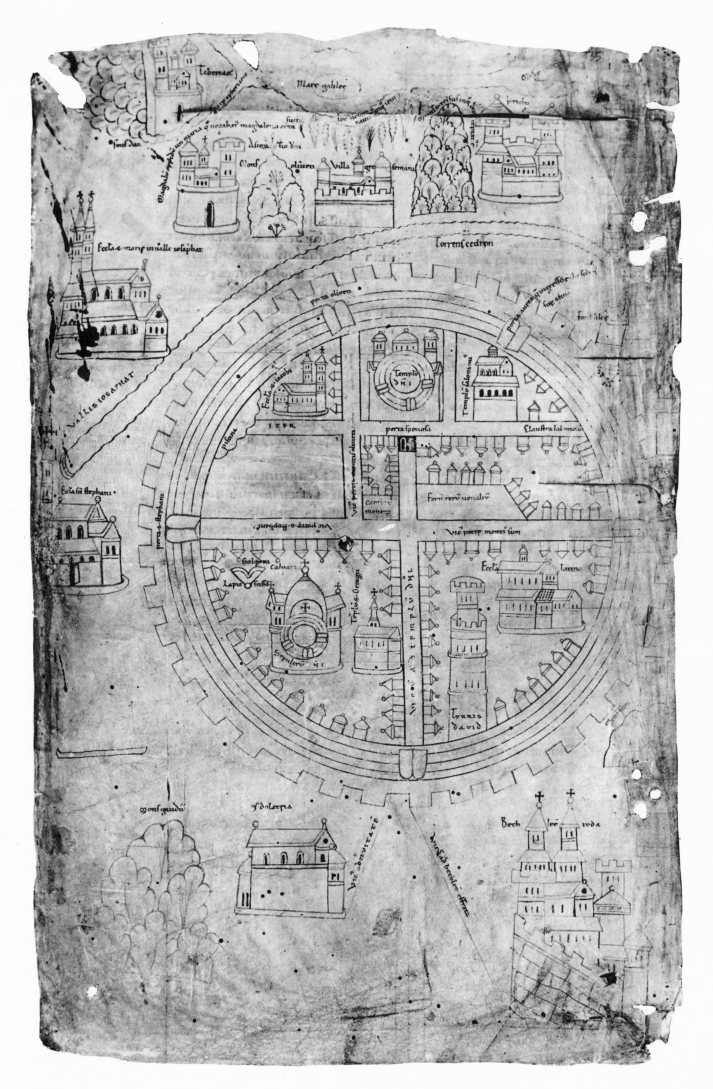

Plate 97

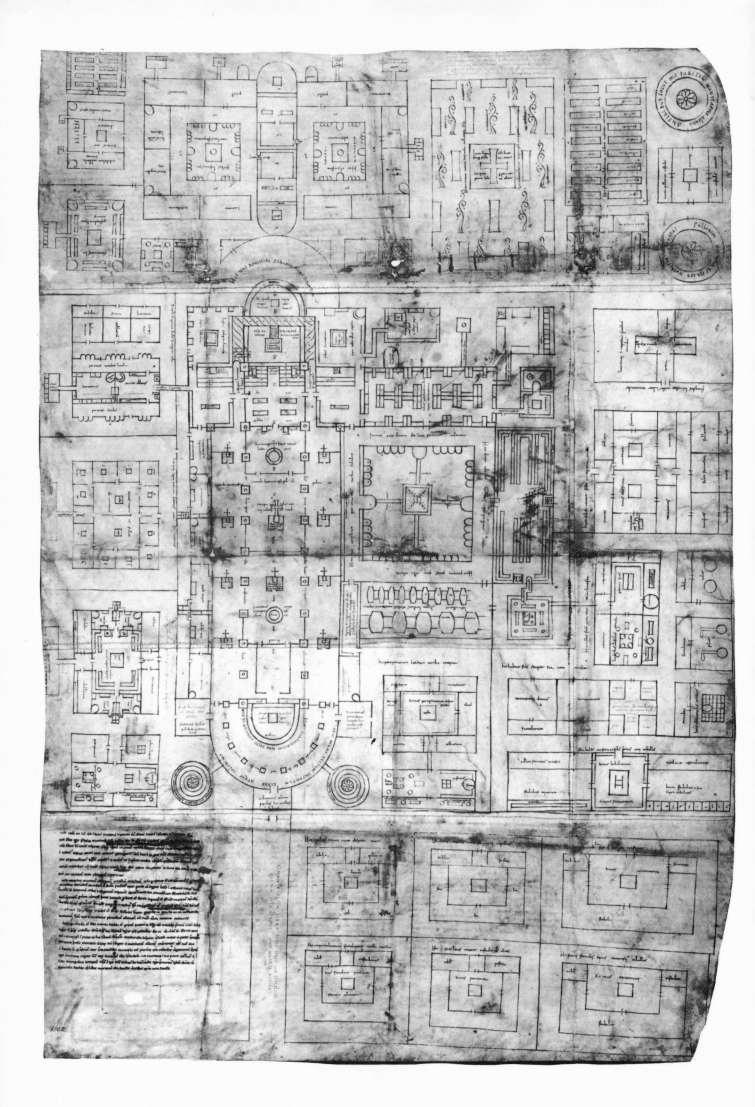

Plate 98

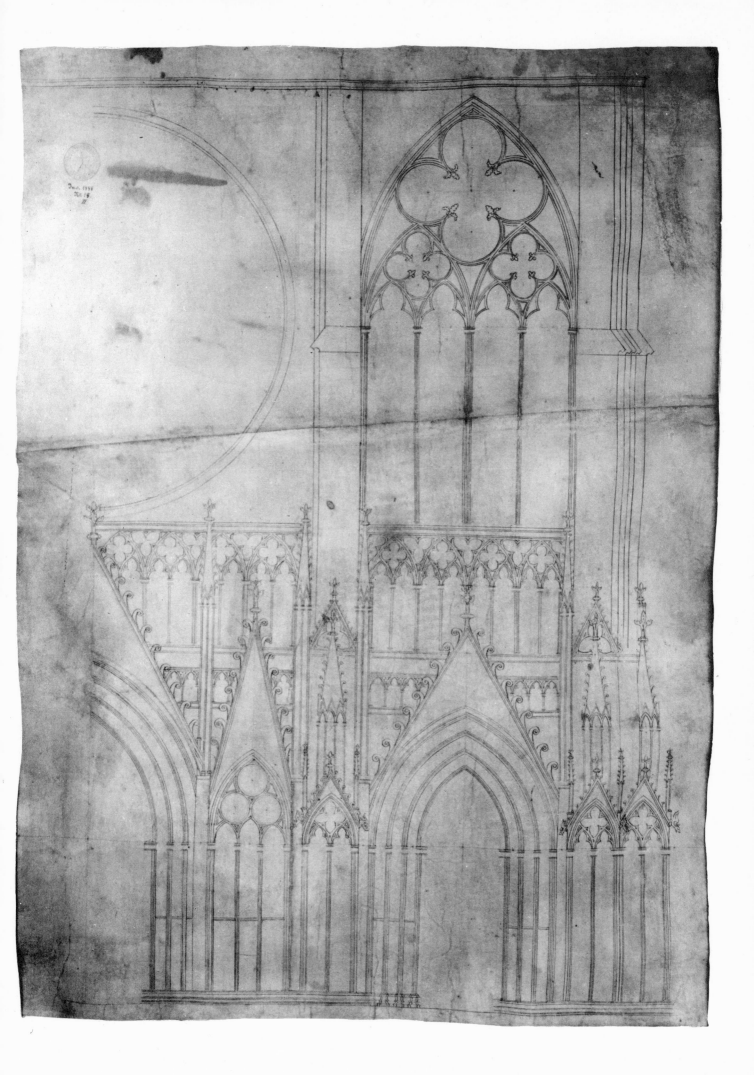

Plate 99

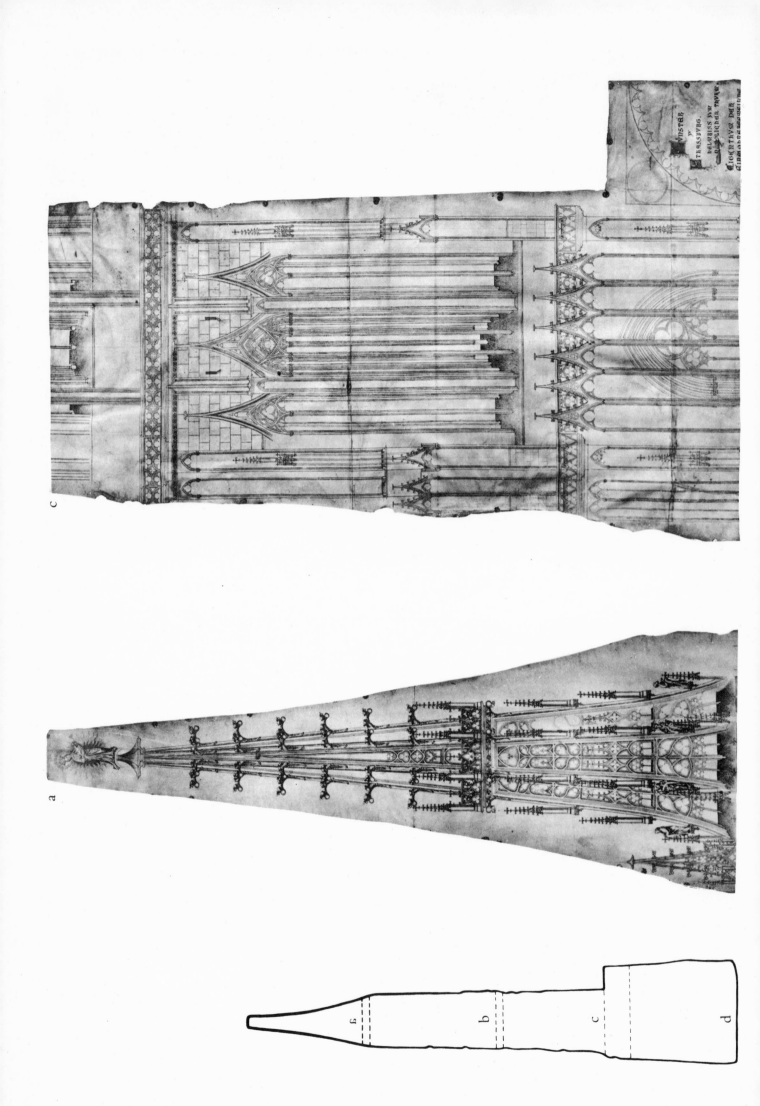

Plate 100

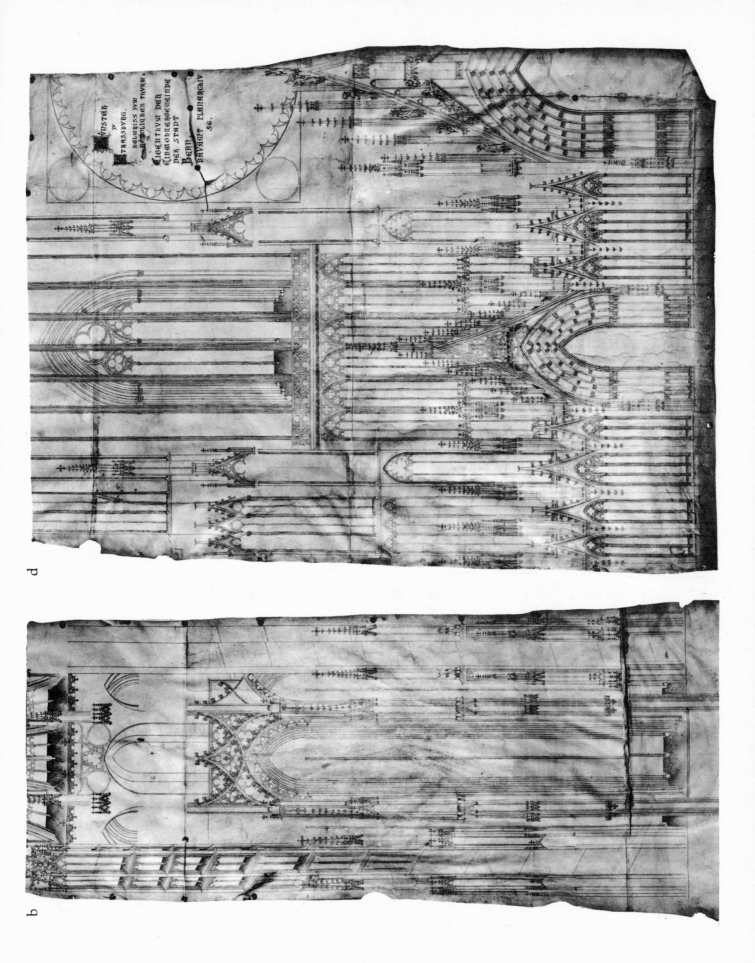

a

b

Plate 101

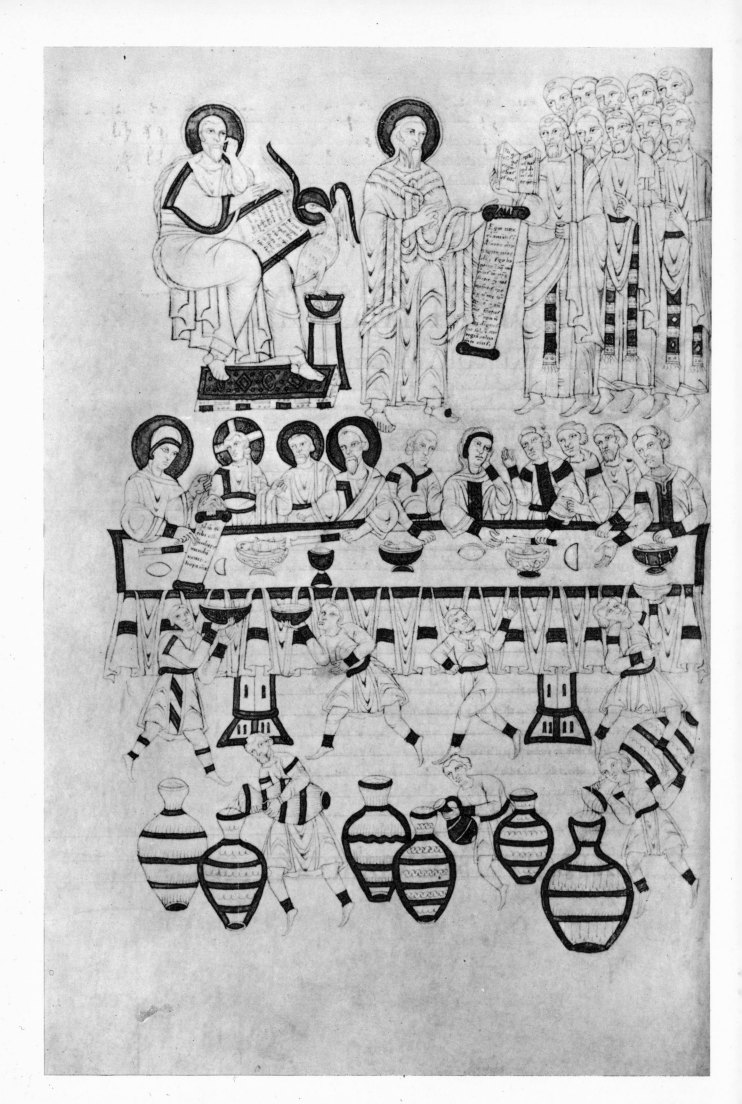

Plate 102

NTIVS SCI EVGLII
SECVMDV IOHM

Plate 103

Plate 104

Plate 105

. In mensa sedet .

Septe elcōnes eligūt. henr̄. cōitē lützill' ī rege tō̄ c̄fūk. xxvij.

die nouēc̄s .

Plate 106

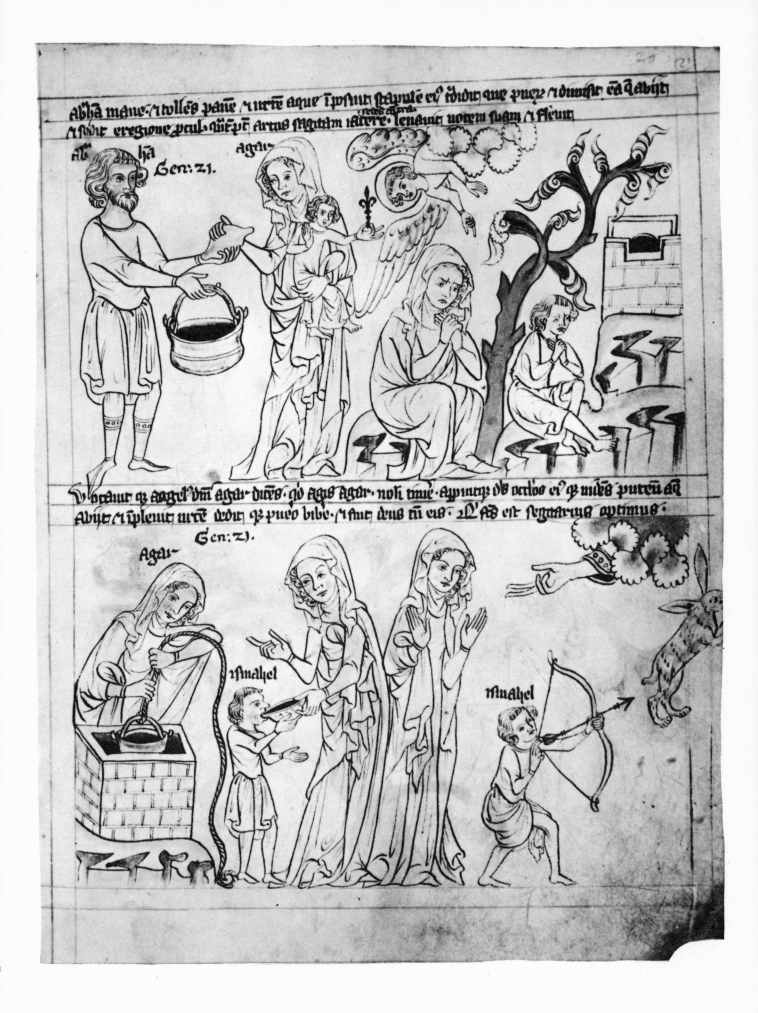

Plate 107

Plate 108

In dien daghe dat god sciep hemel en elke sprute of stote des ackers eer sy rees inder eerde en eer sy groeyde alle dat cruut des lantscaps. Wāt en reghede nyt vā bouen of opter eerde. En gheen mēsche en was die die eerde wōkē of wōnen soude. Ajer een fonteyne quā opter eerde en vsceede al tbouēste d'eerde. Dus formierde die hē god den mēsche vandē lijme der eerden Enhir blies oec in

syn aensichte den adem des leuens. En die mēsche wert gemaect in leuender zielen Dus Text Cap. ij. ware volmaect hemel en eerde. En het wert vol naect idē sesten daghe En dat is dat eerste volmaecte ghetal. Om dattet vgaderē mach vā drien deelen die enē veel hebbē. En god voldede sij werr idē seuendē daghe. Dan der letter heeft idē seste dage En so en isser gheen donkerst' Is vstaen ajer die hebreeusche letter heeft idē seulden daghe

En tis waer god maecte dē seuendē dach oec en benedide En daer na ruste hi of voldede sij werc. dats hi toender dat tet voldaen was. nochtā en maecte hy nyt i desen dage En doe ruste hi vā sinē moeynē werc. Wāt daer na en maecte god nyt. hi en had die matery doe daer of ghemaect als die lychamē. Of die gelikenis als die ziele. Want al seyt die tert dat god rustede dat en salmē nyt vstaen dattet vā moethedē was. Want hi hilt op als ysayas seyt dattie seraphine nyt en haddē ruste seyzzē. Sanctus. Gerūs. Gcs Dats sy en hilde nyt op. Dat die tert seyt hi ruste vā alle wlze dat hi beret had. daer in is ons bewijst datter een werc was dat hi noch nyt volmaect en had daer hi nyt af en ruste. Wāt god had drie wkē gemaect. Hy sciep. Hy ond'sceede. en hi vcierde. ajer tvierde wert d' geboerten daer af en cesseerde hi nyt En god benedide dē seuendē dats hi heylichdē. En hi wilt datmē viert. Wāt oec voir die wet heeft altoes die saterdach gehoudē geweest van veel luden. En dese vierte heeft god idē wet gheheylicht dats du salste vieren. Dits die gheslaechte des hemels en der eerde. Enyghe eyndē hier twerr vā soss daghen En enyghe ander hier na Adam bekede sijn wijf. En

Coment li Reỳ de Egỳpte va chacer au boỳs · e lesse ioseph oue uesq̃
sa Reỳne a lostel · ~

Ici la Raỳne requert ioseph
estre soun ami · E dit ceo ne
frai ioe mỳe · ~

Coment la Raỳne crie e sa cote deschre
e se cheuus tỳre e dit au seriaunt qe
ioseph le voulīst afortier · ~

Plate 110

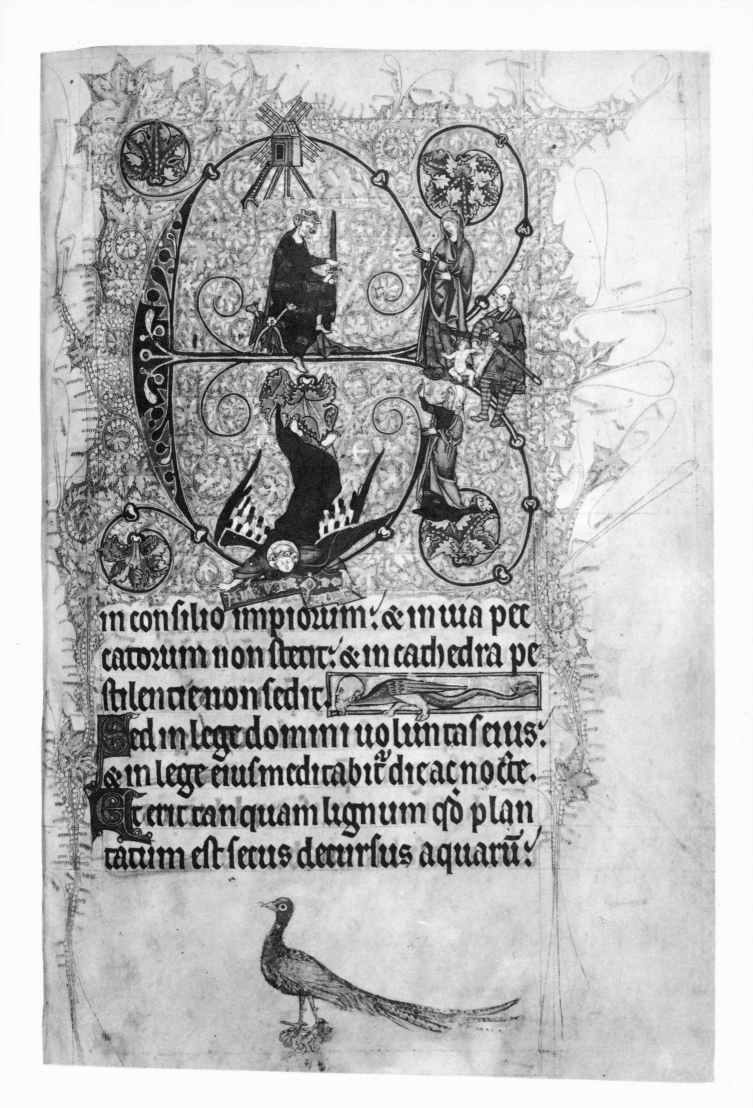

in confilio impioum: & in uia pec
catouum non ftetit: & in cathedra pe
ftilentie non fedit.

Sed in lege domini uoluntas eius:
& in lege eius meditabit dieac nocte.
Et erit tanquam lignum qd plan
tatum eft fecus decurfus aquaru.

Plate 111

EWAN

o descendit cum eis et venit naza[reth]: et erat subditus illis.

In diebus illis venit iohannes baptista in deserto iudee predicans z dicens. penitentiam agite.

oc significat qd dominus docuit per exemplum quod quilibet subditus quanto maior est debet obedire prelato suo in his que sunt ad deum.

oc significat qd dominus doctrinam suam mittit humilibz z infantibz qui enim superbi sunt gratiam domini capere non possunt.

ut iohannes in deserto baptizans indutus pilis cameloz z zona pellicea circa lumbos eius et locustas et mel siluestre edebat.

unc exibat ad eum ierlima et omnis iudee regio circa iordanem et baptizabantur ab eo in iordane confitentes peccata sua.

oc significat qd iuxta sectam communi homini uita separatum vestitus eorum uilis est pro gloria uitanda / victus tenuis pro carne domanda.

oc significat qd oriendum est de pristina conuersatione; qui mundari querit per baptismu[m].

Plate 112

Plate 113

Plate 114

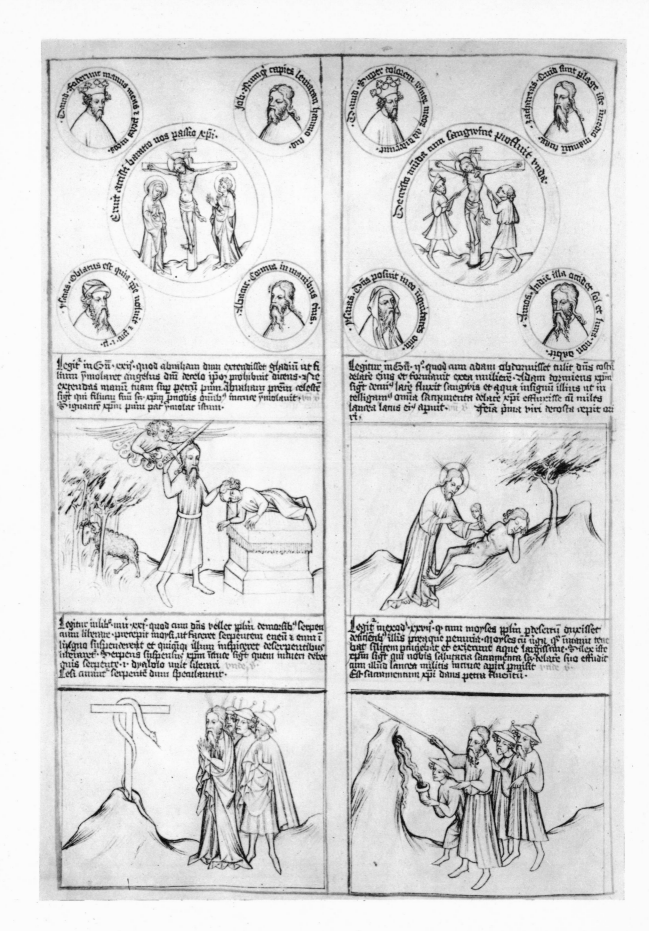

Plate 115

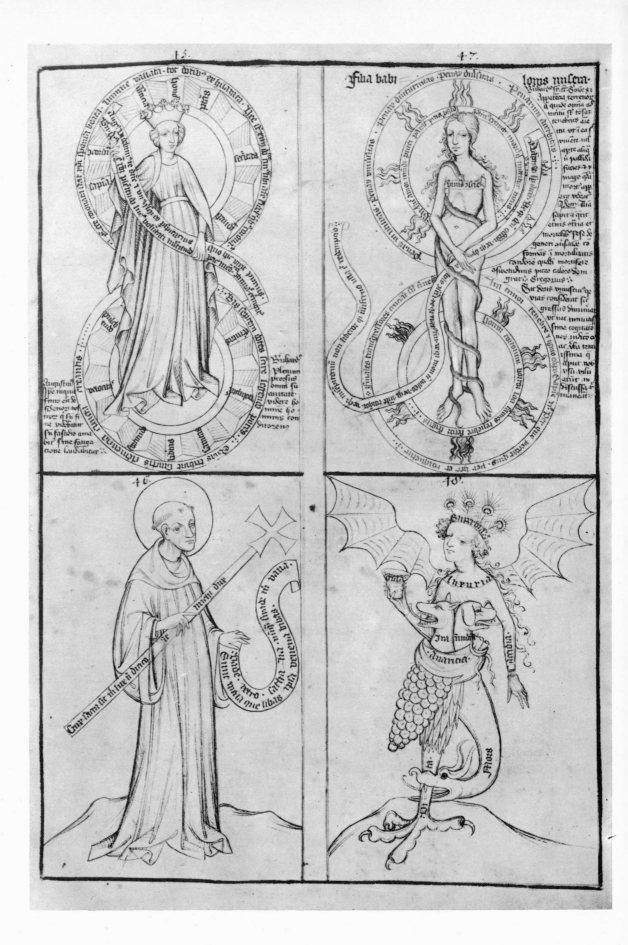

Plate 116

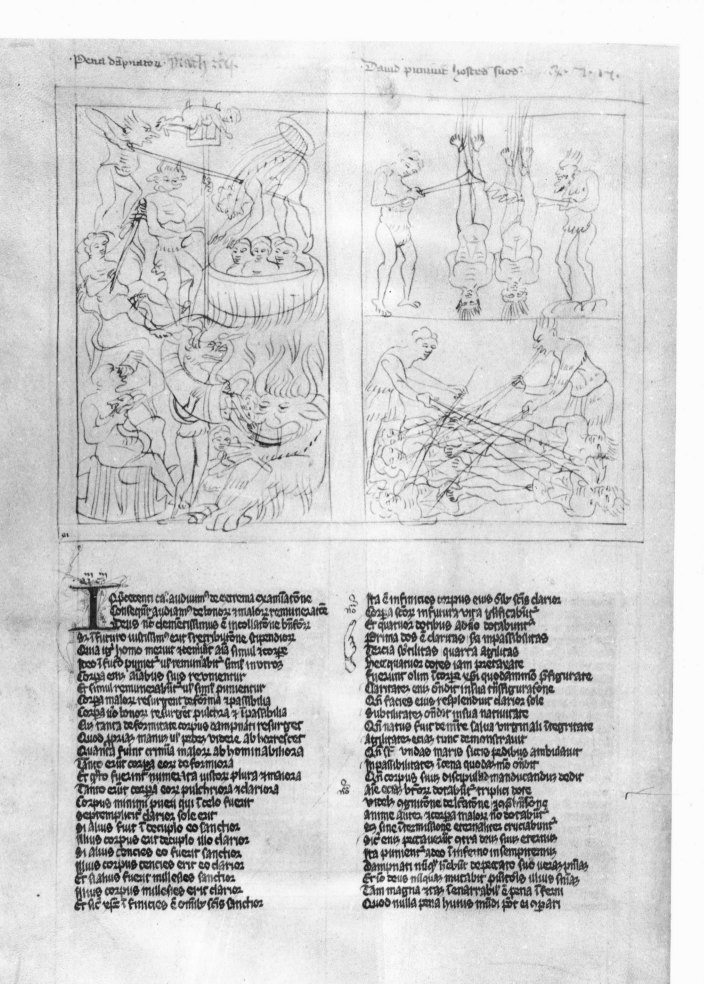

Plate 117

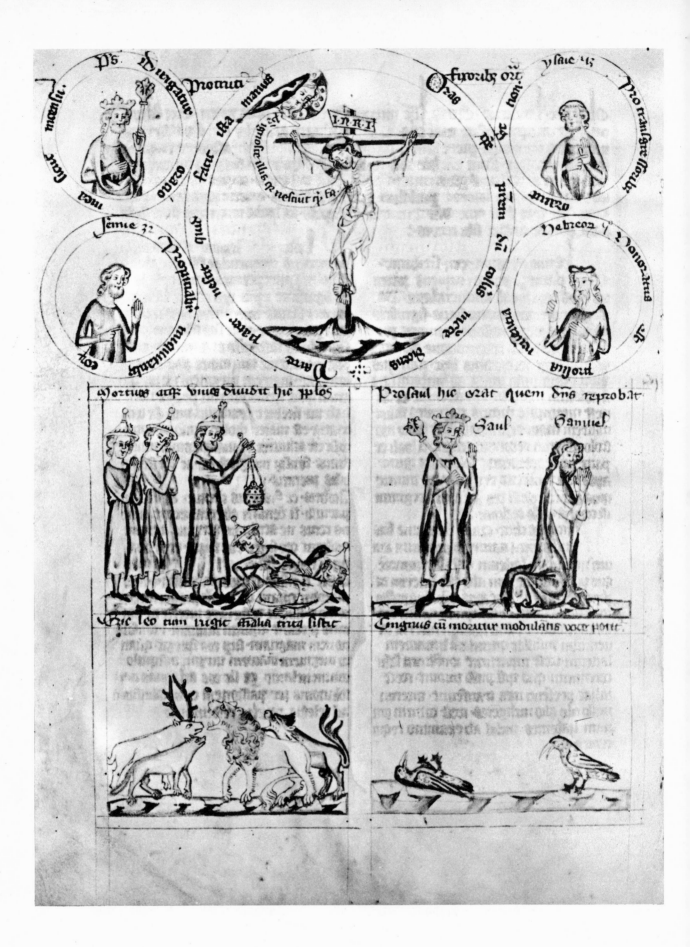

Plate 118

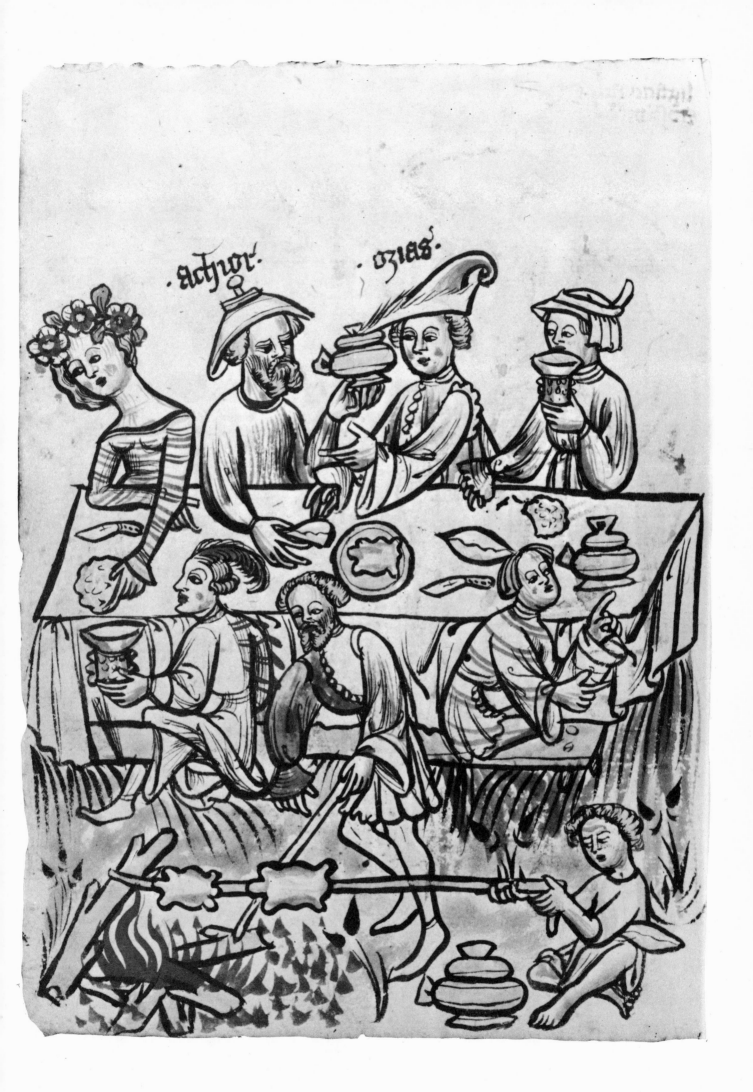

Plate 119

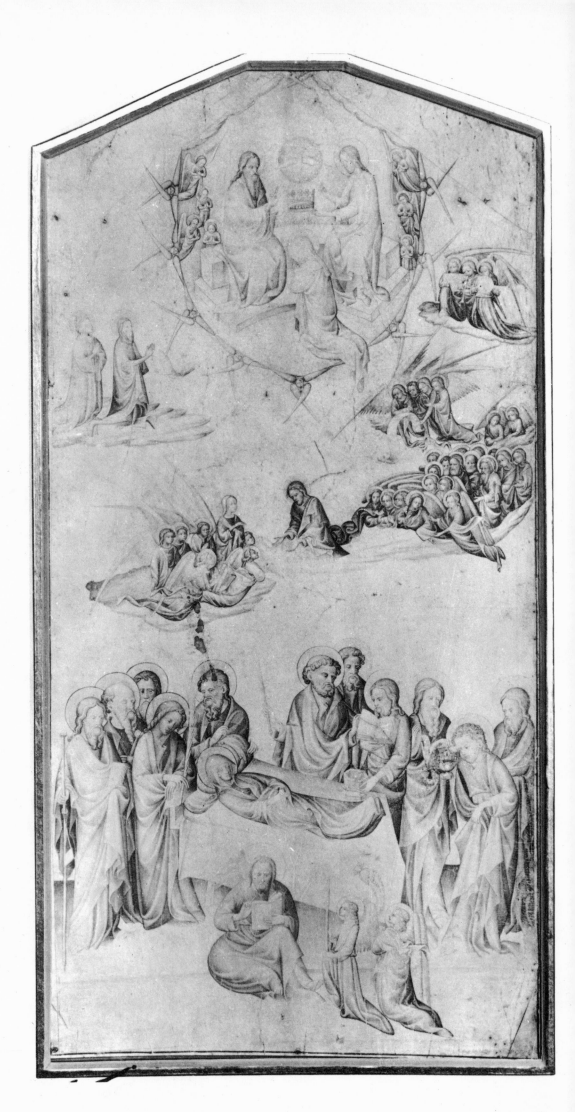

Plate 120

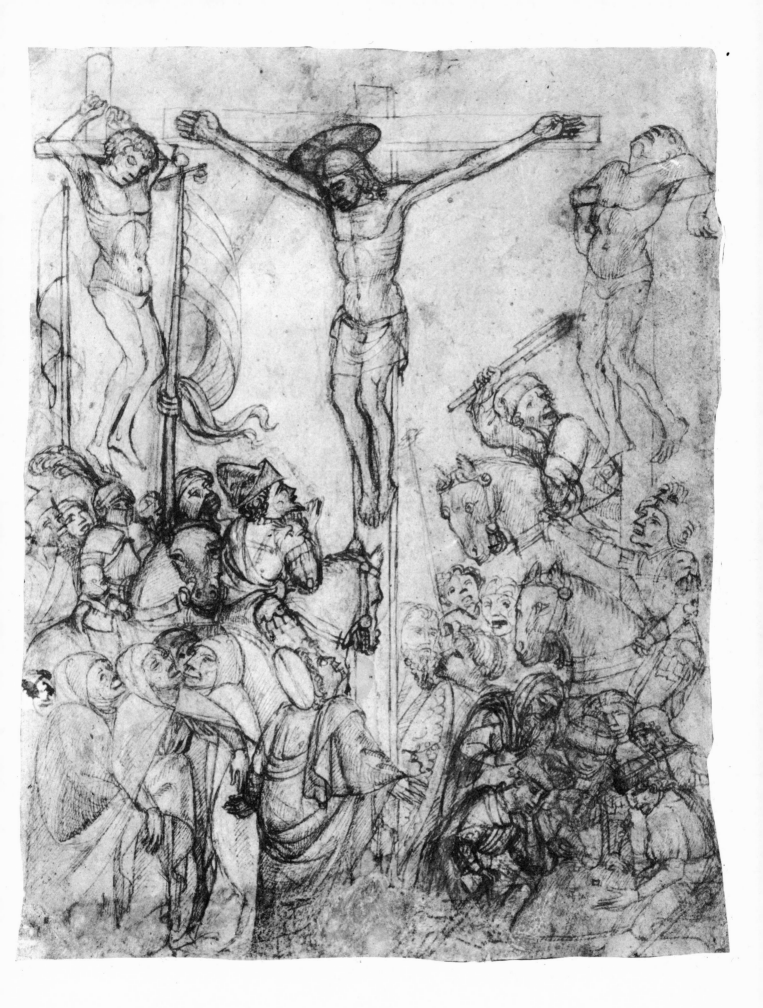

Plate 121

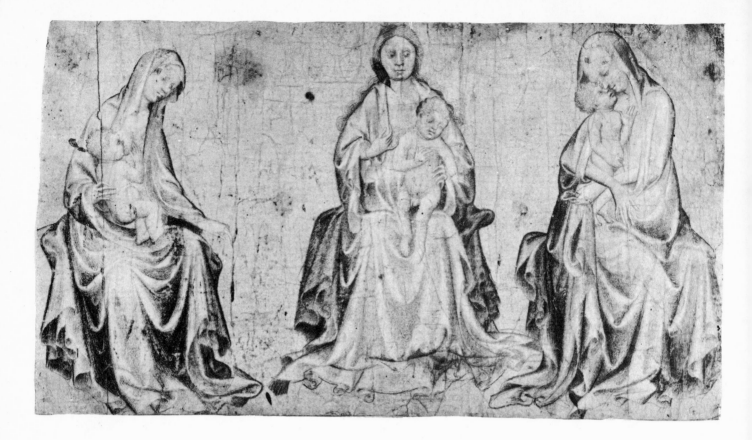

Plate 122

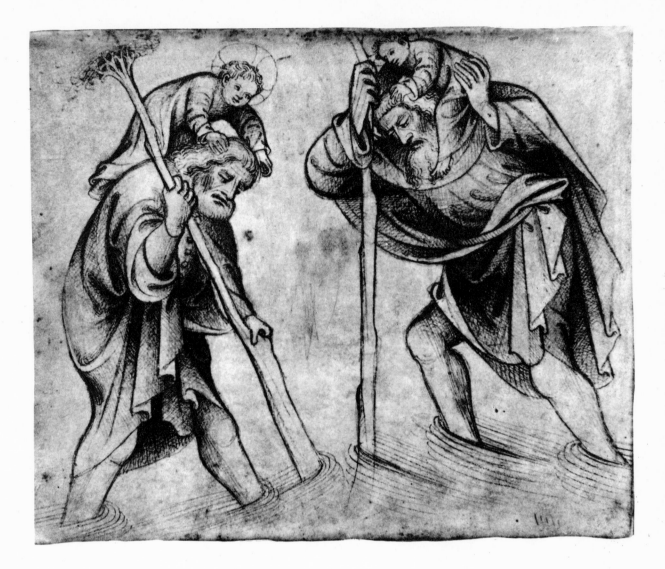

Plate 123

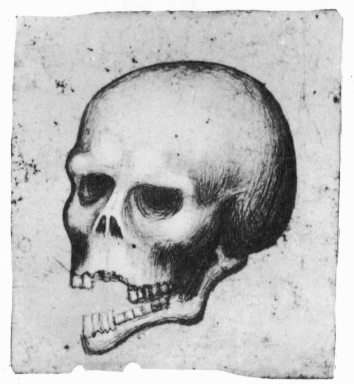

Plate 124

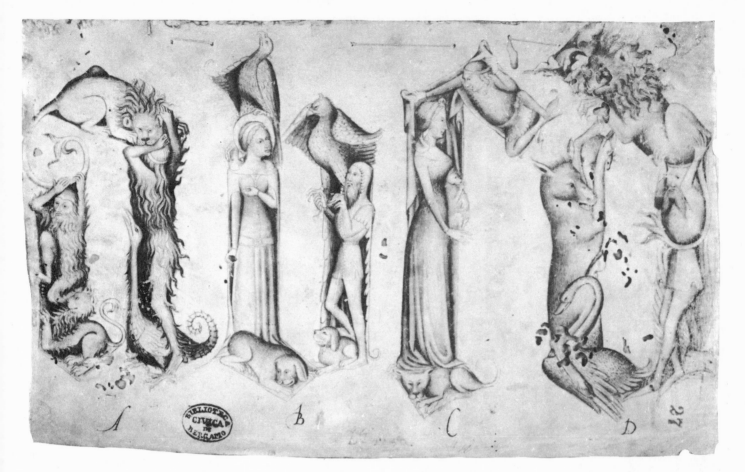

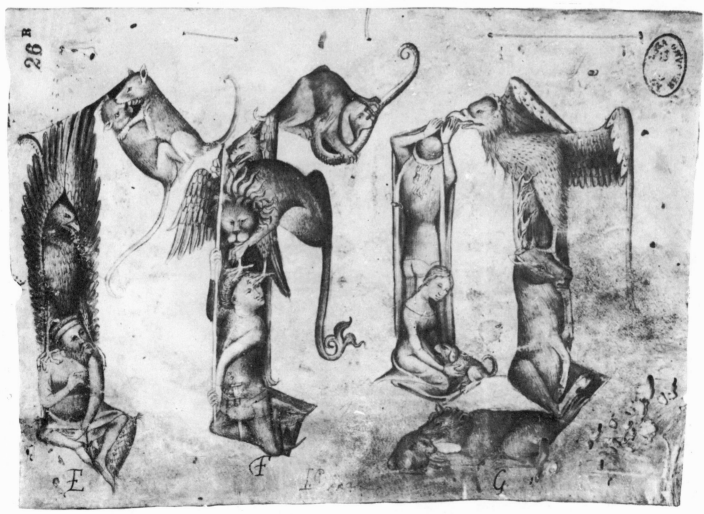

Plate 125

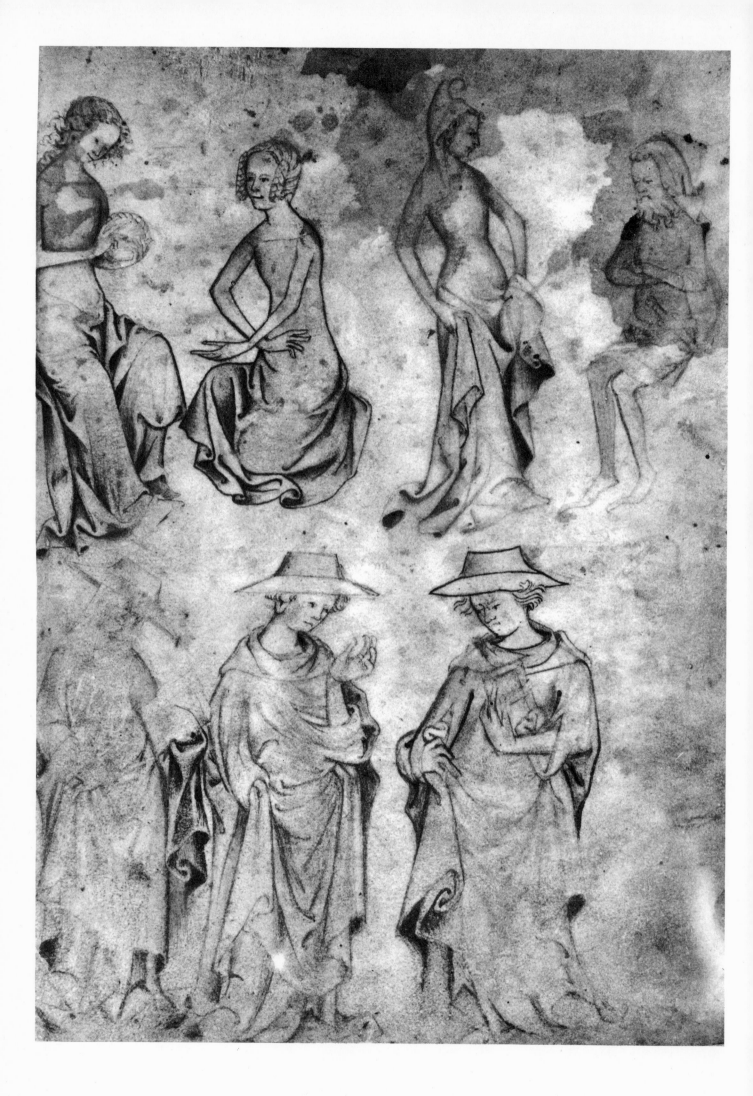

Plate 126

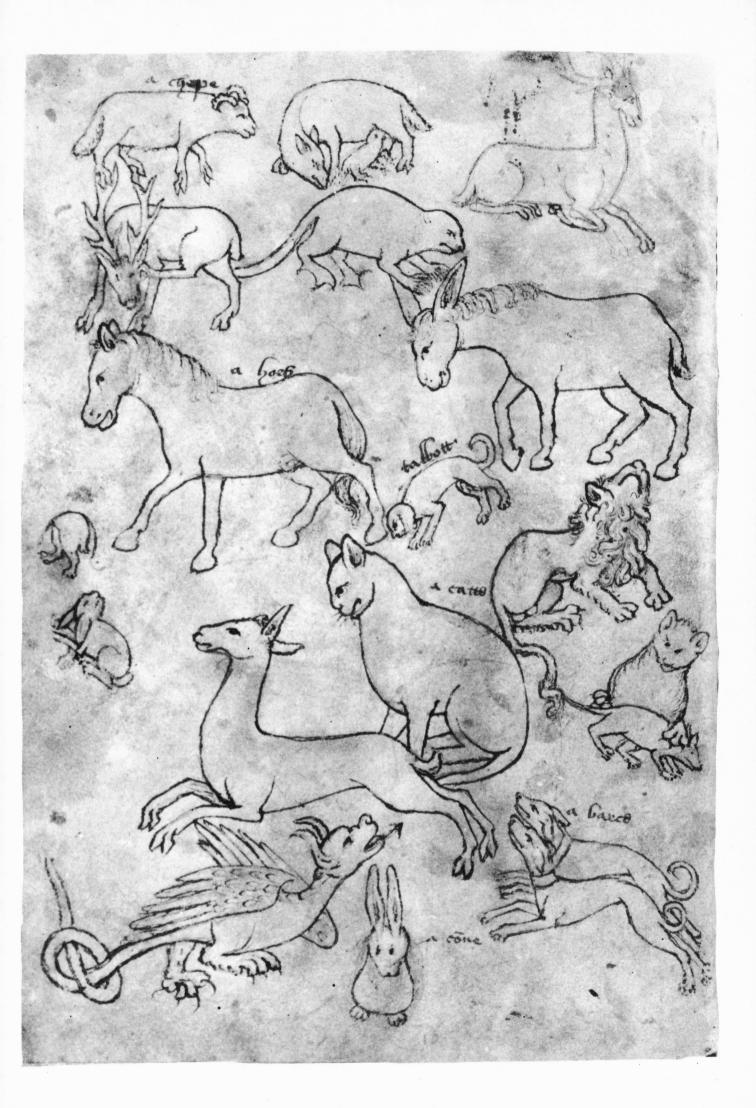

Plate 127

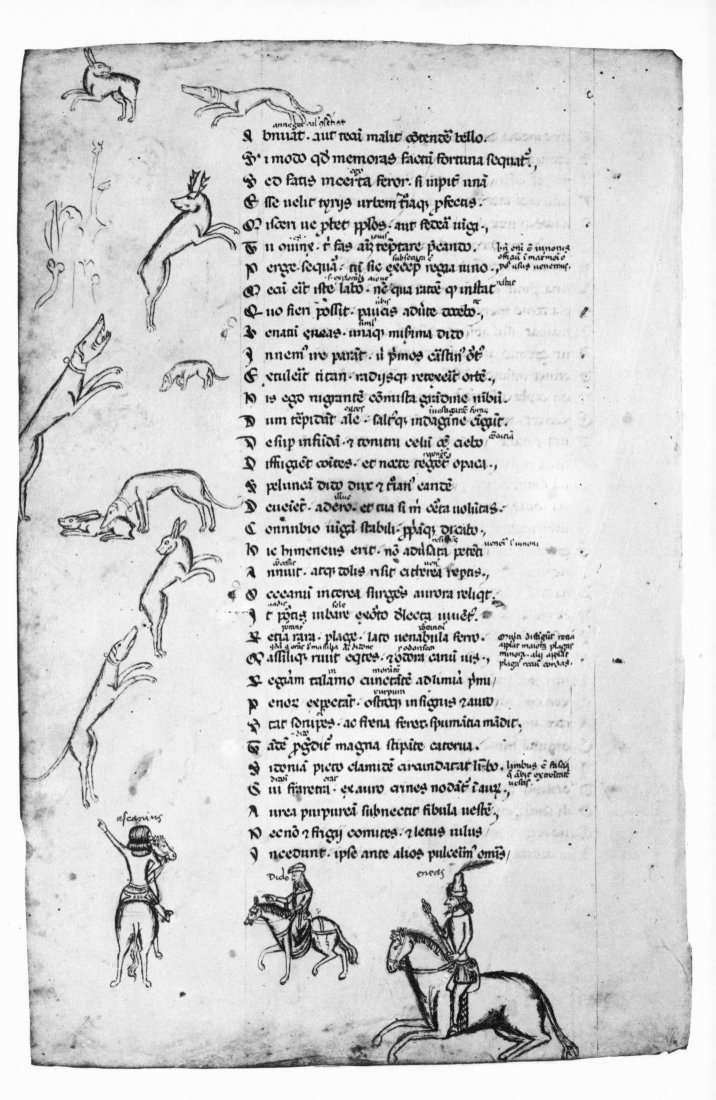

bnuat. aut veai malit cōtendō bello.

i modo qd memoras factū fortuna sequat.

ed fatis incerta feror. si iupit unā

sse velit tyrijs urbem tiaq psecus.

iscen ue pter pplōs. aut fedā uigi.,

u omiux. ꝛ fas aut teptare pcando.

erge sequaꝛ tu sic excep regia iuno.,

ecū eit iste lābō. ne qua rate qꝛ instat

uo fieri possit. paucis adiite trebō.

enatꝰ eneas. unaꝗ misima dido

nnemꝰ io parāt. iꝰ pmos castlin orbē

etuleit titan. radijsꝗ retexeit ortē.,

is ego nigrantē cōmista grādine nibū

um trepidāt alē. saltꝰꝗ indagine cigiit.

e sup infūdā. ꝛ tonitru celū oē ciebo

ffugiet comites. et nocte tegēt opaca.,

peluncā dido dux ꝛ trianꝰ eandē

euenet. adero. et tua si m̄ cēta uolutas.,

onnubio iūgā stabili. pprāꝗ dicābo.,

ic hineneus erit. nō adilata pteri

nnuit. atꝗ tolis risit citherea reptis.,

ceanū interea surges aurora reliqt.,

t prig̈s iubar exoto dlecta iuiet.,

etia rara. plage. lato uenabula ferro.

assiliꝗ ruit eqtes. ꝛodora canū uis.,

egiam talamo cunctāte adlimiā pmū

enor expectāt. ostrōꝗ insignis ꝛauro

tat sdnipes. ac frena ferox. spumātia mādit,

ātē prgdit magna stipāte caterua.

itoniā picto clamidē aircūdatat lūbo

iū fiaretia. exauro crines nodātꝰ īauꝛ.,

urea purpurei subnectit fibula uestē.,

ecnō ꝛ frigij comites. ꝛ letus iulus

ncedunt. ipse ante alios pulceiinꝰ omis.,

ascanius

Dido

eneas

Plate 129

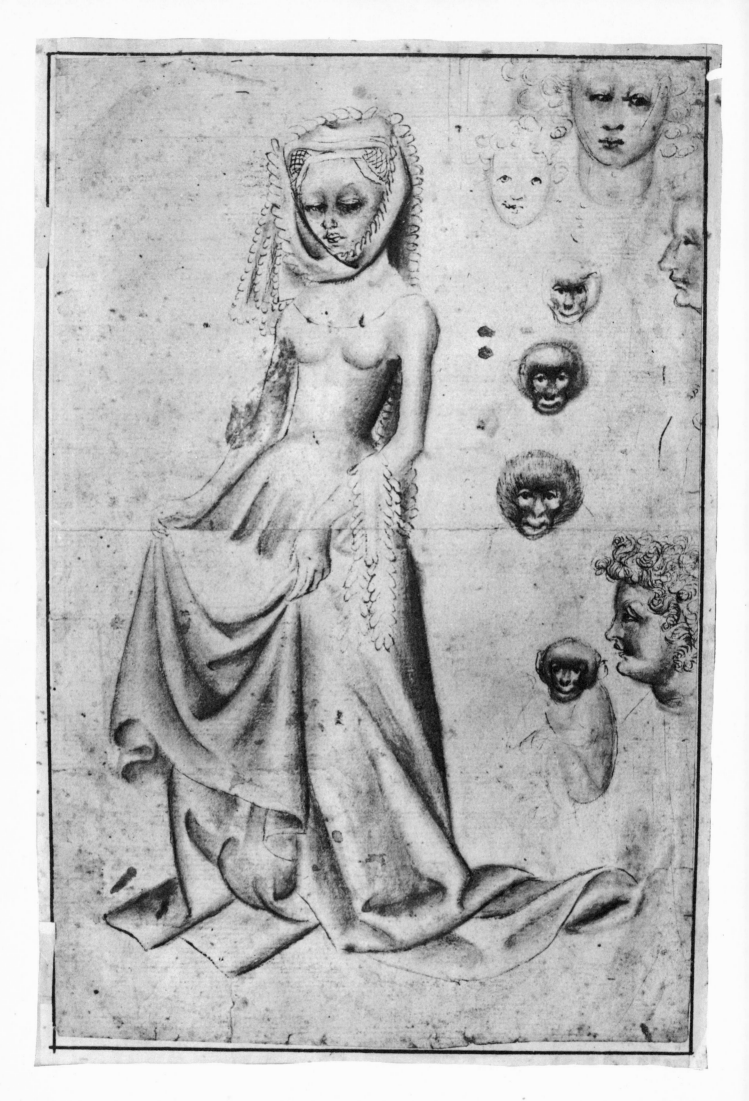

Plate 130

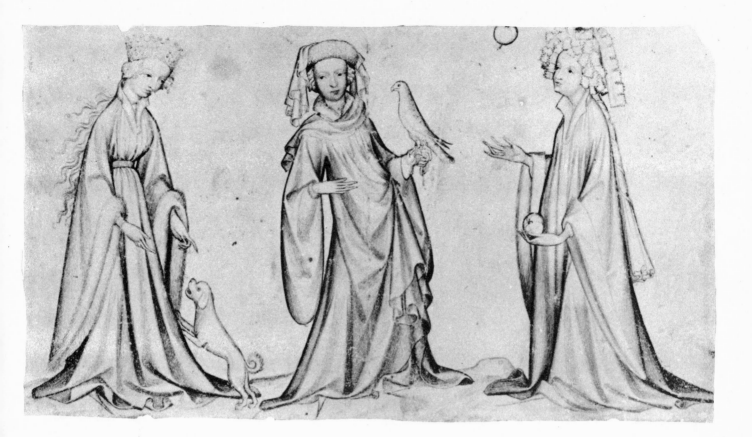

Plate 131

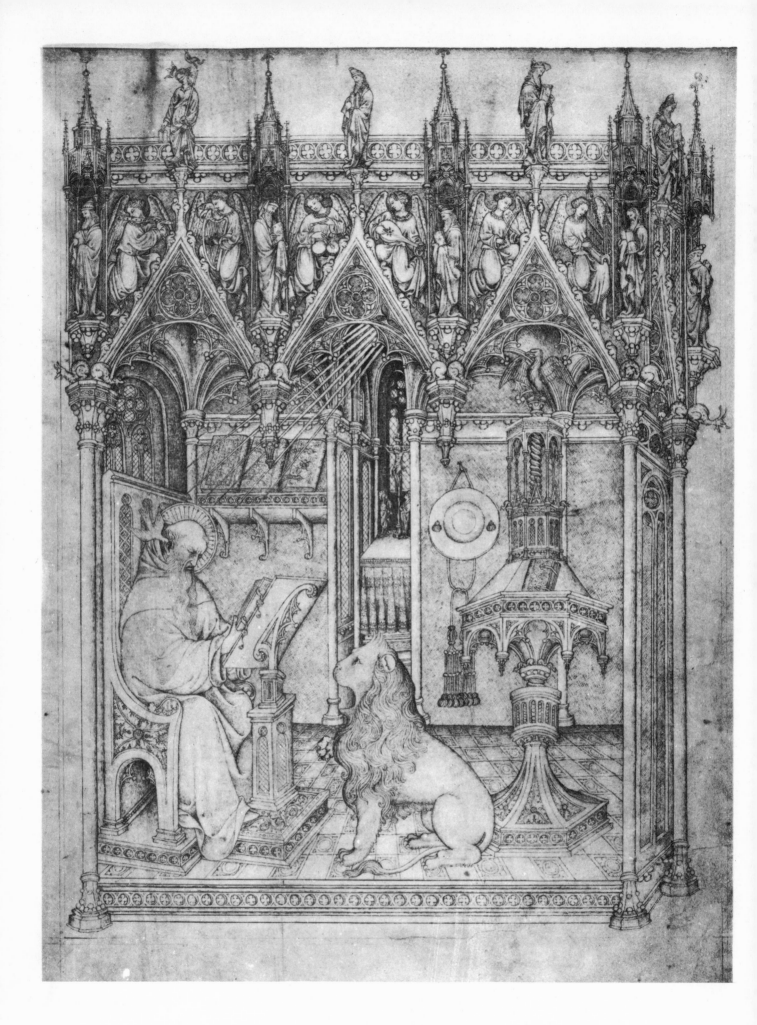

Plate 132